10,000 EYES

"10,000 Eyes: ASMP's Celebration of the 150th Anniversary of Photography" was a two-phase project of the American Society of Magazine Photographers. Designed not only to add new members to the Society, but also to increase public awareness of ASMP's role as an advocacy organization of and for photographers, "10,000 Eyes" provided our members with a self-initiated, chapter-driven, and sponsor-supported project that was all about "taking pictures."

Phase One took place over a 150-hour period in April of 1990. Nearly all of ASMP's 33 chapters planned some sort of photographic project as well as activities to draw attention to the Society and contribute meaningfully to their communities. Project sponsors were the Professional Photography Division, Eastman Kodak Company; LAB-NET; and Refrema/Photoquip. Kodak contributed 25,000 rolls of film, and LABNET, an organization of ten professional photographic labs around the country, donated processing and printing. Refrema/Photoquip supported the project with a cash grant.

Phase Two will conclude with the publication of this book and the curation of an international traveling exhibit. A distinguished panel of editors, chosen for their skill and experience as photo professionals, selected from the more than 13,000 photographs submitted by our members the 181 you see here. General and Associate members were invited to submit ten images from their life's work, while our Affiliates were asked for five each. The photographers of ASMP, responsible for a large percentage of the images seen on a daily basis around the world, work in virtually every discipline of photography, and the images in this book represent their unique and diverse talents.

"10,000 Eyes" has been a resounding success on many levels, fulfilling every objective the Committee set forth nearly two years ago. The most ambitious project ever undertaken by ASMP, supported by committed and generous sponsors and accomplished by a network of strong chapters, "10,000 Eyes" has served to unite and strengthen the Society that protects and promotes photographers while they bear witness to the world.

To the members of the American Society of Magazine Photographers

. . . past, present, and future

"The mission of photography

is to explain man to man

—*Edward Steichen*

and each man to himself."

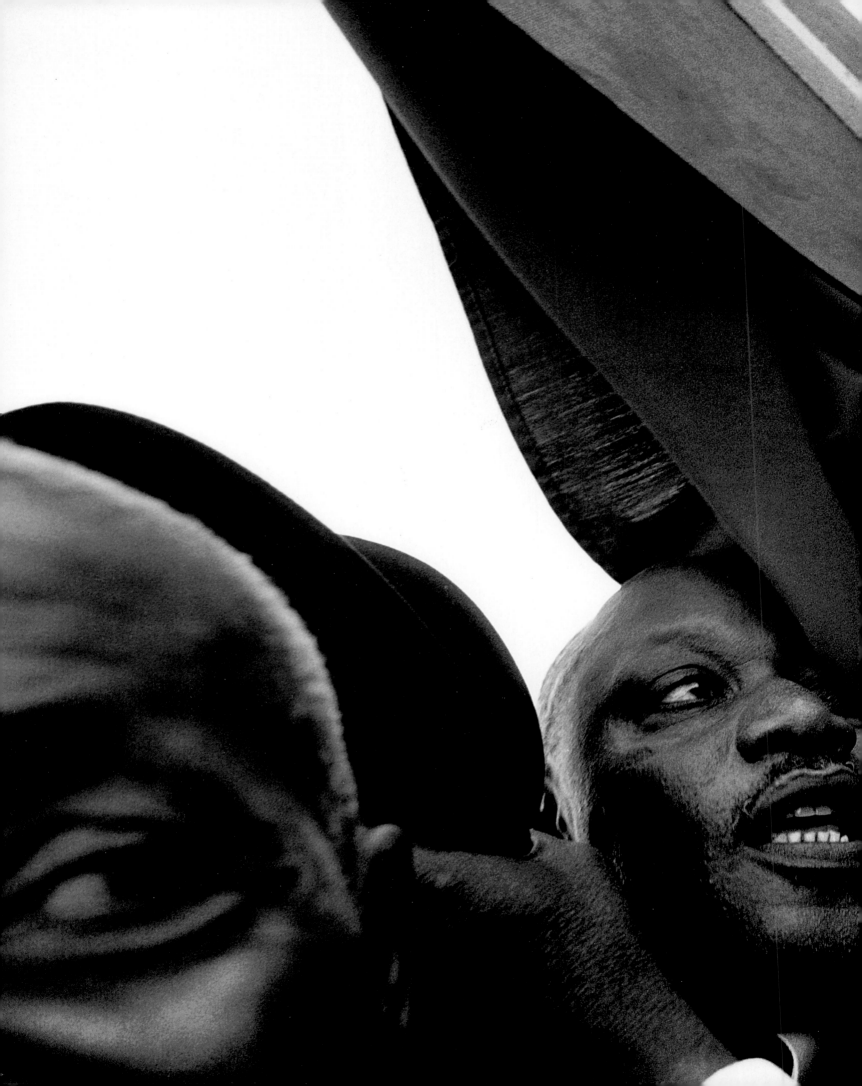

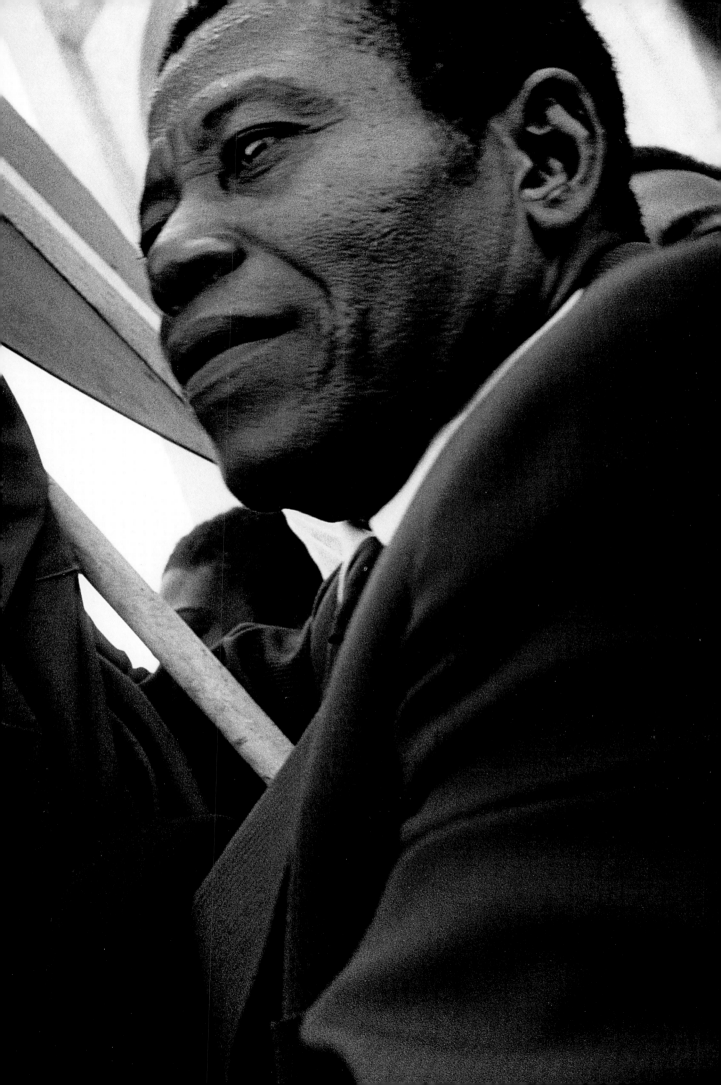

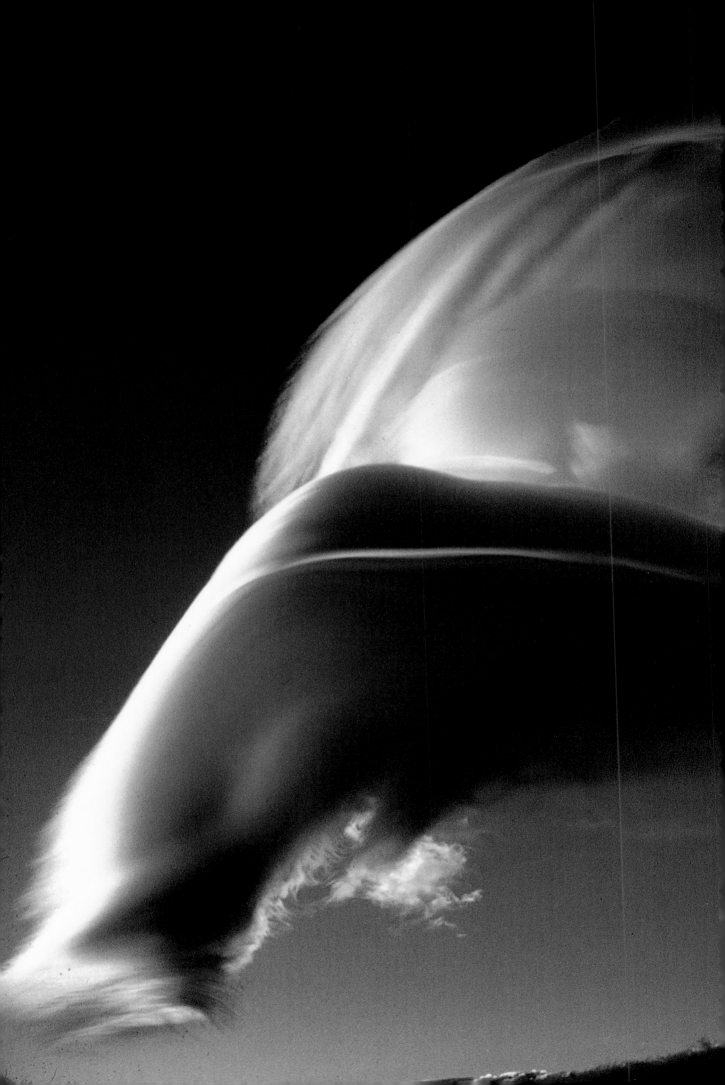

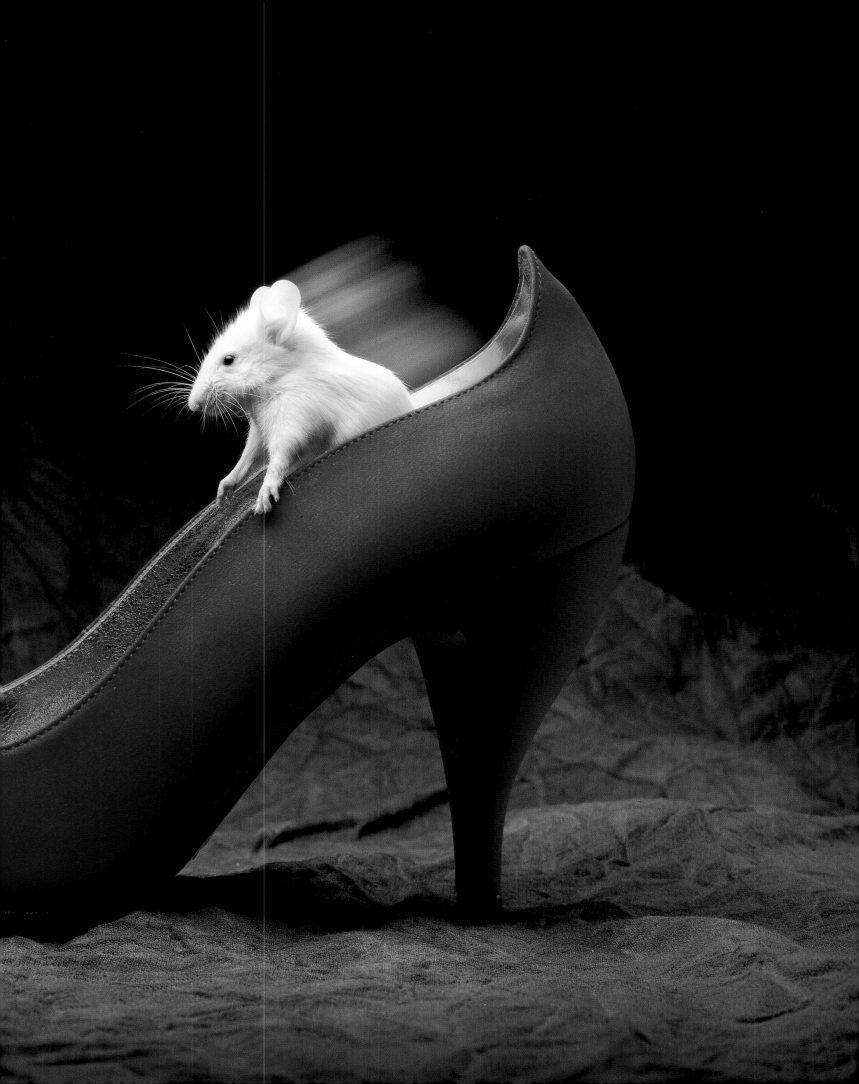

EDITOR • Ann Clements Borum DESIGN • Bill Marr PRODUCTION • Andrew Cleff, Lisa Naples

..

Published by the Professional Photography Division, Eastman Kodak Company and Thomasson-Grant, Inc.

Deepest appreciation to Arnold Newman for his generous contribution to "10,000 Eyes."

A special thank you to Susan Vermazen for her recommendations during the planning stages of this book.

Grateful acknowledgment is made to the estates of
Ansel Adams, Margaret Bourke-White, Philippe Halsman, Ernst Haas, Edward Weston, and W. Eugene Smith,
as well as to Richard Avedon, Berenice Abbott, and Arnold Newman for permission to reprint their photographs.
Thanks also to Black Star, Commerce Graphics, The Center for Creative Photography, University of Arizona,
and *Life* Picture Sales for their kind assistance.

Thomasson-Grant, One Morton Drive, Suite 500, Charlottesville, VA 22901, (804) 977-1780

10,000 EYES

THE AMERICAN SOCIETY OF MAGAZINE PHOTOGRAPHERS'

CELEBRATION OF THE 150TH ANNIVERSARY OF PHOTOGRAPHY

PUBLISHED BY THE

PROFESSIONAL PHOTOGRAPHY DIVISION, EASTMAN KODAK COMPANY

AND

THOMASSON-GRANT

ARNOLD NEWMAN

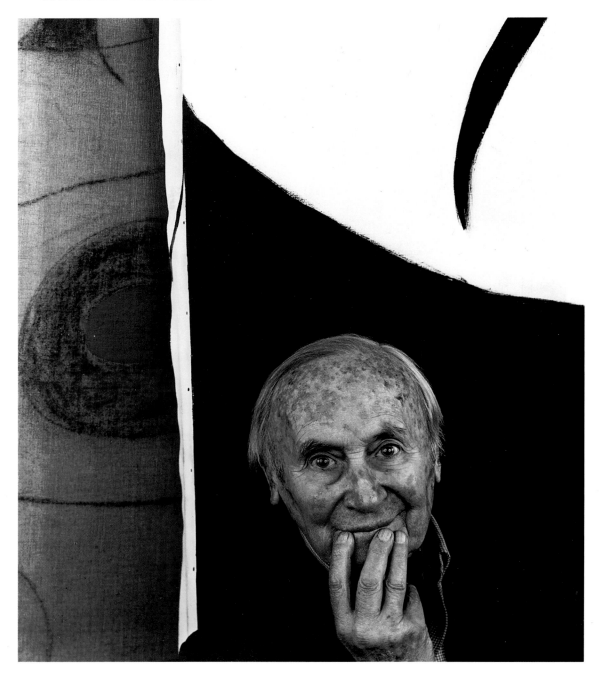

Joan Miró, Palma, Mallorca, 1979

"INEVITABLY THERE MUST BE A GREAT DEAL

OF THE PHOTOGRAPHER IN HIS FINISHED PRODUCT;

IN OTHER WORDS, THE PHOTOGRAPHER MUST BE A PART OF THE PICTURE."

—Arnold Newman

By Arnold Newman

I am ASMP member number 181. W. Eugene Smith and Eliot Elisofon were my sponsors in 1946 when I returned to New York. The war was over, and ASMP was just beginning to grow but had no real power or influence.

Photographers were working under unfair conditions. We were underpaid, the average member's plight was treated with indifference by the magazines, and we were pitted against each other when asked to work on "spec." While some ASMP members were protected by agreements with various publications, we knew we all had to work together. We were angry and had just begun to fight.

Memory is very unreliable. Einstein has been quoted as saying, "Memory is deceptive because it is colored by today's events." I have spent many days carefully reviewing my files, going over tons of copies of the old ASMP magazine *Infinity,* Board and committee reports, memos, etc., and have been startled to realize that today's events not only color our memories, but the issues and problems are virtually the same as they were when ASMP came into existence.

From the earliest meetings, we organized against the injustices of speculative assignments, censorship, and copyright abuse. We addressed the issues of codes, rates, insurance, minority rights, etc. Our constitution was, and still is, in a constant state of change. Despite this, we sponsored exhibits, published newsletters, and presented awards to our members as well as to others in the photographic world.

Our meetings were spirited, to say the least. We came from all over America and all around the world. We discussed issues and argued, often heatedly, but we never lost sight of our real objectives. Ironically, our antagonists were

also our principal clients. But the editors and executives, mostly at Time, Inc., could not or would not understand us, and despite a few friends and sympathizers among them, they resisted collective bargaining. It was corporations like this that we had to battle —item by item, day after day, year after year. Gradually, we made headway, but they would never officially recognize ASMP as an organization. Unhappily, our trouble was we needed them. Their trouble was they needed us. We had the talent.

A key victory nearly forgotten and often overlooked, was a non-ASMP act. In 1955, *Life* published nine essays, "American Arts and Skills," and later sold them to Dutton as a book. Five of the essays were shot by staffers or were handouts. The problem was they "conveniently forgot" that the other four were shot by three freelancers, Gjon Mili, Bradley Smith, and myself. We, naturally, requested additional payment for this unauthorized use.

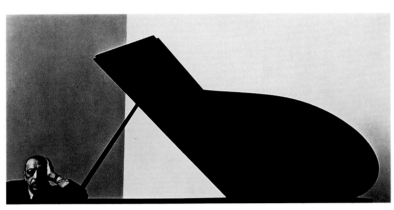

Igor Stravinsky, New York City, 1946

In settlement, *Life* offered remuneration with the stipulation that we sign a contract (also sent out to their other freelancers) that required us to give up our copyrights, reducing or wiping out payment on reuses. Our hard-earned rights were threatened as control over, indeed the very loss of, our negatives, our *work*, was at stake. All hell broke loose!

Seven other top freelancers refused to sign, and in effect, ten of us went on "strike." Because this was limited to *Life* freelancers, it did not become an official ASMP issue, but we, Philippe Halsman, Jerry Cooke, Milton Greene, Cornell Capa, Lisa Larson, Charles Rotkin, Mark Shaw, Gjon Mili, Bradley Smith, and I, were all members, some officers and members of the Board. The wrangling went on for almost a year. Alternate contracts were offered and refused again and again. But as Charles Rotkin recalls, the turning point came when *Life*, attempting to divide and conquer, claimed that they could do without any five of us. Mili became furious and confronted his friend, *Life*'s editor-in-chief, Ed Thompson, saying, "I think [Dimitri] Kessel [who worked for *Life*] is going to have one hell of a time crossing any picket line I'm on." *Life*, at this point, gave up and offered us a fair agreement restoring all our rights. What would have been a disastrous precedent for all ASMP members was avoided.

Despite our problems, we did enjoy ourselves. We developed a camaraderie, we worked together hanging exhibits, and we

threw parties for our own benefit and fun. Many were organized by our "wives committee" until that phrase became outdated with time and as more women photographers became members of ASMP. Our entertainment often featured famous actors and comedians. After all, we did photograph them for important publications, and some were our friends. I remember one unknown comic trying vainly to put over a new act and gradually losing some of his noisy audience. A few of us realized we were watching a great new talent Woody Allen.

What was so wonderful was the sheer enjoyment of getting to know each other. ASMP became part of our lives. Best of all were the coffee klatches after each meeting, where we exchanged real and tall tales of location dramas, customs nightmares, and technical information. Most importantly, we learned from each other. There were no aesthetic, racial, or economic barriers. It was ASMP at its best. One night in the early 1960s, at a fully packed coffee klatch, one member observed in awe, "If a bomb fell here tonight, photographic history would forever be changed." Life-long friendships evolved over pastrami, Danish, and coffee.

Being a photographer is a wonderful way of life. I've enjoyed it for over 52 years, 45 as an ASMP member. Let us not forget the photographs we made, the opportunities we had, the fun and immense satisfaction photography has given us. Relationships were formed, and not surprisingly, many editors became my close friends.

Yes, ASMP had, and continues to have, the "names." Just look over our past and present membership. We did not just record events, people, and the world. Our members made and changed the course of photography. We created a new form of history, and many reshaped our medium as an art form. Check the long international list of photographic books, magazines, exhibits, and museum collections. We are there.

—*Arnold Newman*
May 1991

"WHAT WAS SO WONDERFUL WAS THE SHEER ENJOYMENT OF GETTING TO KNOW EACH OTHER. ASMP BECAME PART OF OUR LIVES MOST IMPORTANTLY, WE LEARNED FROM EACH OTHER."
—Arnold Newman

Masters of photography

These ten "Masters of ASMP," whose images accompany the foreword and historical perspective, are among the best-known members of the Society. Representative of the rich and vast pool of talent within ASMP's ranks, they have had an immeasurable influence on the medium of photography.

ERNST HAAS

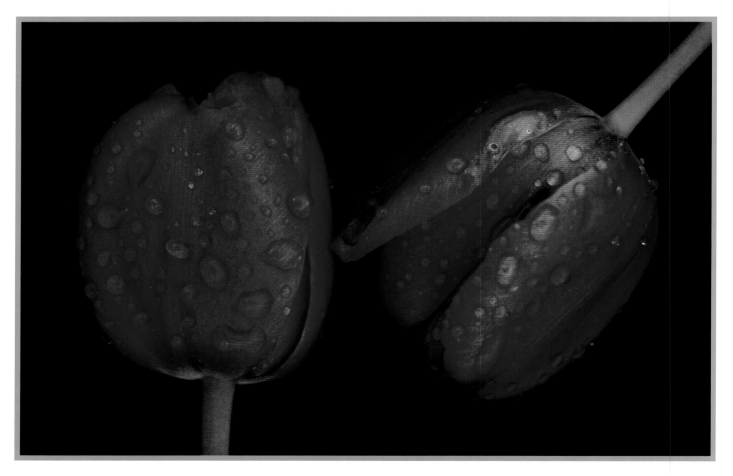

Two Tulips, Japan, 1980

"A PICTURE IS THE EXPRESSION OF AN IMPRESSION.

IF THE BEAUTIFUL WERE NOT IN US,

HOW WOULD WE EVER RECOGNIZE IT?"

—Ernst Haas

Joined ASMP 1951

A historical perspective

"The beginnings have been made and the opening headaches are in the past. We now definitely have a Society." These straightforward words in the inaugural issue of the Society of Magazine Photographers' (SMP) national *Bulletin*, February 1945, introduced to postwar New York a new organization that would change the face of magazine photography and the entire profession of picture-making. Having begun in the fall of 1942 as a casual discussion between *Click* magazine photographers Bradley Smith and Ike Vern with *New York Post* columnist/critic John Adam Knight about the need for magazine photographers to "have some sort of club or something," real progress began on October 12, 1944, when a group of two dozen photographers gathered in Ewing Krainin's New York studio and agreed that a formal organization was both wanted and needed.

Says founding member Bradley Smith, "It was the year of 1944, a year of the beachheads of Normandy, the beginning of the end of World War II. It was also the year of the first meeting to organize photojournalists, a new breed of concerned visual communicators." Philippe Halsman, a portrait and editorial photographer who had moved to New York from Paris in 1940, attended that first meeting because, "I am curious by nature and partly because I had a vague feeling that such a society was necessary. The unselfish spirit and the high standards of the discussion impressed me, and I became a member."

Concerned with issues that have since changed remarkably little—lack of credit lines, unauthorized reproduction of images, and uncredited copying of photographs by artists and illustrators—SMP's founding members recognized the value of communication among themselves and the

PHILIPPE HALSMAN

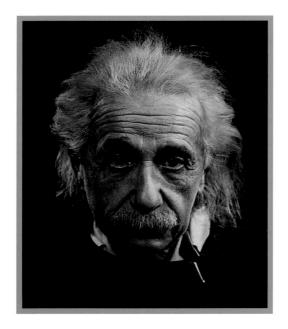

Albert Einstein, 1947

"WE, MAGAZINE

PHOTOGRAPHERS, ARE

NOT WITHOUT ARMS.

THE PICTURES THAT

WE MAKE AND THAT

ARE SEEN BY MILLIONS

EVERYWHERE ARE

WEAPONS OF

TREMENDOUS IMPACT.

WE ARE, INDEED,

THE SHOCK TROOPS

OF PUBLIC OPINION."

—Philippe Halsman
Joined ASMP 1944

potential for strength through unity. Said Halsman in the fall of 1945, "Only the SMP can bar the chaos in the magazine field. Our aims are to preserve and to improve the artistic, ethical, and material standards of our profession. The only way photographers can help carry out these aims is by grouping around the SMP, because for us too, a new era is beginning. This era is as yet undefined. But we know one thing; there will be forces, in the country and in our profession, that will work, consciously and unconsciously, for chaos. We of the SMP will stand against this chaos."

With no minimum day rates and most magazine jobs shot on speculation, photographers were further demeaned by the standard practice of crediting wire services or magazines but not individual photographers. Artists commonly used published photographs as uncredited references. *The Saturday Review of Literature* published an artist's woodcarving copied from a Philippe Halsman photograph of Wendell Wilkie, while Joe Rosenthal's iconic image of the Iwo Jima flag-raising was widely published without his credit. *Time* magazine's standard practice of reprinting photographs from its sister publication with only a *Life* credit prompted Halsman to comment, "This Mr. Life who gets so many credits in *Time* magazine must be a very active, very good photographer. We should ask him to join the Society." With the second issue of the Society's *Bulletin,* the founding members established a tradition of publicly applauding publications that gave photographers credit lines, beginning with *Look* magazine.

By November of that first year, there were 30 more paid-up members at $25 initiation and $2-per-month dues. After one year it was estimated that over three-fourths of all eligible magazine photographers belonged to SMP, including David Eisendrath, Margaret Bourke-White, Robert Capa, Louise Dahl-Wolfe, Jerry Cooke, Andre Kertesz, Peter Stackpole, Lisa Larsen, Andreas Feininger, Dimitri Kessel, and Arthur (Weegee) Fellig.

Chartered by the state of New York in December 1944 and guided through the complex task of writing its constitution by a temporary board of governors that included Herbert Gehr, Nelson Morris, Herbert Giles, Bradley Smith, Roland Harvey, and Allan Gould, the young Society of Magazine Photographers elected John Adam Knight to serve as temporary president and Philippe Halsman to serve as temporary secretary.

Knight, born Pierre de Rohan, in addition to writing columns on photography for the *New York Post* and *Pic* magazine, was a chef, a musician, and a composer, as well as the author of a music column syndicated in more than 450 newspapers. He was popular and influential on New York's photographic scene and worked tirelessly and selflessly to get the SMP off the ground. Attorney Stanley A. Katcher, himself a photography enthusiast, was introduced to the founding members by Knight and donated his time and services as needed for the resolution of the young Society's constitution, charter, and bylaws. As strongly as he believed in the importance of the SMP, John Adam Knight also believed that a full-time working magazine photographer should serve as president. After the foundation was established, he stepped aside.

Philippe Halsman was elected president on February 28, 1945, and served with his fellow officers Eliot Elisofon, Harold Rhodenbaugh, Herbert Giles, Michael Elliot, Nelson Morris, and Robert Disraeli, as well as board members Fritz Henle, Fritz Goro, and George Karger. Operating temporarily from Halsman's studio on West 67th Street, the founders group, with great gusto and determination, established committees for publications, membership, exhibitions, and a monthly bulletin. Regular meetings were held at the Hotel Belmont-Plaza as well as the Waldorf-Astoria and attracted more and more interested photographers as word spread about this small but increasingly visible group.

After it was brought to the Board's attention that the School of Modern Photography held claim to the letters SMP, the members voted to rename their group the Magazine Photographers Guild but discovered that name, too, was spoken for. Adding "American" seemed to satisfy everyone, and in May of 1946, the acronym ASMP officially entered the vernacular of New York's magazine and photography world.

Said the membership committee, "The young and less experienced photographers are joining the ASMP readily, feeling that the organization can give them help, advice, and support. It might have been feared that the older and more successful magazine photographers would ask themselves, 'Why should I join the Society? I am doing all right by myself. What can the Society do for me?' Very fortunately this selfish attitude is the exception. The greater part of the Society consists of known and successful photographers with many years of experience who joined the Society,

EDWARD WESTON

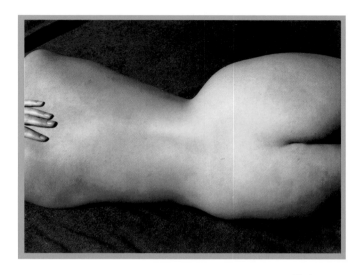

Nude, 1935

"I WANT THE STARK BEAUTY THAT A LENS CAN SO EXACTLY RENDER, PRESENTED WITHOUT INTERFERENCE OR 'ARTISTIC EFFECT.'"
—Edward Weston
Joined ASMP 1946

B E R E N I C E A B B O T T

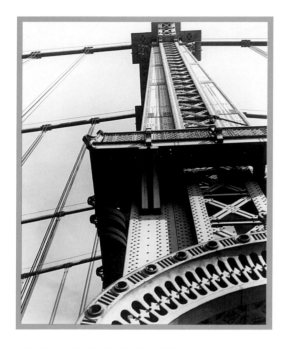

Manhattan Bridge, Looking Up, 1936

"THE PHOTOGRAPHER'S

ACT IS TO SEE THE

OUTSIDE WORLD

PRECISELY, WITH

INTELLIGENCE AS WELL

AS SENSUOUS INSIGHT."

—Berenice Abbott
Joined ASMP 1946

not because they expected to 'get something out of it,' but on the contrary, with the desire of giving to it to help the others. They want to be close to their fellow photographers, and they feel —and that is the reward of every collective idealism—that by giving to the others, that by promoting and advancing the whole, they are, in the final analysis, promoting and advancing themselves, too."

As the Society grew, the Board and officers not only encouraged New York magazine photographers to attend meetings and join, but solicited participation by some of photography's giants of the day. Edward Weston joined in 1946, saying, "I do want to join SMP, I'm all for you!" and Captain Edward Steichen wrote to Halsman that same year, remarking, "Please accept and convey my appreciation and thanks to the members of SMP for this distinction. I hope that being an honorary member does not preclude my taking an active interest in the welfare and future of the Society." Asked to join in 1956, French photographer Henri Cartier-Bresson responded, "I am much honored of your proposal. Being far from New York I had not considered joining ASMP, though I have many friends in its bosom, and I always was in full sympathy with its works and aims. After your letter I am more than happy to ask for admission. I never belonged to any club, nor did my camera, but my trigger finger and I cannot resist your suggestion."

In the very first days of the organization, ASMP had stated its official purposes as follows: "to safeguard and promote the interests of magazine photographers; to maintain and promote high professional standards and ethics in magazine photography; and to cultivate friendship and mutual understanding among professional magazine photographers."

The founding members were an understandably close-knit group, and the writings of the Society were full of personal news. Marriages, births, and travels got equal billing with tech tips, reports about exhibits, new magazine policies, difficult assignments, and legal briefs. Interest in each other's welfare was genuine, but perhaps no member of the Society tested his fellow members' devotion quite like W. Eugene Smith.

Smith, a driven personality (he asked ASMP to retract the adjective "jolly" from their description of him and substitute "morbid") and a photographer of immense talent (he worked for

Life magazine at age 18), often neglected his personal responsibilities and received the Society's help more than once. ASMP raised money with a print auction to pay Smith's rent, and members Arnold Newman and Jay Maisel, among others, remember moving the first Mrs. Smith and her children to another apartment after they were literally put out on the sidewalk. One of ASMP's brightest stars in the realm of war photography, Smith was seriously wounded by a Japanese mortar on Okinawa, where "his left index finger was almost amputated, the middle finger sustained compound fractures, his left cheek was torn open, his soft palate and the roof of his mouth destroyed, an as yet undetermined number of teeth were knocked out, both cheekbones were fractured, a piece of shrapnel which would probably have proven fatal, if it had not been deflected by the Contax he was wearing around his neck, hit in the left shoulder just about 1/8 inch from the spine, his glasses were hit, glass broke and cut his face in circles about his eyes, but fortunately none hit the eyeballs."

From his recovery room in the Pacific, Smith wrote to the Society (for whom he served as president in 1946): "Worn white hospital sheets, blank wooden hospital walls, pain in my body, strangers in my room. One of the strangers, a Navy corpsman, brings a cable, unfolds it and smooths it out before placing it in my hand. I have difficulty reading it, and then waving the cable, I make a sincere but poor effort to smile—and then just as poor an effort to talk to the corpsman, 'Friends in New York... they call it an accident... it was no accident.' It feels very good to be remembered by the Society, and the Society is each individual saying 'Hello' and 'We hope it's all right.' The body is the same (with improvements) although the background is different. I have just arrived home and must rest and not move around much. Music, my best doctor, begins to arrive in the form of records. Again, the Society. Frankly, I'm bewildered, embarrassed, and very appreciative. Thank you for making things easier."

ASMP's *Bulletin*, originally edited and written by Herbert Giles, Allan Gould, Sid Latham, and Jack Manning, had first appeared in February 1945 and, in keeping with its stated goal, "to report the Society's doings," was crammed full every month with news of meetings, committee reports, letters to the editor, and member news. The first issue contained not only reports about a future members' exhibition at the Museum of Science

W. EUGENE SMITH

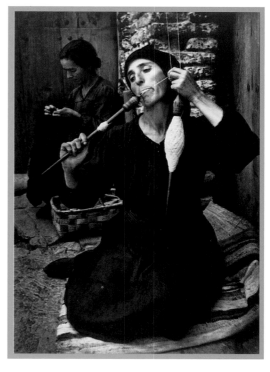

The Spinner, 1951

"NEVER HAVE I FOUND THE LIMITS OF THE PHOTOGRAPHIC POTENTIAL. EVERY HORIZON, UPON BEING REACHED, REVEALS ANOTHER BECKONING IN THE DISTANCE. ALWAYS, I AM ON THE THRESHOLD."

—W. Eugene Smith
Joined ASMP 1945

MARGARET BOURKE-WHITE

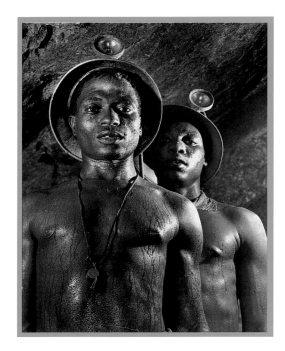

South African Gold Miners, Johannesburg, 1950

"I FIND THAT FOR A
PHOTOGRAPHER, AT
LEAST THIS
PHOTOGRAPHER, THE
ELEMENT OF DISCOVERY
IS VERY IMPORTANT. I
DON'T REPEAT MYSELF
WELL. I WANT AND NEED
THAT STIMULUS OF
WALKING FORWARD
FROM ONE NEW WORLD
TO ANOTHER."
—Margaret Bourke-White
Joined ASMP 1945

and Industry and plans for a lecture series by members to be held in conjunction with the Museum of Modern Art, but even a small advertisement for the American Red Cross.

Written with style and wit, the *Bulletin* kept ASMP members abreast of the news of the Society, even reaching "the man in the field, or overseas, unable to attend meetings or contribute actively." John Adam Knight's 89-year-old father, also a photographer, wrote to the editors in the second issue, "Thanks for sending me the first issue of the SMP *Bulletin*. It is a lively, literate little publication, and I enjoyed it very much. Except for it I probably never would have known that my son was the organizer and first president of what ought to become a tremendous power in photography The Society's *Bulletin*, it seems to me, ought to be as youthful, virile, and up-to-date as the photography produced by the members—which is the best in the world."

Humor, directed both inwardly and at others, was a constant thread running through the bulletins, and it tempered the very serious business of the Society. The report of the April 1945 meeting noted that, "on a motion by Disraeli, Karger and Breitenbach were appointed to work on the problem of arranging for group insurance for the members' photographic equipment. The meeting adjourned without bloodshed at midnight." The member news column contained amusing, informative anecdotes about Society members and proved so interesting that, in May, John R. Whiting, *Popular Photography*'s editor, bought the column to be published, in part, in his magazine. *Bulletin* editors responded by saying to the members, "Since our *Bulletin*, in four issues, has, at least in part, had about a 249,000% jump in readership, it is important that the title of the reprinted column do everybody justice. Remember, 'repetition is reputation' so let's have whatever news you have about yourself or another member. Keep it clean though—we have second class mailing privileges to think about now."

Letters from members overseas arrived with the salutation, "Dear gang," and the *Bulletin* cover photographs for several issues running were images that had been rejected (deservedly in some cases) by publishers. The bulletins also ran members' classified ads, such as, "Veteran, B.A. Carnegie Tech, experienced in travel and semi-documentary photography, 35mm, 4x5, and 8x10, wishes to apprentice to magazine photographer under G.I.

training bill. Lou Jacobs, August 1946." Plentiful, too, were interesting tidbits of wisdom, such as this from the 1945 publicity committee chairman, Hal Reiff: "The Society will furnish three members as judges for a beauty contest on a local television program and, although television has as yet no terrific value as a publicity medium, SMP members should consider appearance on this program as excellent training for their participation in radio programs which are being planned for the future."

In December 1946, ASMP's nonmember *Bulletin* editor, Mary Ellen Slate, tongue planted firmly in cheek, published a special "1956—Preview *Bulletin*" issue. She reported that future meetings would be held in the new auditorium at the United Nations to accommodate all members (it seats 15,000); the Society had a newly completed building on Central Park South, and dues were being reduced to a nickel a month to prevent the Society from going into a new tax bracket. Furthermore, imported champagne would be served at all future meetings, and Ike Vern had won that month's door prize—a case of Rolleiflexes. She went on to report that photo agencies had signed a new contract for 1957 giving 5 percent to them and 95 percent to the photographers and that page rates had gone to $2,000 per.

Born out of frustration over the inequities of the magazine business in the early 1940s, ASMP has been, since its very inception, the champion of photographers' rights. In 1948, *Collier's* magazine stated its inflammatory policy of assigning picture spreads on "a semi-speculative" basis. ASMP's *Bulletin* editor, Bernard Hoffman, rose to the occasion and editorialized: "What an intriguing place our planet would be if, regardless of profession, we could all take advantage of the 'semi-speculative' plan ... what a wonderful way to buy a car, see a movie, bury our dead, rent an apartment, travel to Europe, or deal with our local bartender. We might even be able to purchase *Collier's* itself on a semi-speculative basis So hurry hurry! Step right up and take a chance! Photography, suckers, has just been elevated to the level of Bingo!"

By 1950 there were many in ASMP who felt the sincere need for a means of collective bargaining. Said the *Bulletin*: "The magazine photographer today is an artist, but he also has to have the analytical abilities of a good lawyer, the integrity of a bank president, the stamina of a road racer, and frequently the patience of a

DOROTHEA LANGE

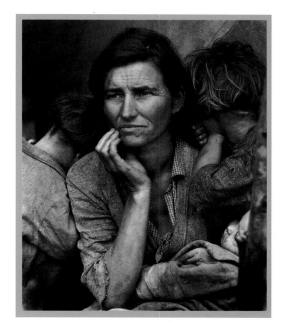

Migrant Mother, 1936

"PICK A THEME AND WORK IT TO EXHAUSTION. PICTURES ARE A MEDIUM OF COMMUNICATION, AND THE SUBJECT MUST BE SOMETHING YOU TRULY LOVE OR TRULY HATE."

—Dorothea Lange
Joined ASMP 1956

RICHARD AVEDON

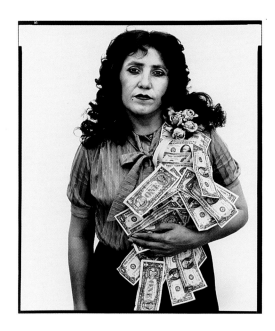

Petra Alvarado, factory worker,
El Paso, Texas, on her birthday, 1982

"A PORTRAIT IS

NOT A LIKENESS.

THE MOMENT AN

EMOTION OR FACT IS

TRANSFORMED INTO

A PHOTOGRAPH

IT IS NO LONGER

A FACT BUT AN

OPINION."

—Richard Avedon

Joined ASMP 1949

plumber. It is high time he learned some of the business acumen of the latter." The Society had already amended its charter in 1949 and had fought for the right to represent magazine photographers in matters of wages and working conditions. ASMP was licensed by the state of New York to act as a labor union in April of 1951. The National Labor Relations Board, however, when approached by ASMP in 1976, denied its request for union status. ASMP, a group of independent contractors, was officially a trade association.

Also in 1951, ASMP established the Code of Minimum Standards, an agreement that, while not legally enforceable, spelled out what the Society believed to be fair pay rates for freelance magazine photographers.

One by one, magazines signed the agreement, and the publishing industry was forever changed. Like all change, however, it did not happen overnight or without a struggle. Individual photographers, when faced with a noncomplying magazine, often lost the job when they refused to work for less than the code's minimums. This type of sacrifice on the part of ASMP members, for the good of the photographic profession, was seen again in 1967, when the issue of residual rights to images shot during a magazine assignment was raised and vigorously challenged by the magazine industry. ASMP's answer was to write a "Declaration of Conscience" stating that "reproduction rights and ownership belong to the photographer; that each use of a photograph must be compensated for; that limitations on a photographer's freedom to reuse his own creations must be related to the purpose and protection of the publication and must be limited in time; and that no ASMP member or unaffiliated photographer should agree to terms inconsistent with the resolution." A two-year battle with Time, Inc., was waged, and many ASMP members jeopardized their livelihoods before this basic right was recognized by the publishing industry. The stock photography business, and the benefits photographers realize from it, is a direct result of the stand that ASMP took in 1967.

Perhaps no more important role has ever been taken on by ASMP than that of advocate for change in the copyright law. The Society, throughout the entire decade of the 1970s, worked tirelessly for the Copyright Act, which, when it went into effect in 1978, placed ownership of a photographer's creative work back in

his hands. Every creative freelance working today owes ASMP an enormous debt for this brave and costly effort.

ASMP and its attorneys have been involved on an ongoing basis in cases that have resulted in precedent-making legislation on behalf of photographers, including the unauthorized reproduction of photographs in another medium (1945), the value of exposed but undeveloped film (1949), the rescinding of the IRS's Uniform Capitalization Rule (1988), and the reaffirming decision by the United States Supreme Court during the *Community for Creative Non-Violence v. Reid* case concerning work-for-hire in 1989.

Who among those founding members, drawn to each other for both personal and professional support, would have imagined that, nearly 50 years in the future, their legacy of pride and commitment would continue to shape and lead the photographers of the world? ASMP today, through its publications, its national offices in New York, its 34 chapters across the United States, and its more than 5,000 members around the world, represents the very best the photographic profession has to offer.

Halsman said in 1945, "There is little that is feminine in me, but when I am asked about the aims of ASMP, I feel like a mother who is asked what she wants her baby to become when the baby grows up." ASMP has grown up to be the industry leader, the standard by which photographic organizations are measured, and the Society that takes care of its own.

—*Ann Clements Borum*
10,000 Eyes National Committee

ANSEL ADAMS

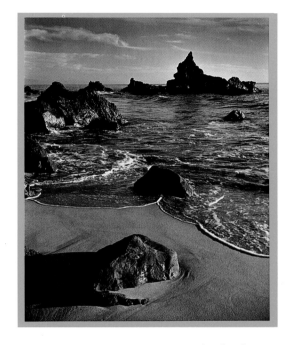

Rock and Surf, 1951

"THE FUNCTION OF THE ASMP SHOULD BE THE FURTHERANCE OF PHOTOGRAPHY AND PHOTOGRAPHIC QUALITY IN THE RELATED FIELDS, THE DISSEMINATION OF INFORMATION ABOUT PHOTOGRAPHY AND PHOTOGRAPHERS, AND THE ELEVATION OF STANDARDS."

—Ansel Adams
Joined ASMP 1952

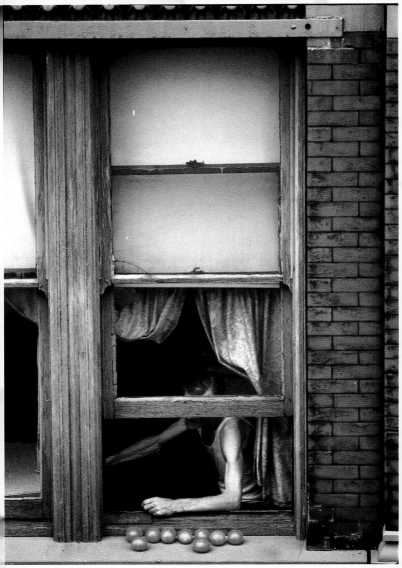

"Art is both the taking and giving

of beauty, the turning out

—Ansel Adams

to the light the inner folds

of the awareness of spirit.

It is the re-creation on another

plane of the realities of this

world; the tragic and wonderful

realities of earth and man."

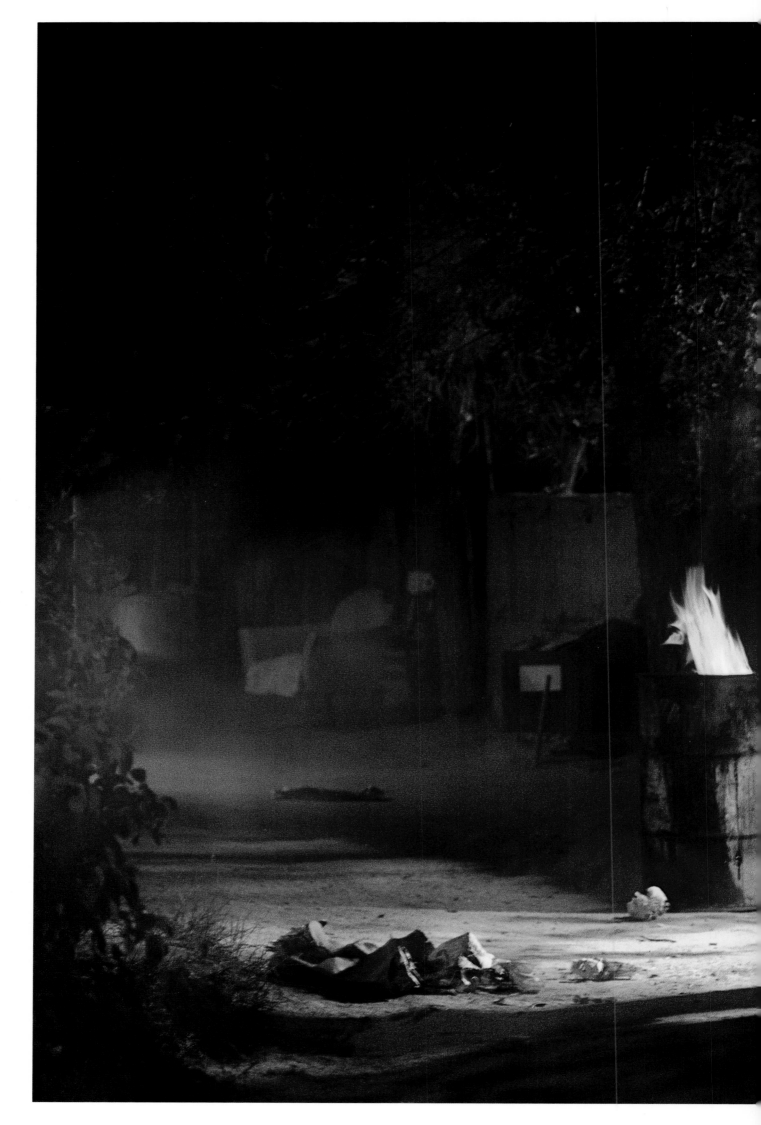

"Halloween Eve" festival near Taos, New Mexico

BOB SHAFER

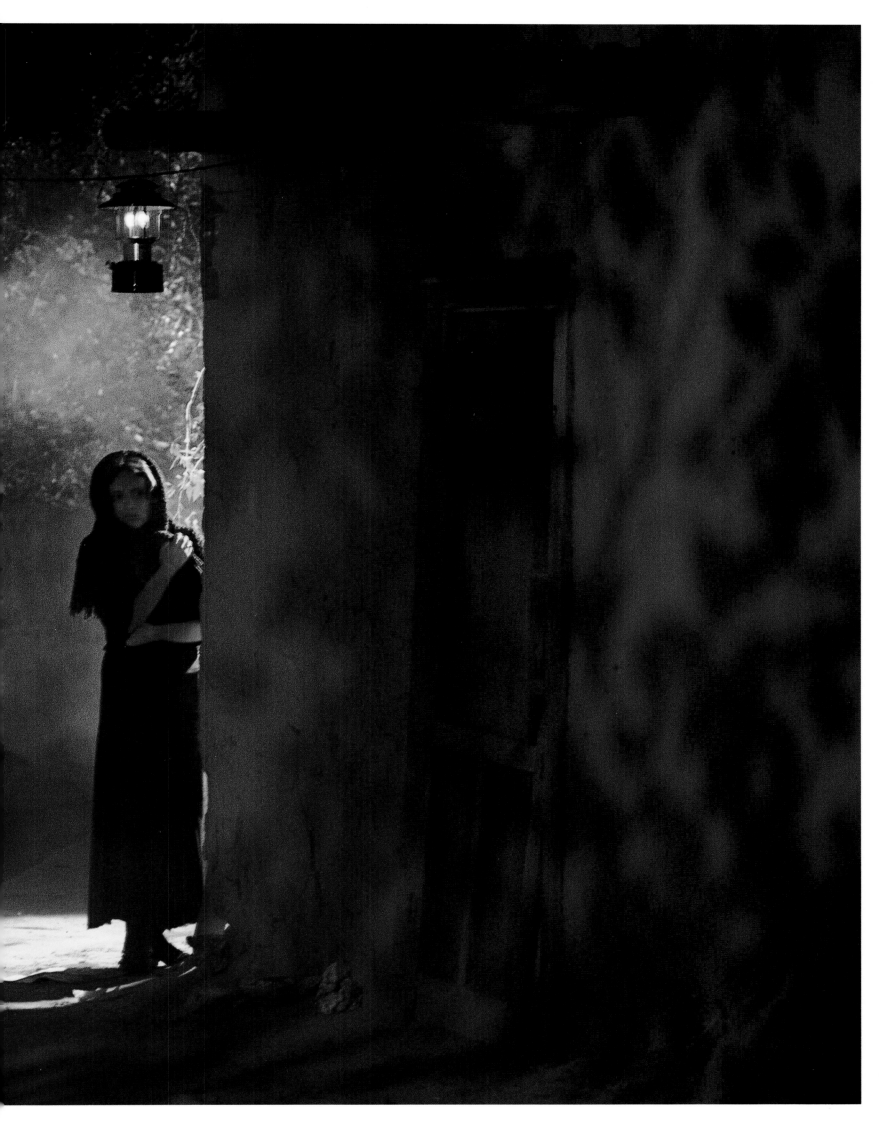

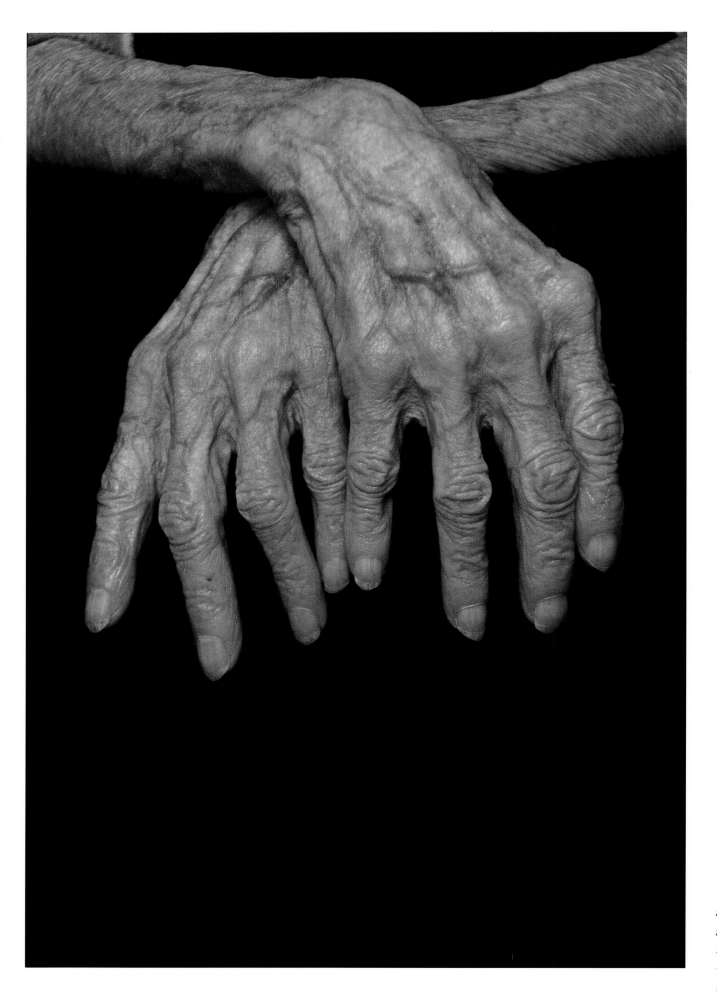

When McEntee photographed her 93-year-old grandmother, Charlotte Marie Bradley Miller, she was so frail McEntee had to carry her on and off the studio set. A photographer herself in the 1920s, Charlotte died shortly after this image was taken.

© 1987 **REBECCA MCENTEE**

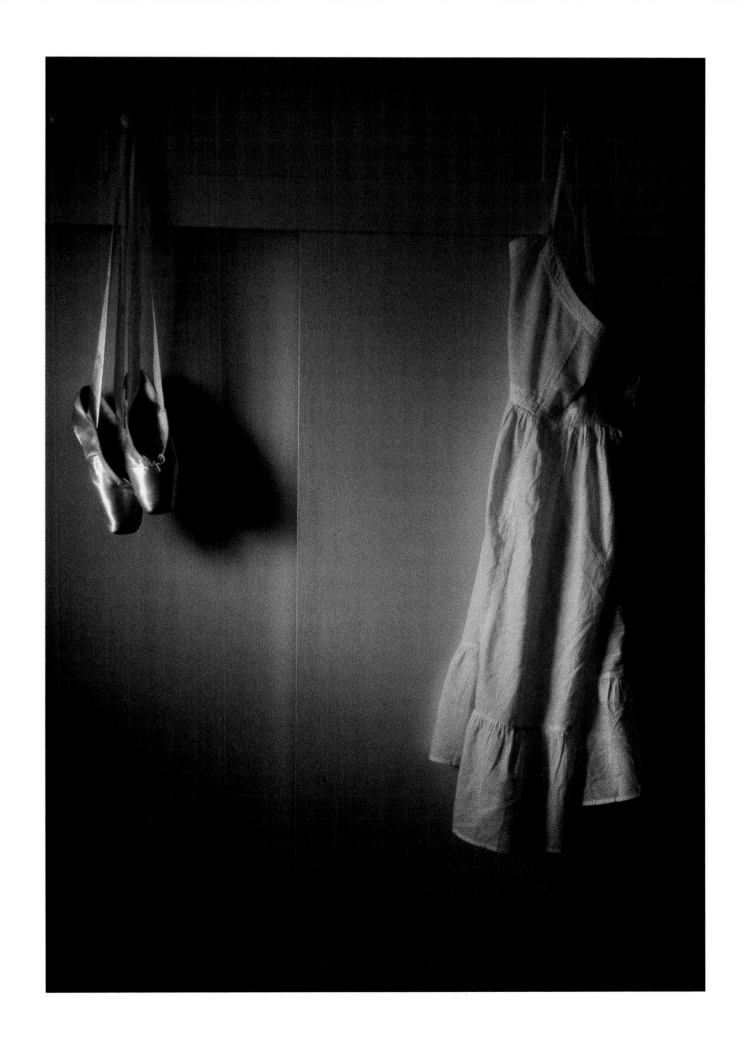

"Intermezzo"

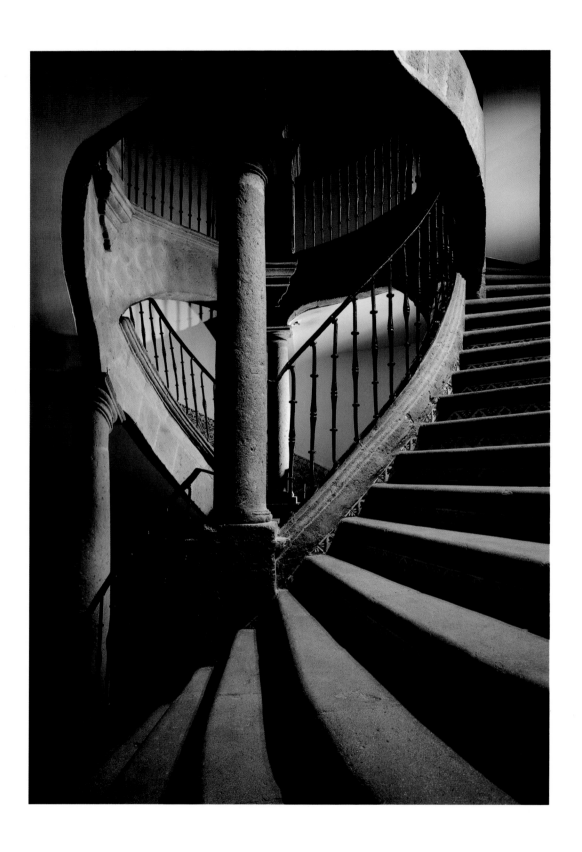

Double-helix stairway,
Banco Nacional de
Mexico, Mexico City.

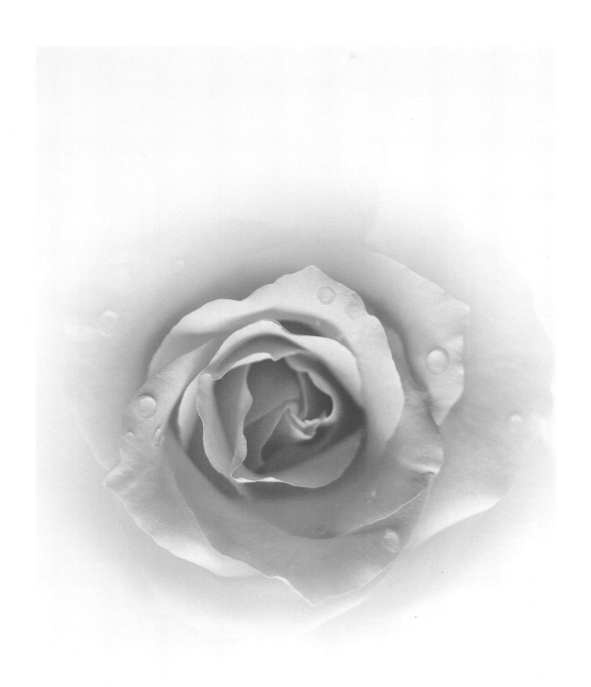

"Forever a Rose"

© 1991 **DANNA MARTEL**

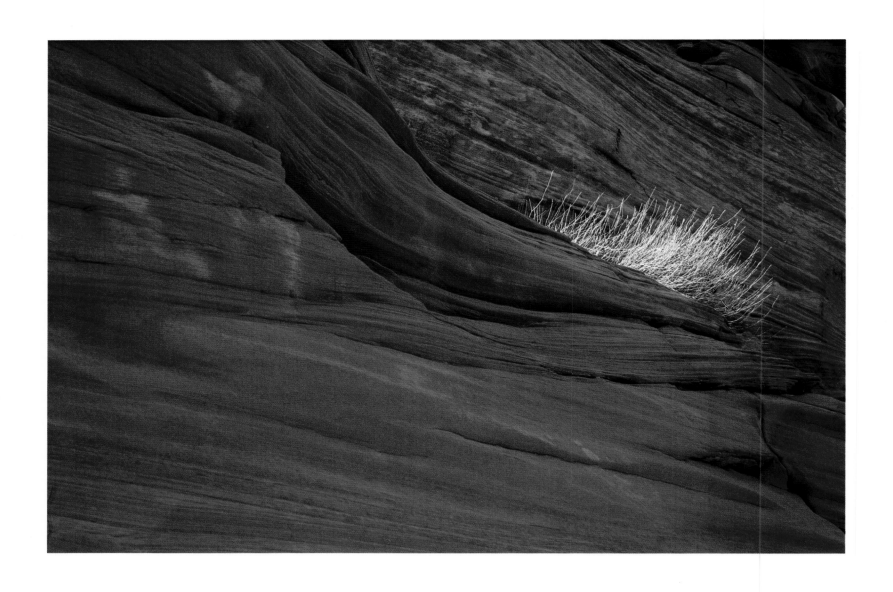

Desert near

Page, Arizona, 1989

STUART N. DEE

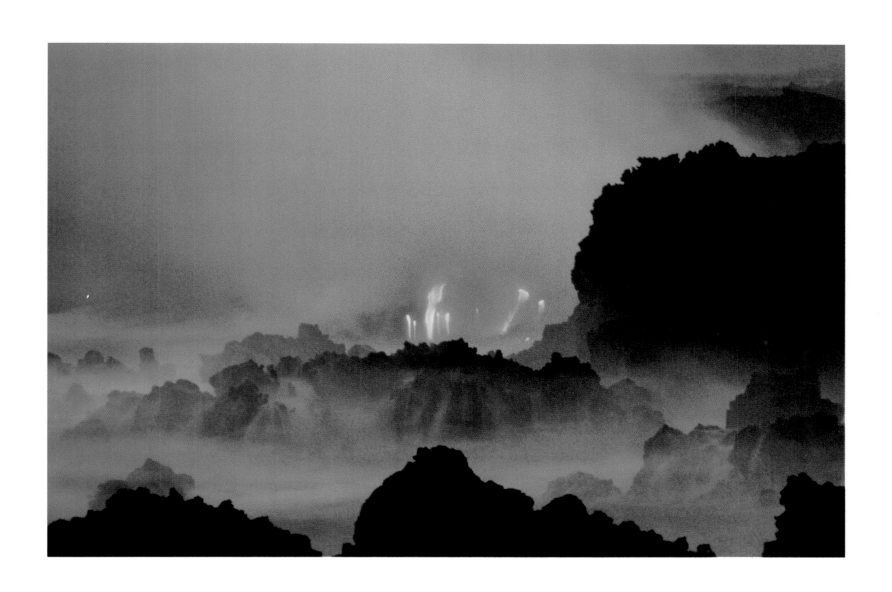

*Fingers of pahoehoe lava
enter the Pacific Ocean
during an eruption of
Kilauea Volcano,
Kalapana, Hawaii, 1987.*

© 1991 RON DAHLQUIST

"Coca Kid,"
Port-au-Prince, Haiti

© 1972 **ERIC MEOLA**

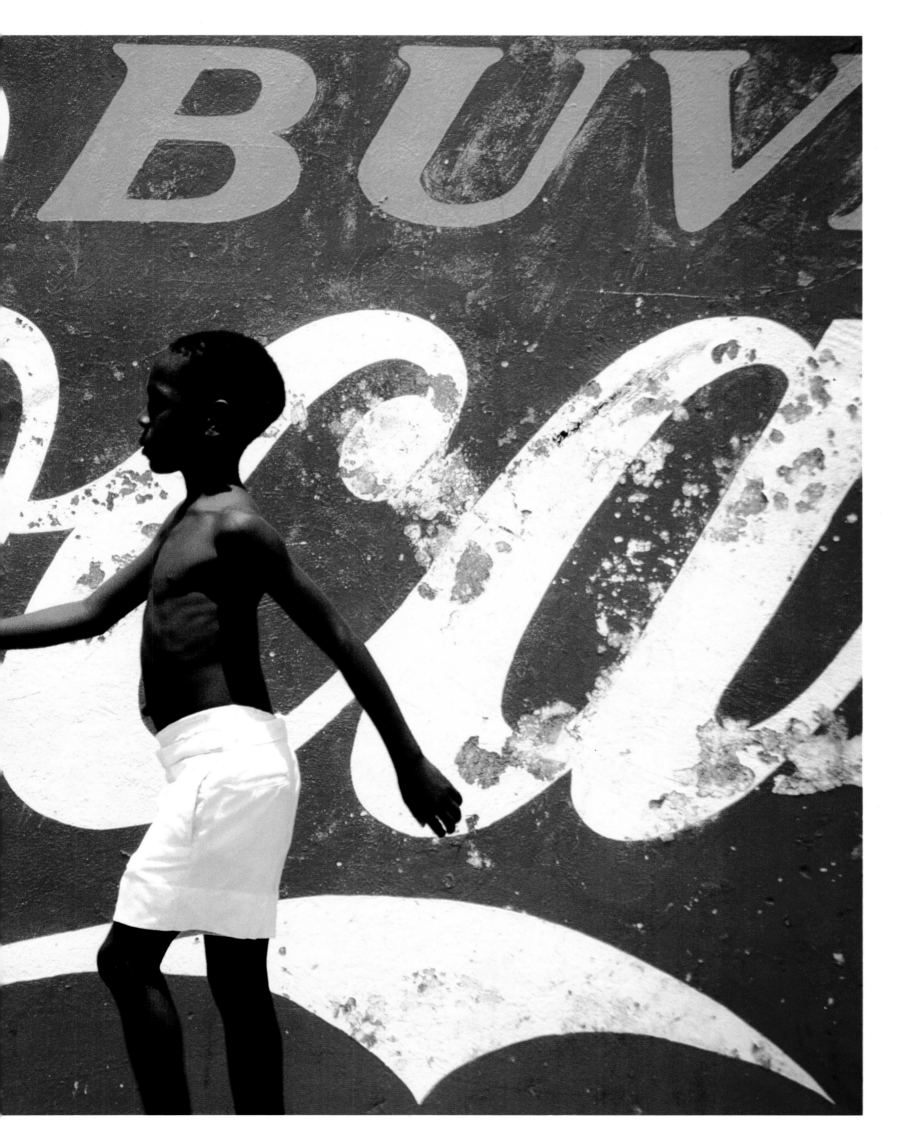

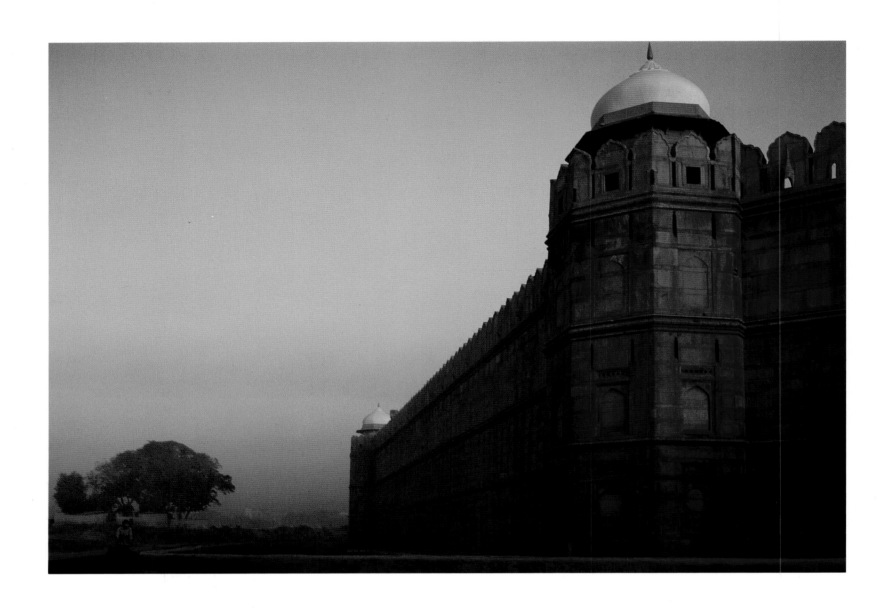

Lal Qila (Red Fort),
built by the 16th-century
emperor Shah Jahan,
Delhi, India

KATE BADER

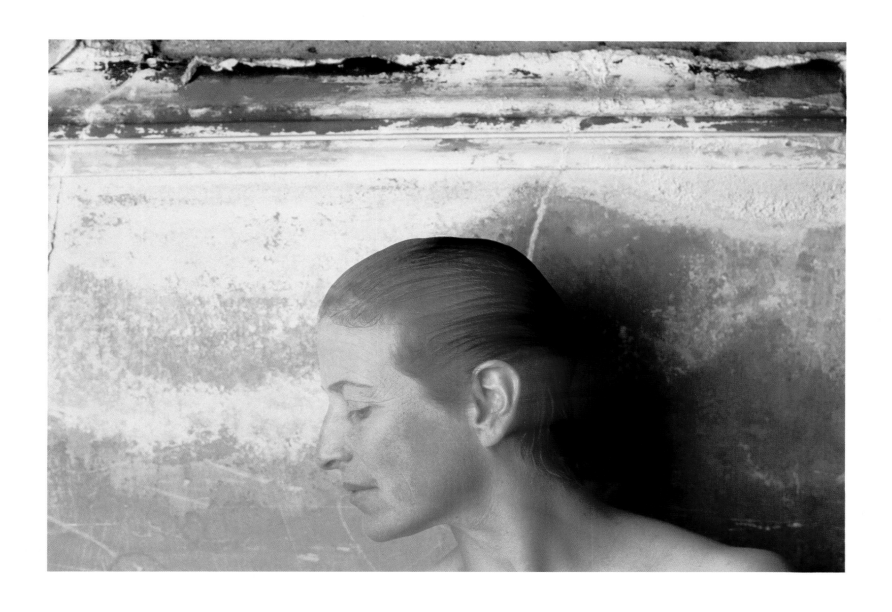

"Etruscan Woman,"
a self-promotion effort
by the photographic
team of Carol Bobo and
Jean Alexander

© 1988 **BOBO · ALEXANDER**

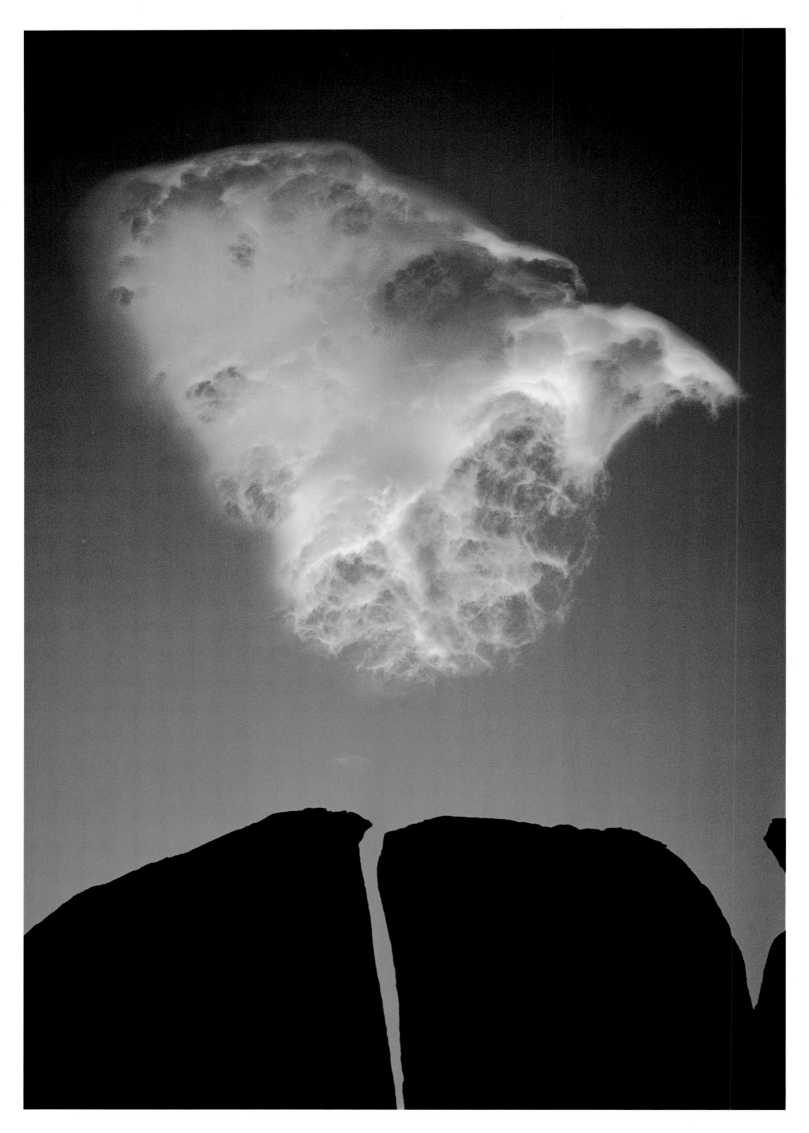

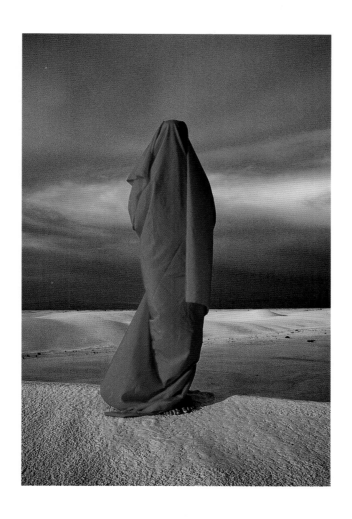

Split rock and cloud,
eastern Sierra Nevada
Mountains, California,
1976

White Sands,
New Mexico

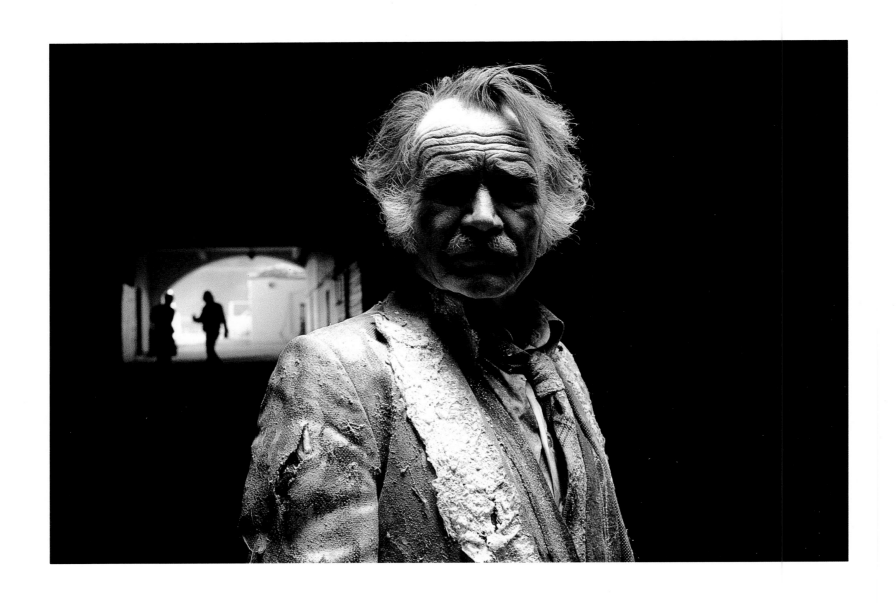

*Sir John Mills, on
location at Wembley
Stadium, London, during
the making of the British
TV movie, "Quatermass"*

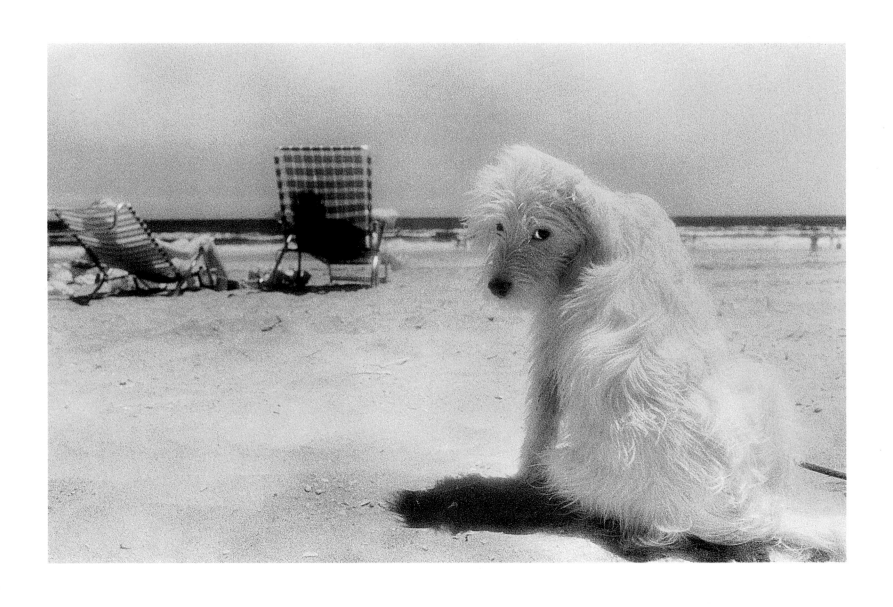

"Lois at the Beach,"

from an infrared series

titled "Rockaway Beach"

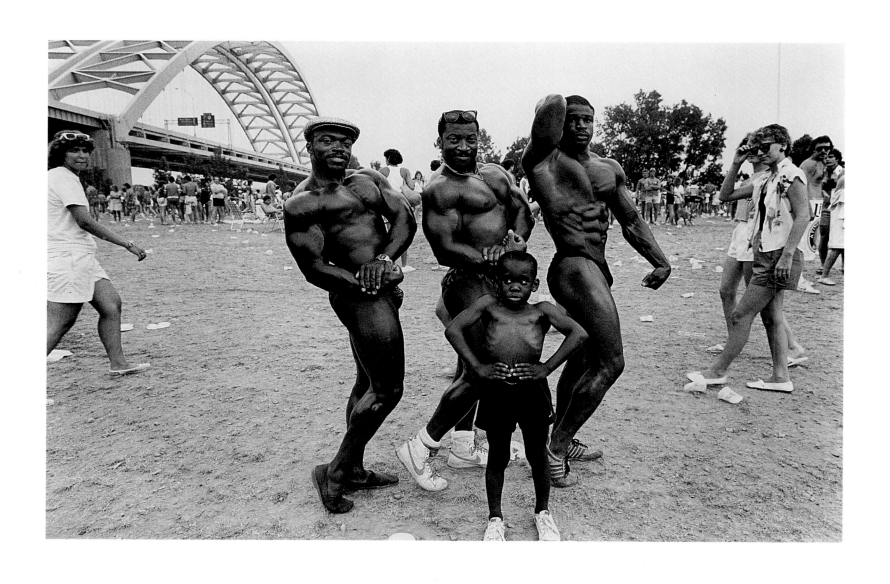

"Muscle Men,"

Cincinnati

MAUREEN FRANCE

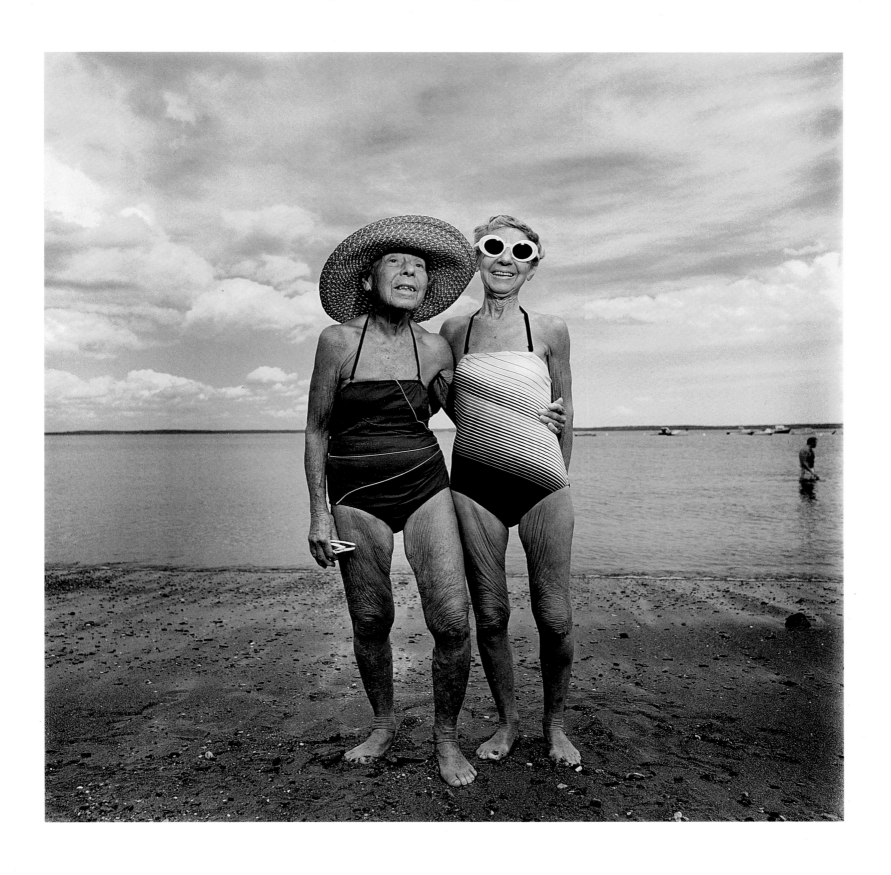

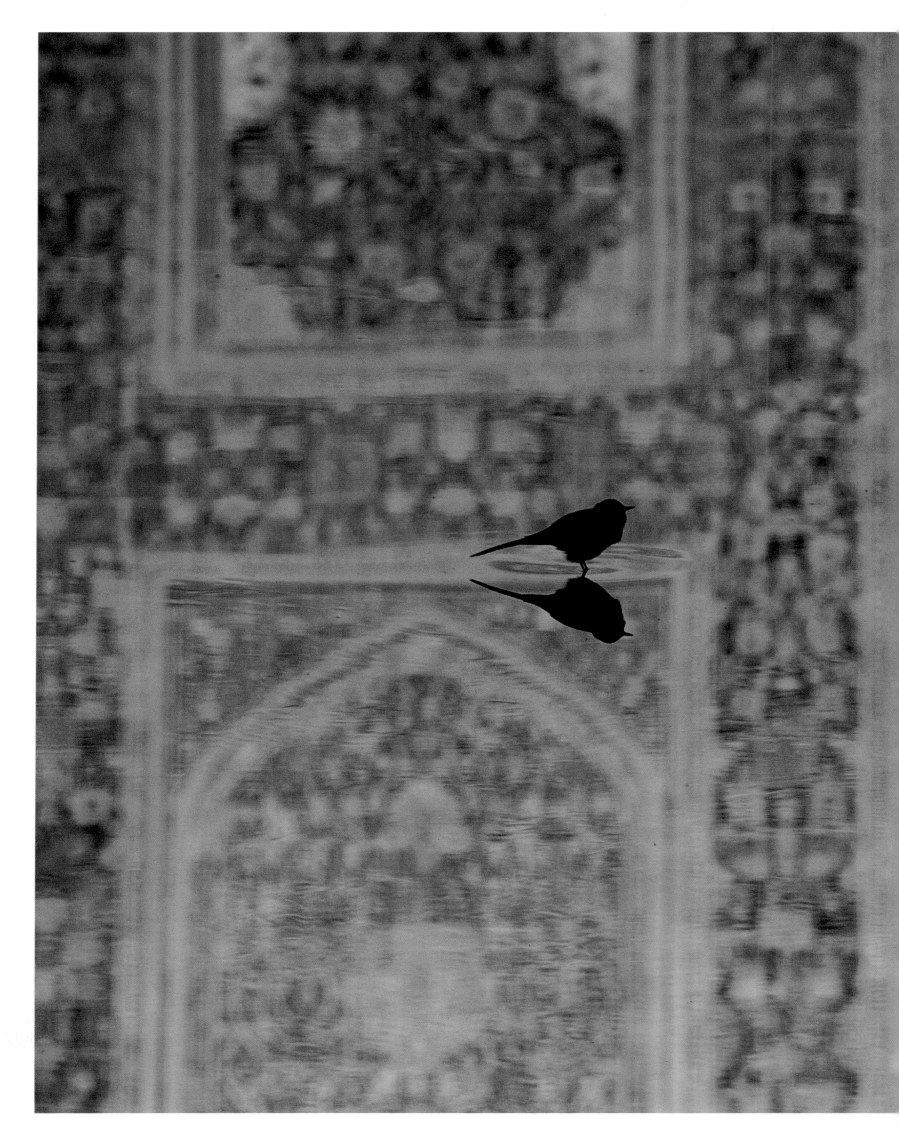

Pool, Isfahan, Iran, 1971

© 1972

JAY MAISEL

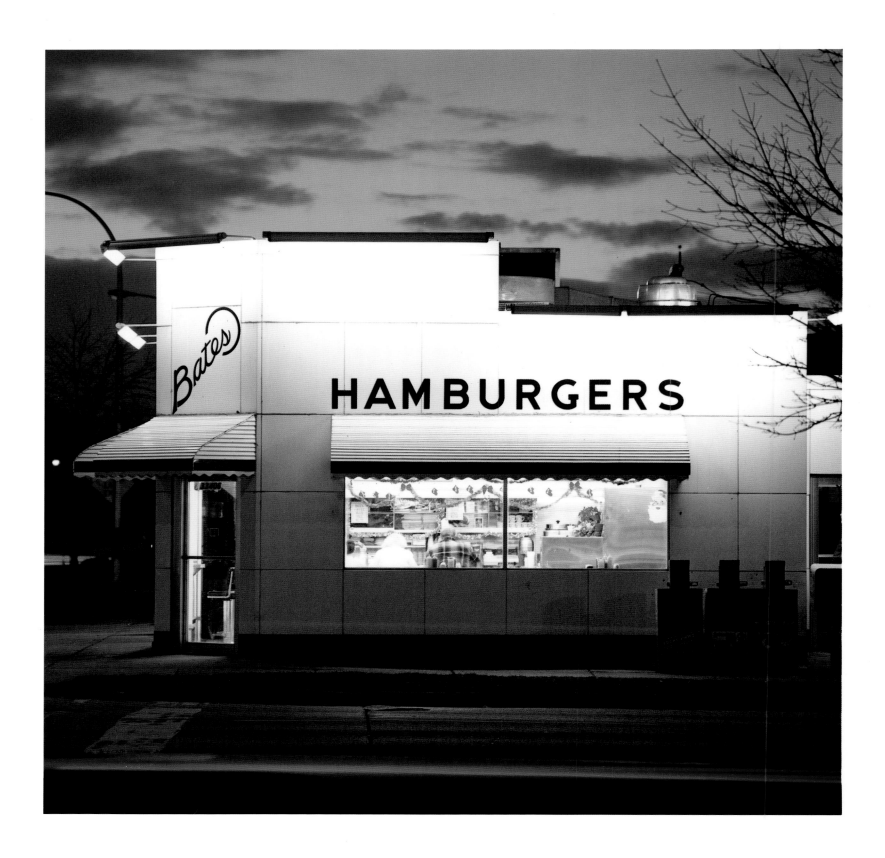

Bates Hamburgers,
Livonia, Michigan

© 1991 **JAY ASQUINI**

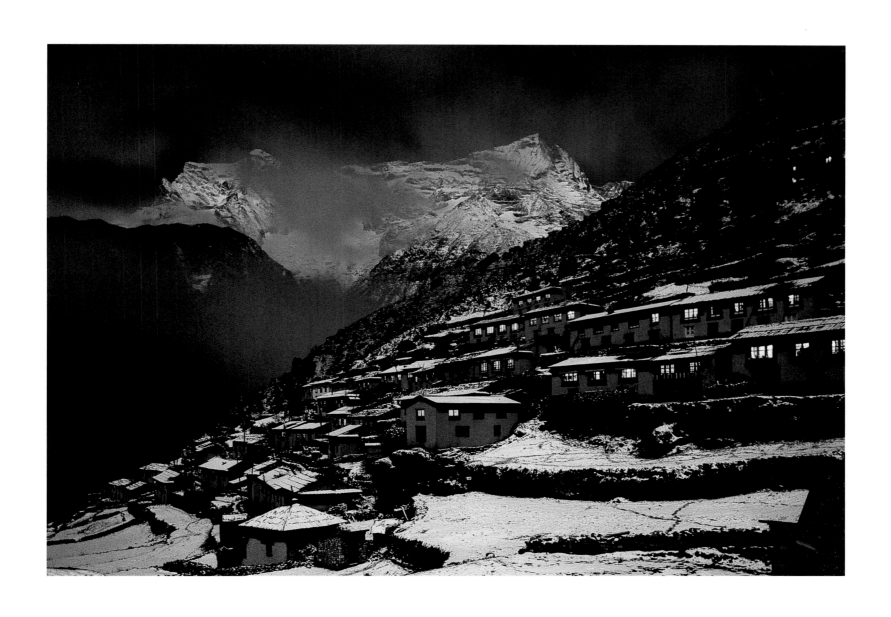

Namche Bazaar, 1987,

a small Nepalese town that

had just gotten electricity

© 1991 **ROBERT HOLMES**

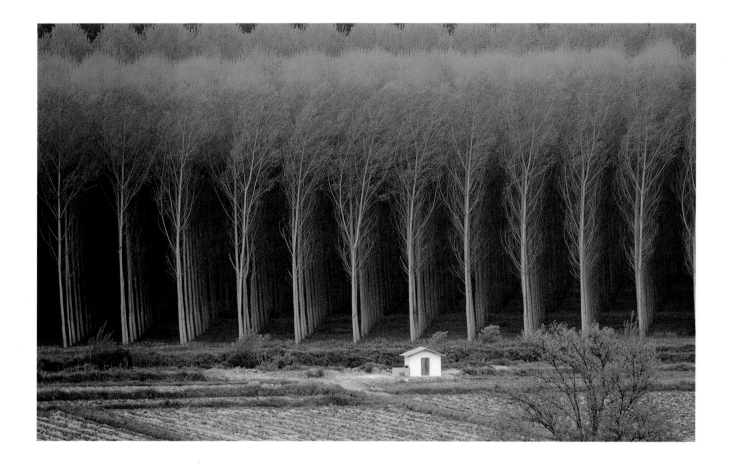

Eucalyptus trees, Portugal

..........................

©1987 **TONY ARRUZA**

Cooling tower,

Callaway nuclear power

plant, Missouri

..........................

©1989 **KEN J. MACSWAN**

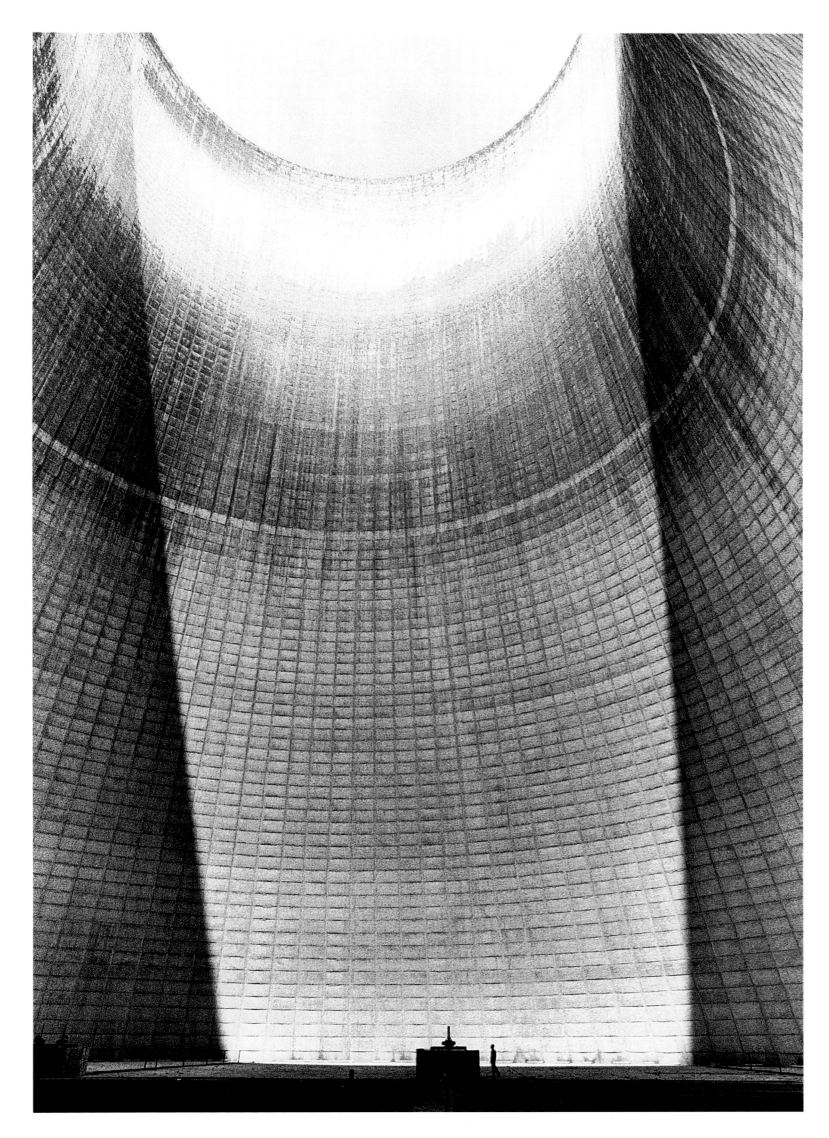

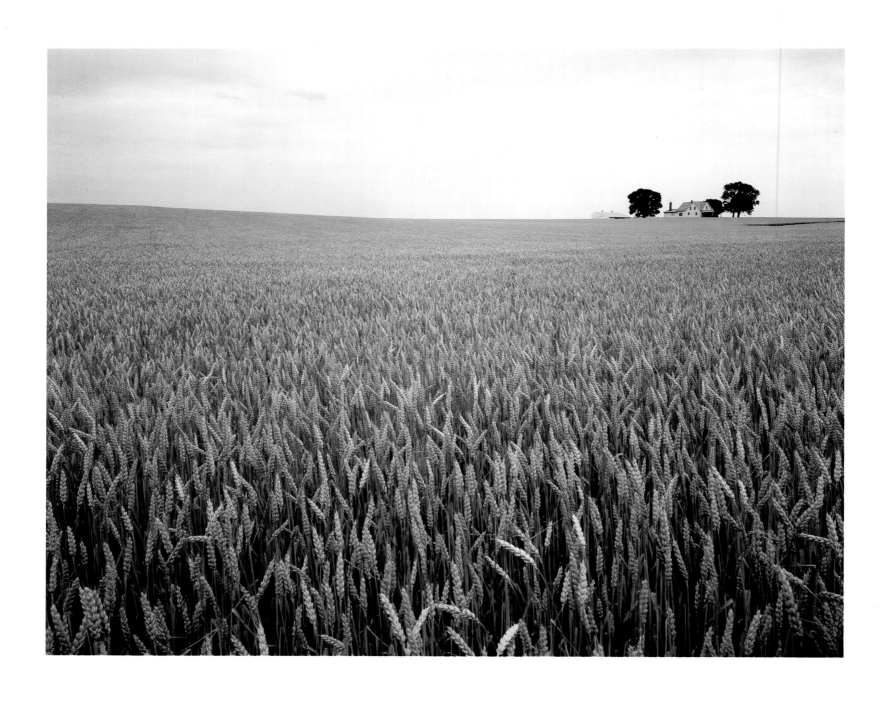

"Wheat Fields"

'56 Olds Rocket 88

©1985 **WILBUR A. MONTGOMERY**

©1987 **CARL W. CANNEDY**

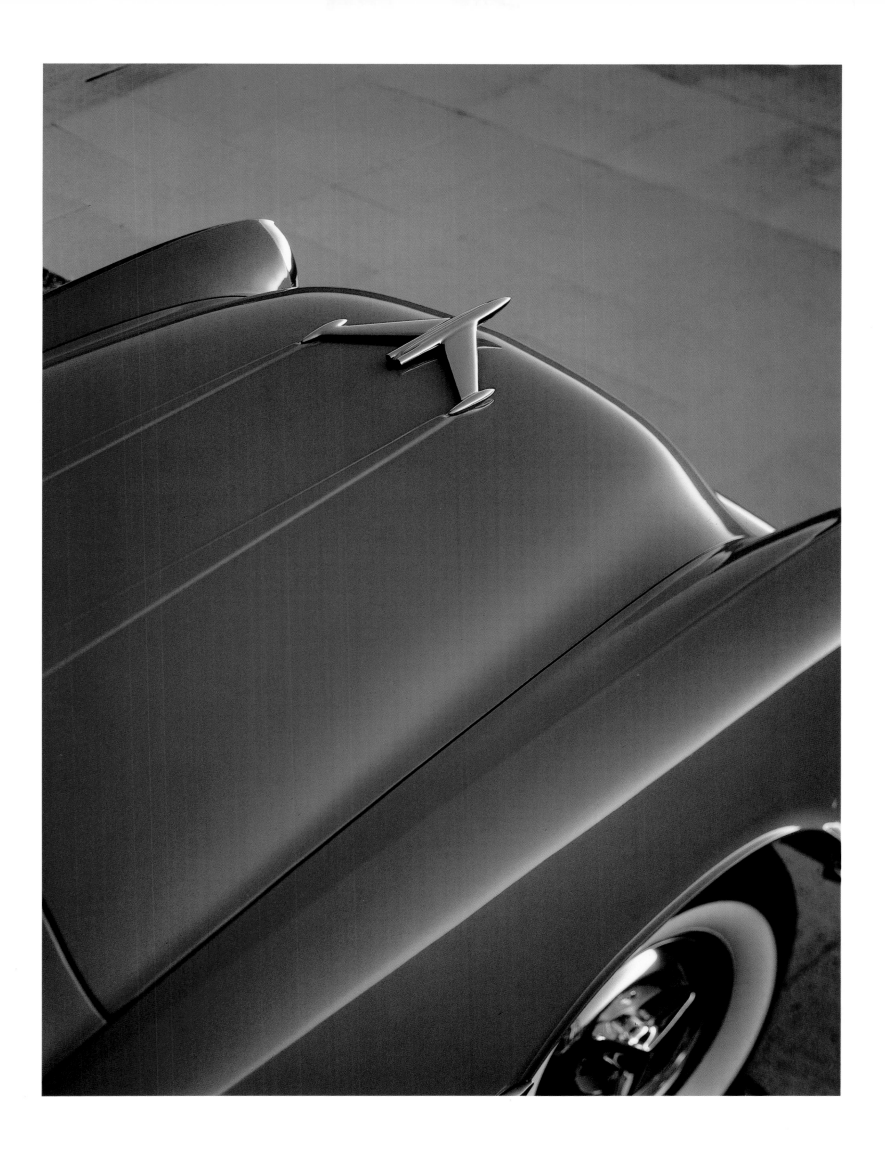

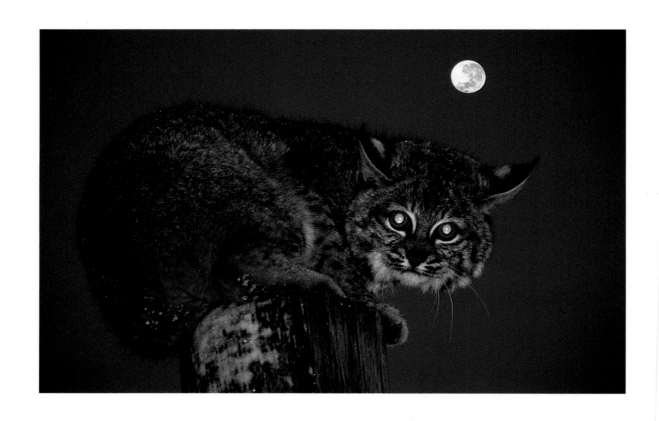

"Bobcat, Northern
California Sierras,"
double exposure

© 1986 RON SANFORD

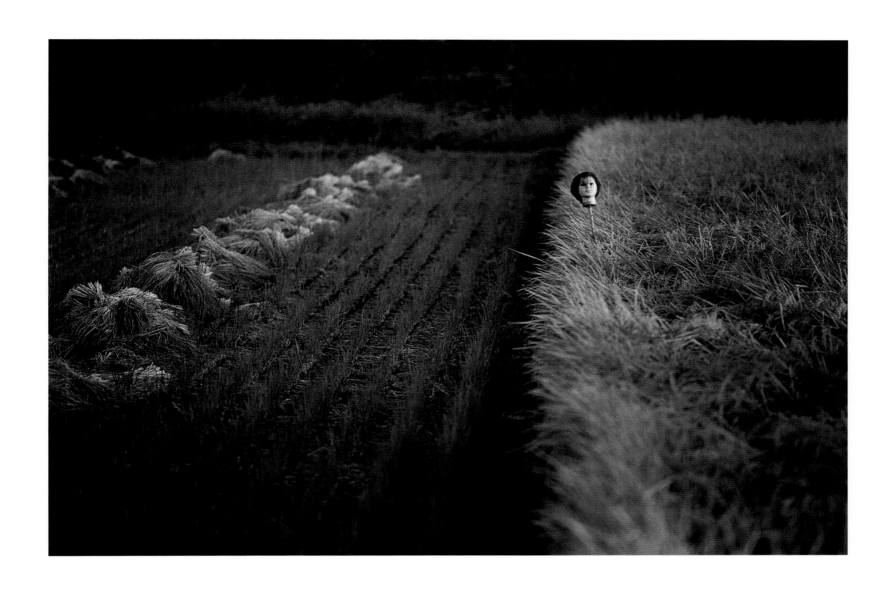

Scarecrow with
mannequin head,
Masuda, Japan

JOHN DERRYBERRY

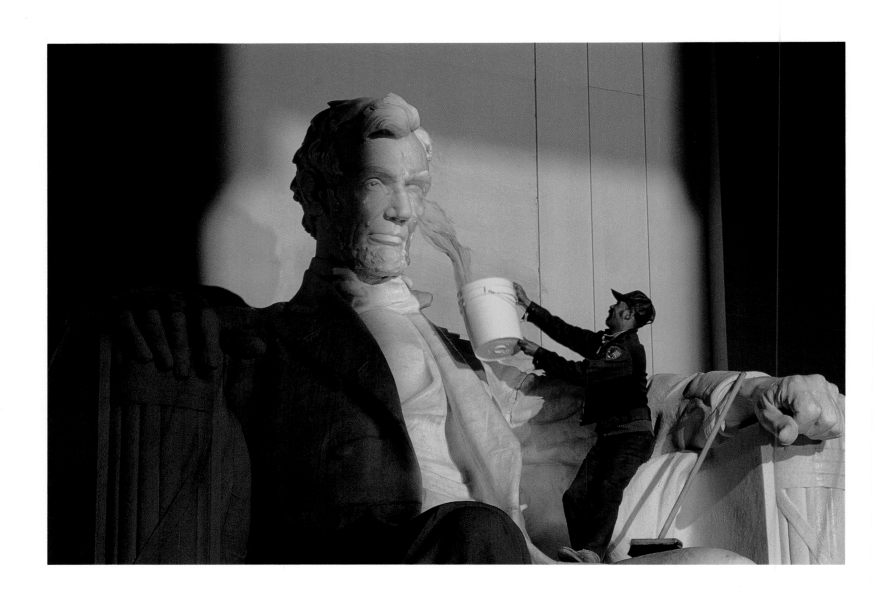

Lincoln Memorial,
Washington, D.C.

© 1991 **EVERETT C. JOHNSON**

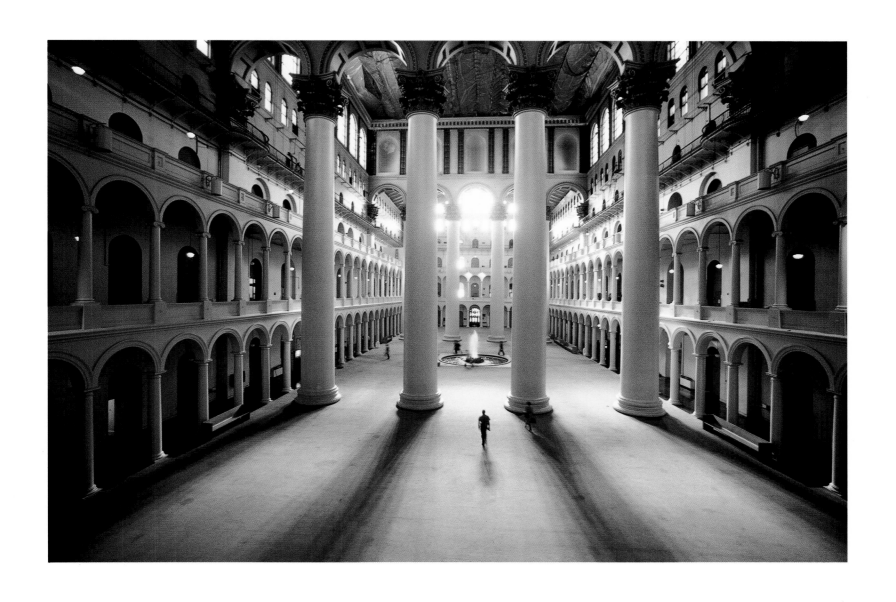

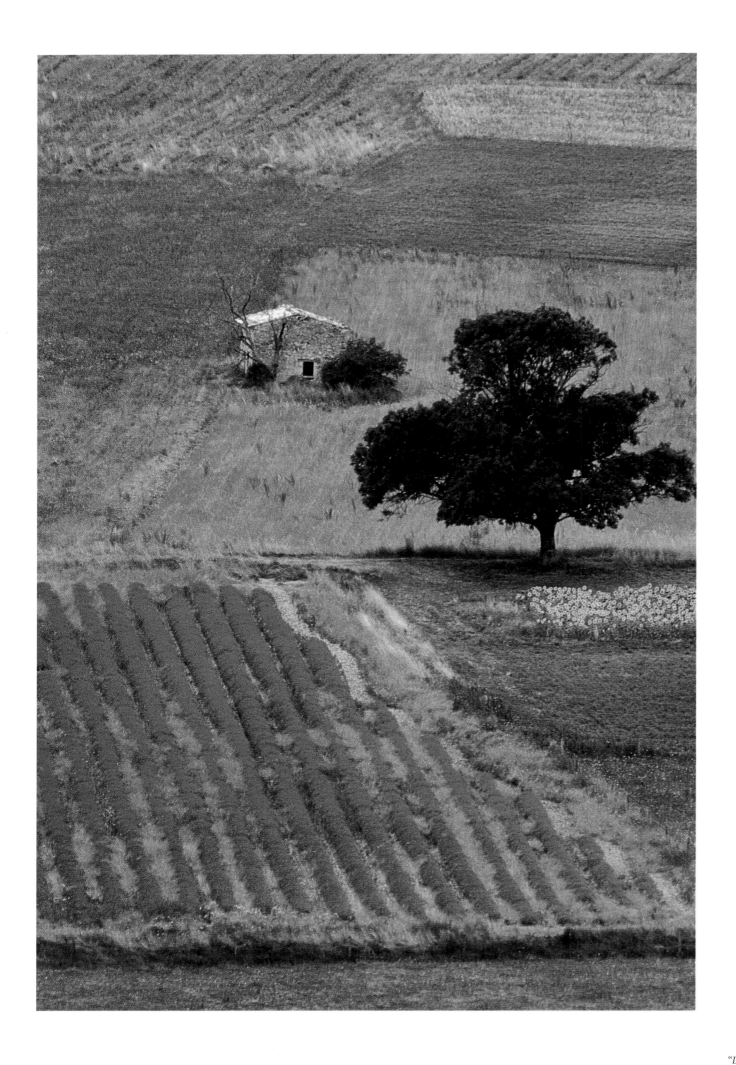

"Lavender,"
Provence, France

©1985 **SONJA BULLATY**

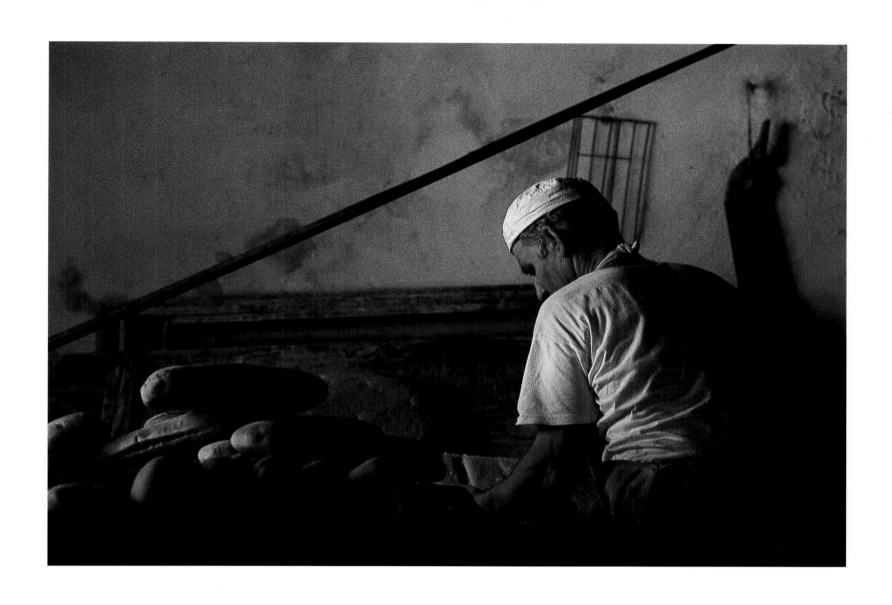

Baker,

Naxos, Greece, 1984

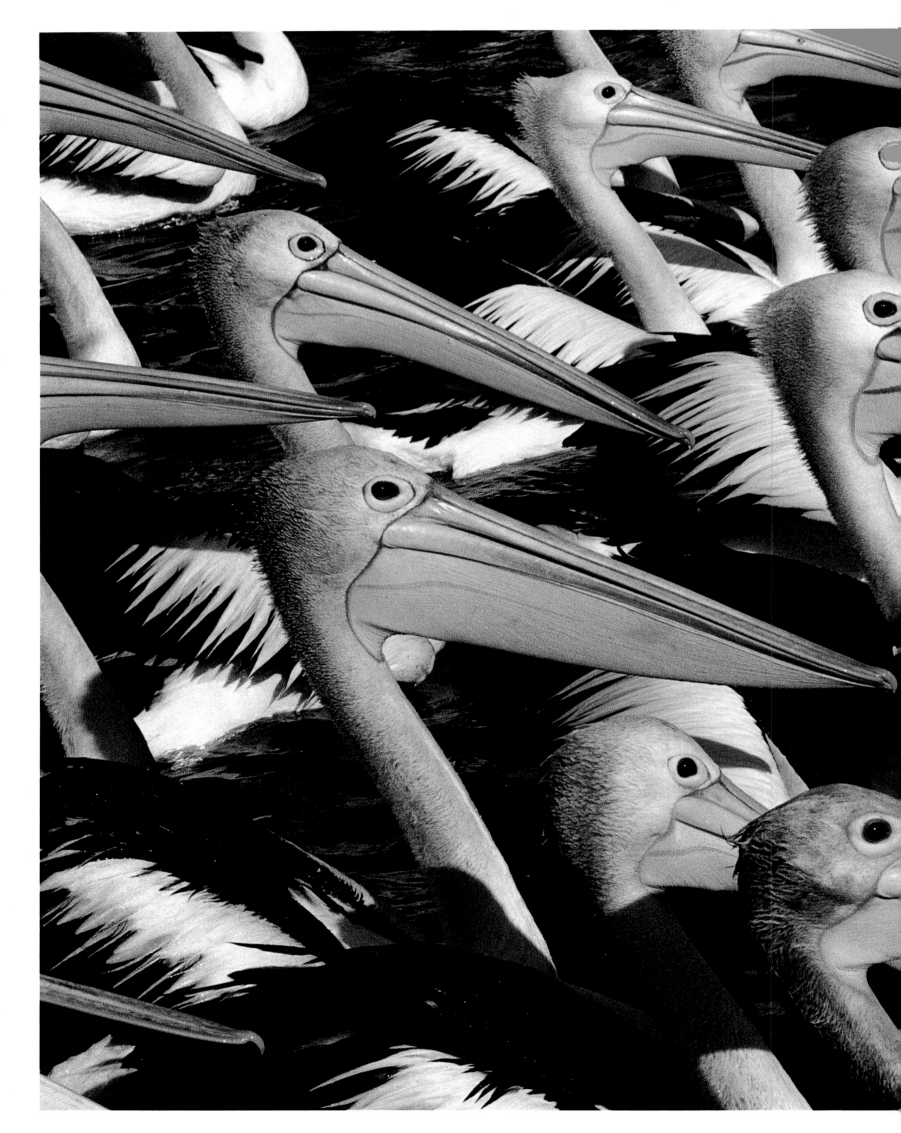

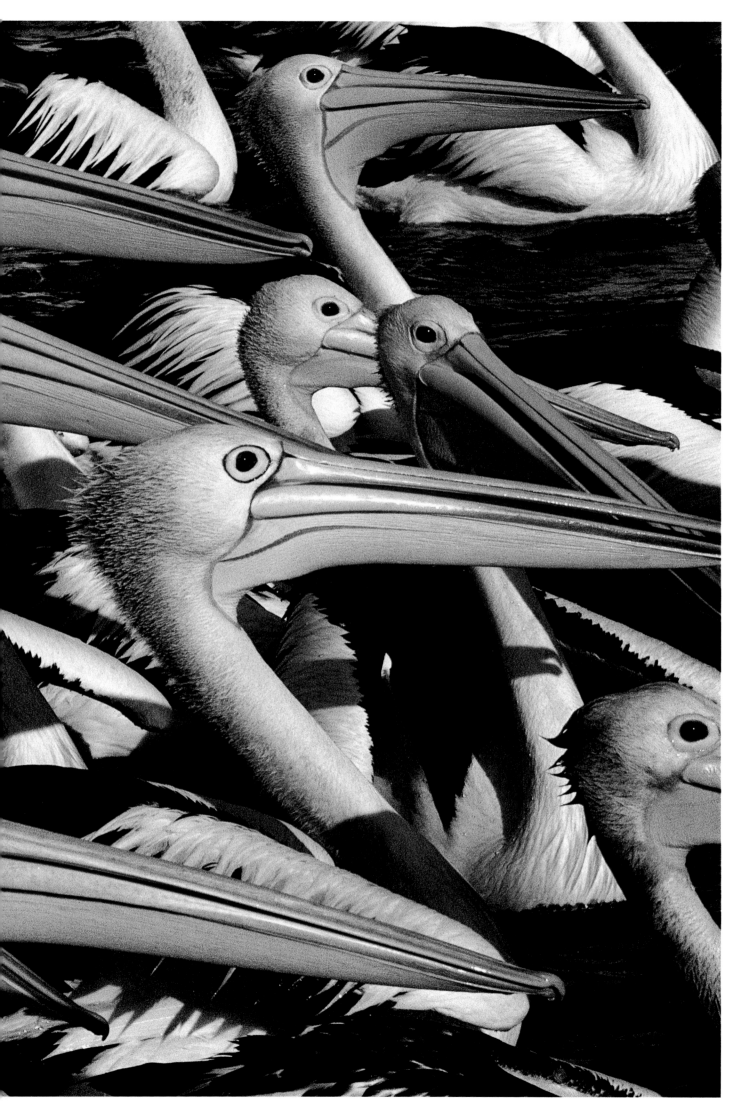

"Captive Audience"
Queensland, Australia

©1987

DAVID **W**ATERSUN

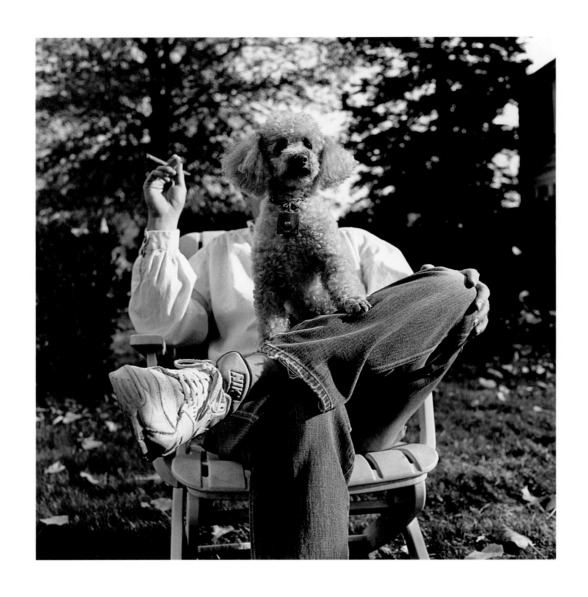

Self-portrait with poodle
"It occurred to me that if I
couldn't see the camera, the
camera couldn't see me."

Scanning photomacro-
graph of an acorn weevil

HERBERT ASCHERMAN, JR.

DARWIN DALE

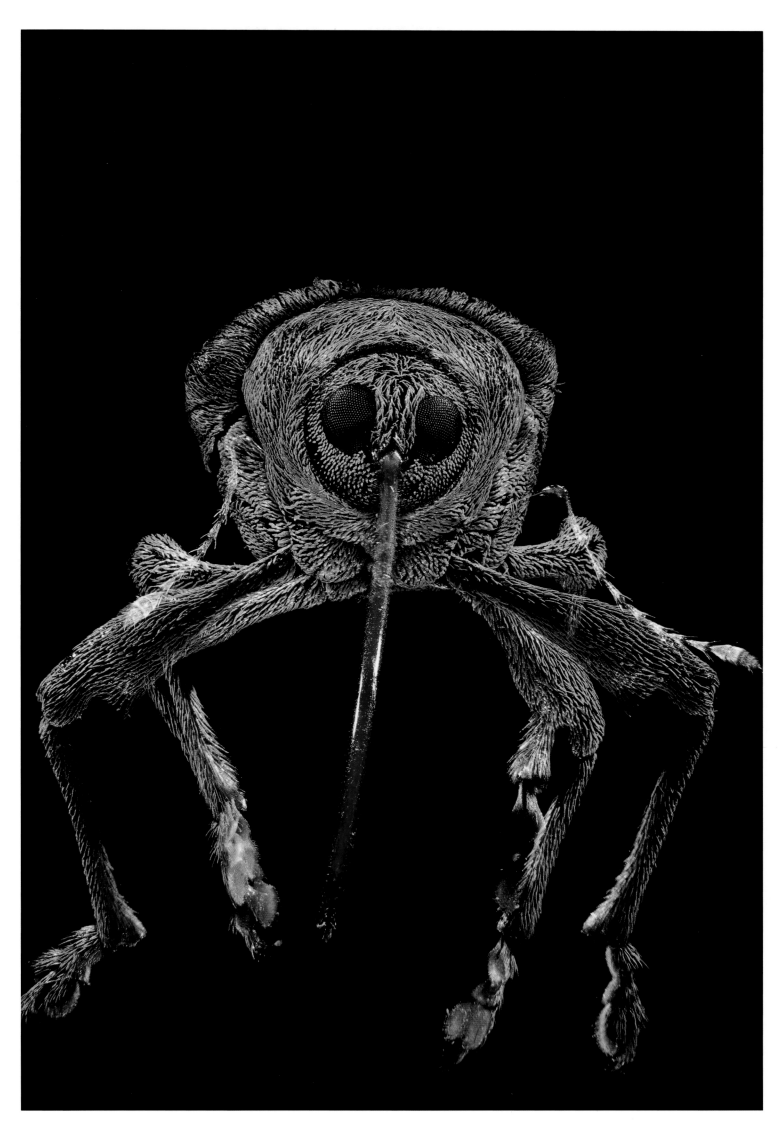

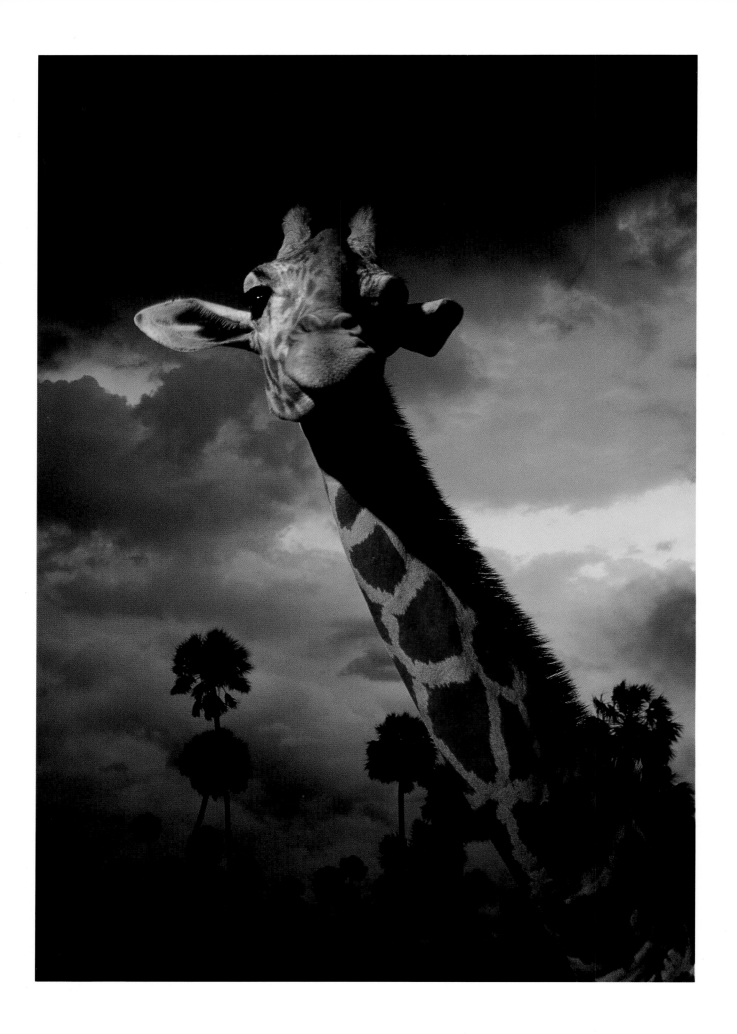

Giraffe in thunderstorm,

Busch Gardens,

Tampa, Florida

©1990 **LOUIS BENCZE**

66

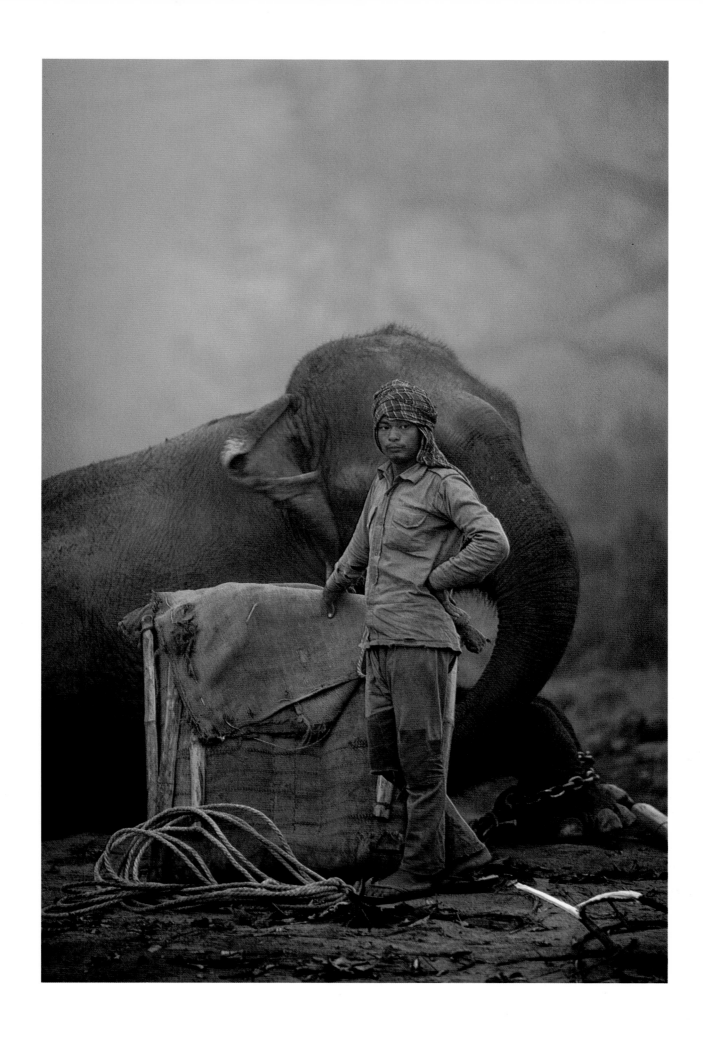

Nepali mahout and
elephant in Chitwan
National Park

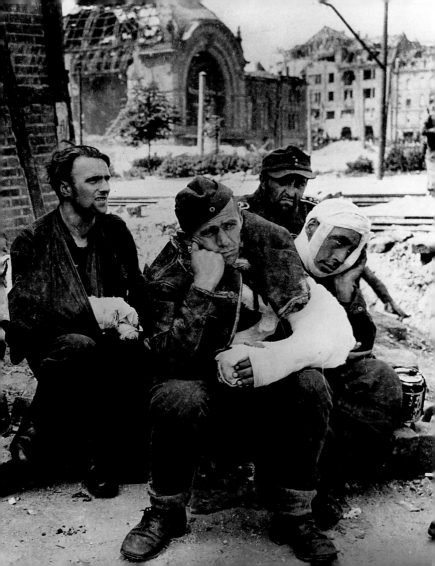

*A*nd each time I pressed the shutter

release it was the shouted con-

Eugene Smith

demnation hurled with the

hope that the picture might

survive through the years . . .

echo through the minds of men

in the future—causing them

caution and remembrance and

realization."

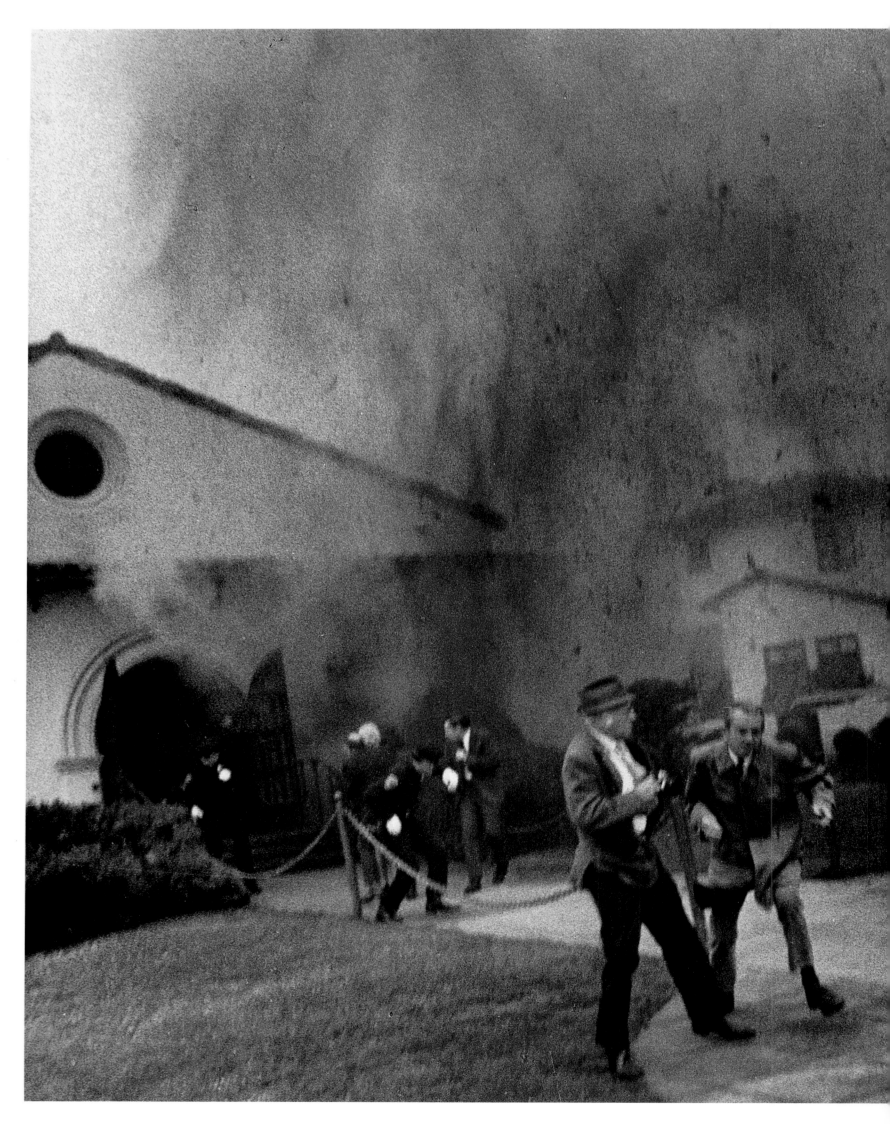

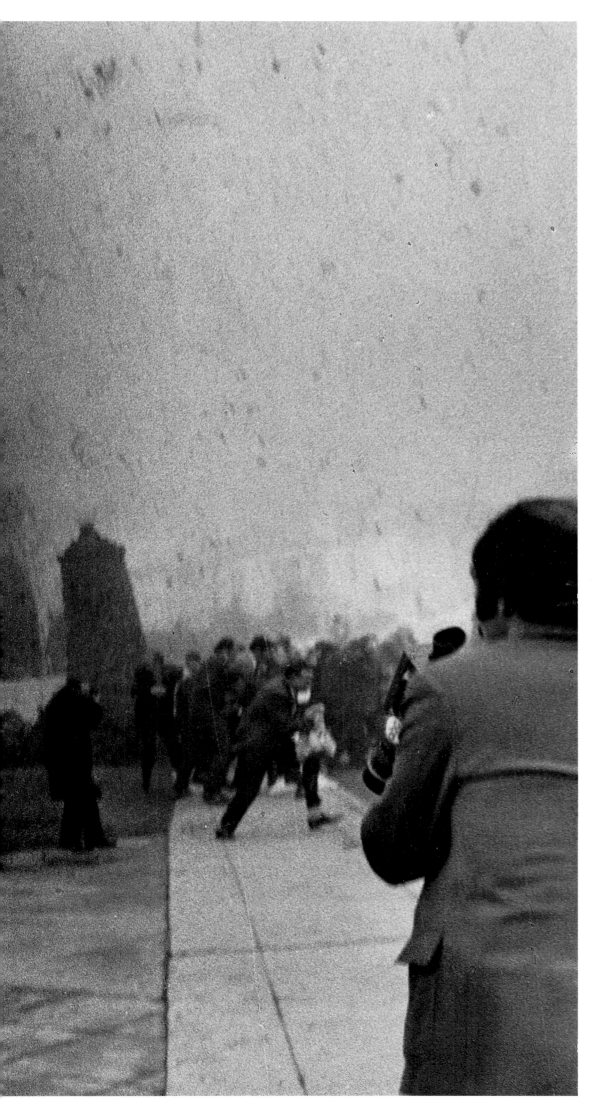

*Explosion of a terrorist
bomb just before a
policeman's funeral,
San Francisco, California*

SEYMOUR W. SNAER

© 1970 ***SAN FRANCISCO CHRONICLE***

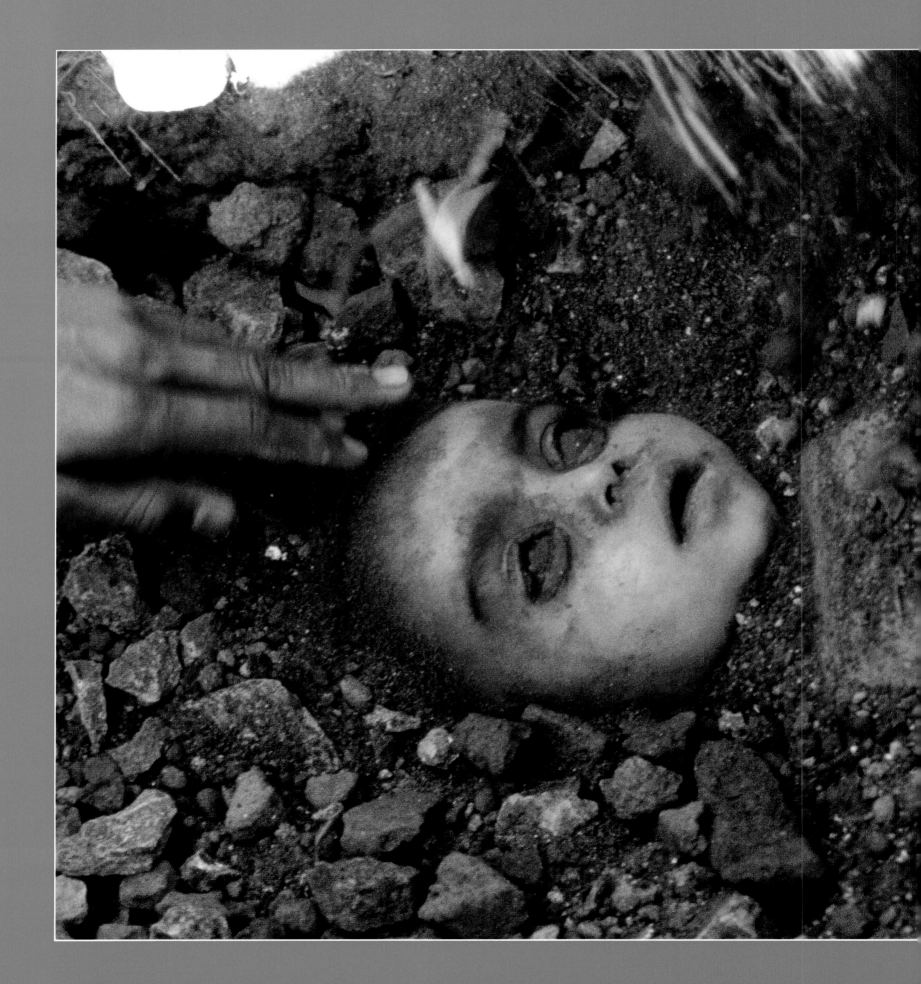

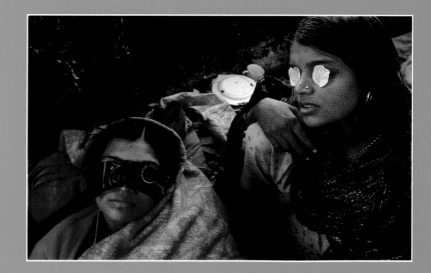

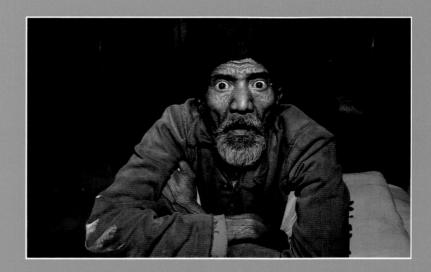

Left: A child's burial three days after the chemical disaster at Bhopal, India, December 1984. Rock salt is poured around the body to aid decomposition.

Top: Two women, their corneas burned by MIC gas, have their eyes bandaged at Hamidia Hospital.

Above: On assignment a year later, Bartholomew photographed this old man still at Hamidia Hospital, his lungs badly damaged by the gas.

© 1984-5 **PABLO BARTHOLOMEW**

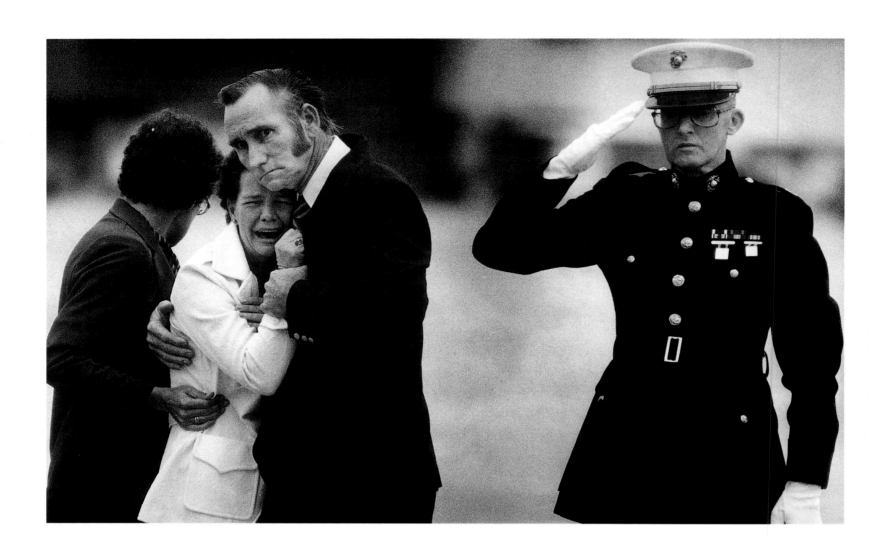

*The homecoming of
Marine corporal John
Blocker, one of 241
American Marines killed
in the terrorist bombing
in Beirut, August 1983*

JIM BRYANT

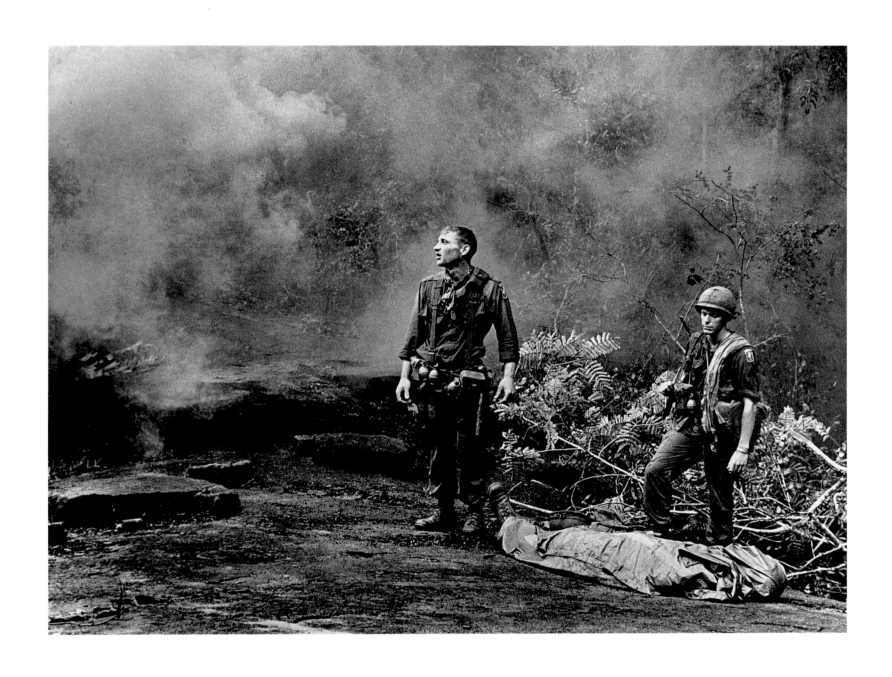

"Agony of War"
Epley, a paratrooper with
the 173rd Airborne
Brigade, photographed
soldiers of the 4th
Battalion of the 503rd
Infantry as they waited
for a medevac chopper,
Long Khan Province,
Vietnam.

©1966 **PAUL EPLEY**

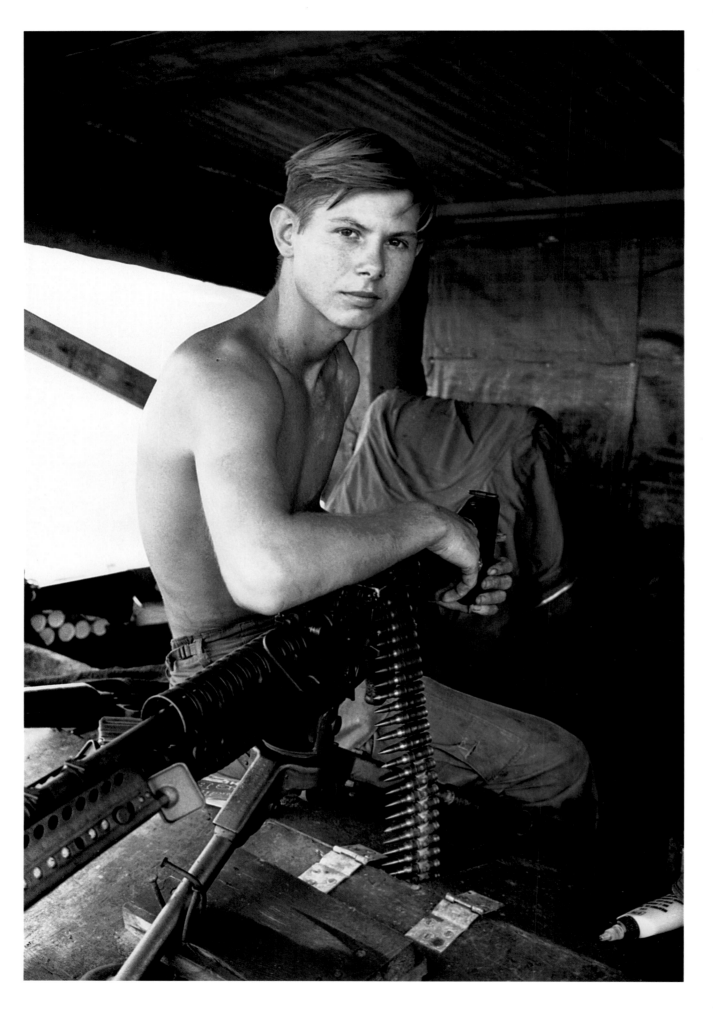

M-60 gunner at Nui Ba Den (Black Virgin Mountain), Tay Ninh Province, Vietnam, photographed while Goff was on assignment as a divisional photographer with the 25th Infantry

©1969 **D. R. GOFF**

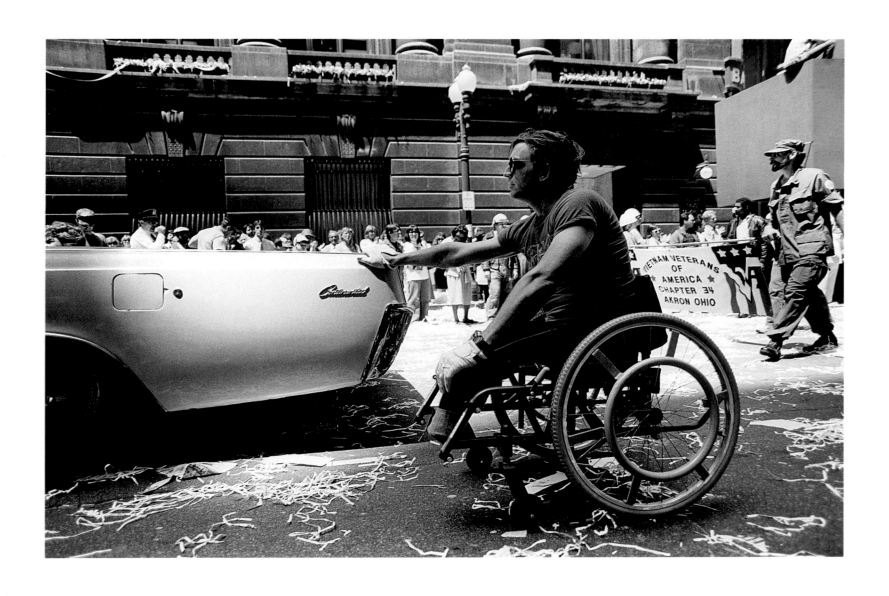

Belated "Welcome Home"
parade for Vietnam
veterans, June 1986

© 1988 **JANET CENTURY**

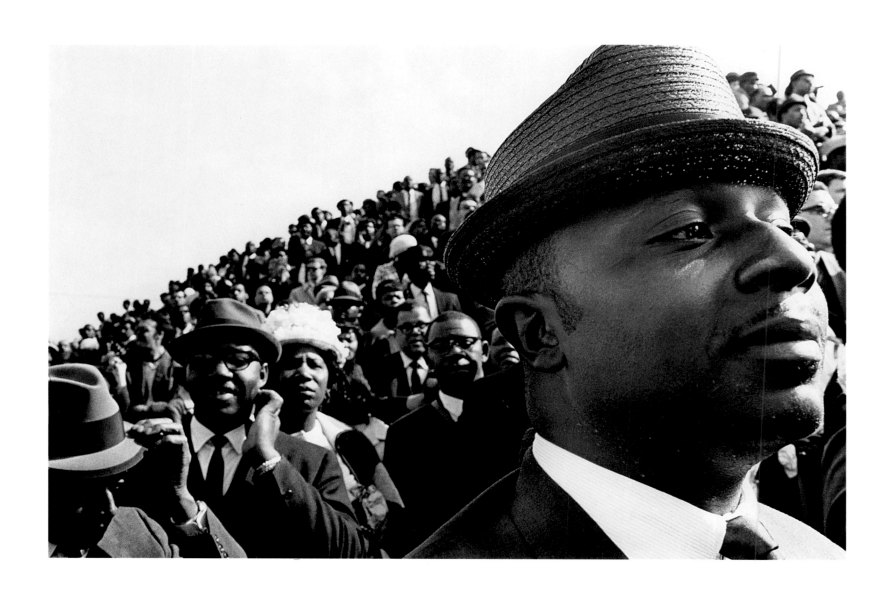

© 1991 **DON RUTLEDGE**

© 1962 **PHIZ MEZEY**

Mourners at the funeral
of Martin Luther King, Jr.,
Ebenezer Baptist Church,
Atlanta, Georgia, April 1968

Martin Luther King, Jr.,
waiting to address
ministers at the Third
Baptist Church, San
Francisco, 1962

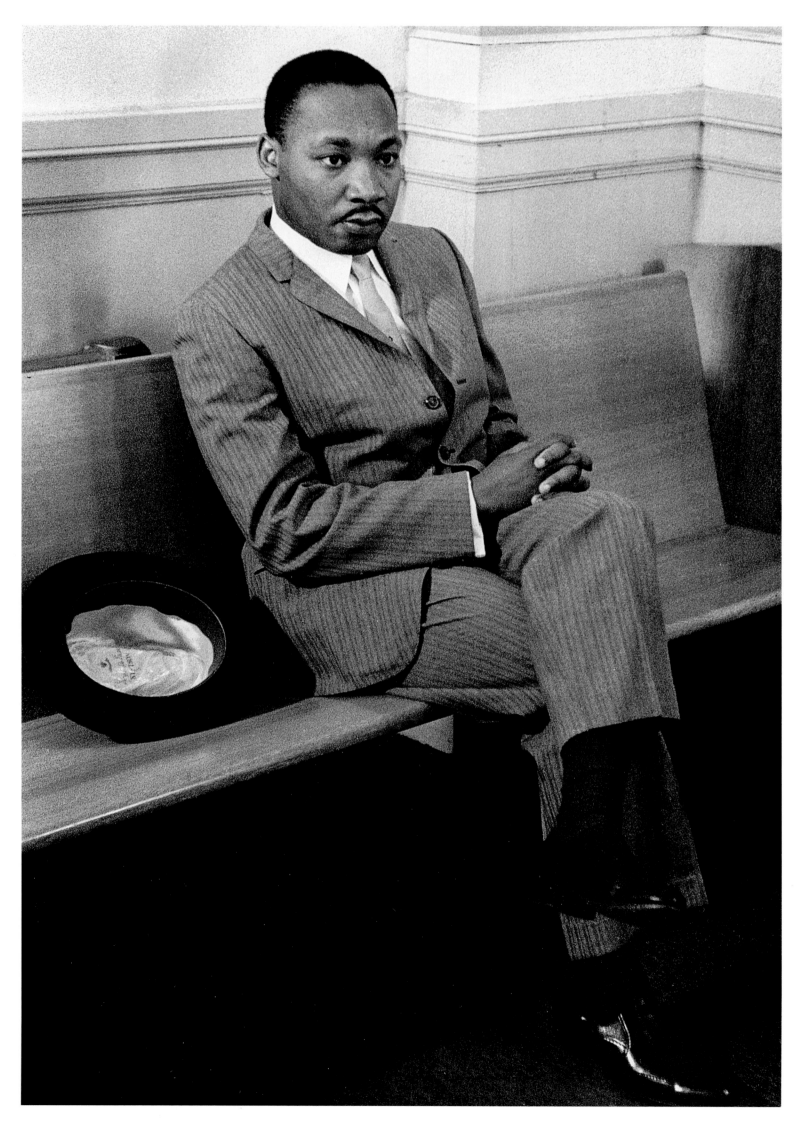

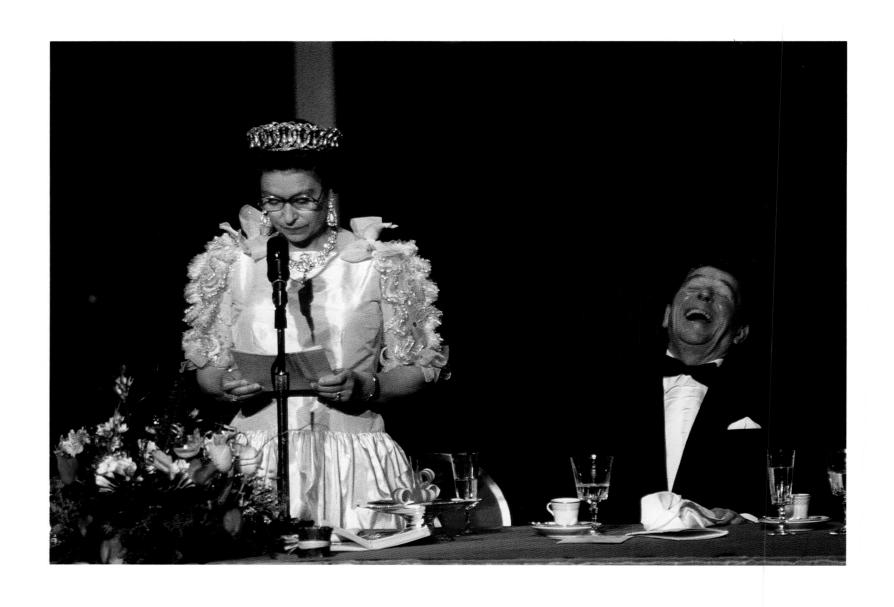

"Court Jester"
At a dinner in San Francisco,
President Reagan reacts
to Queen Elizabeth's joke
about the rain during her
visit to California.

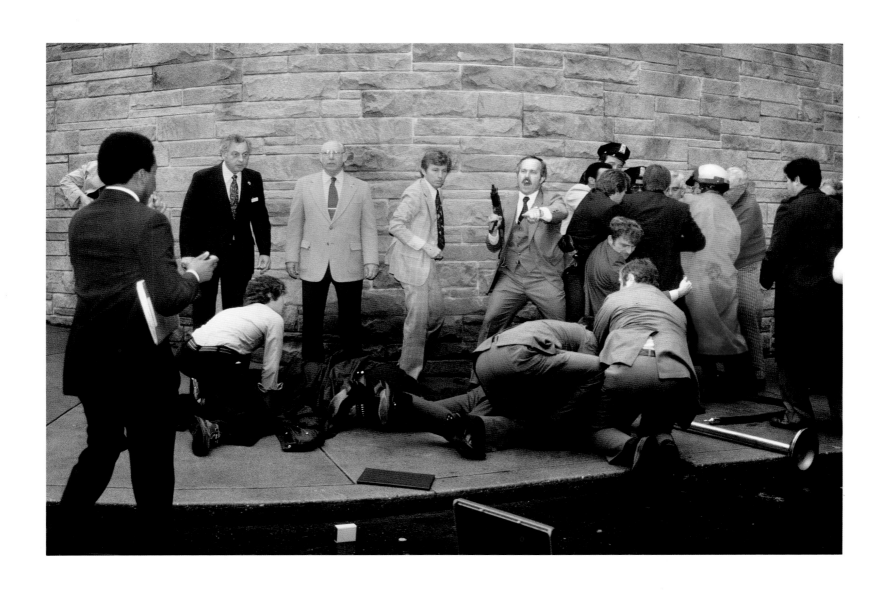

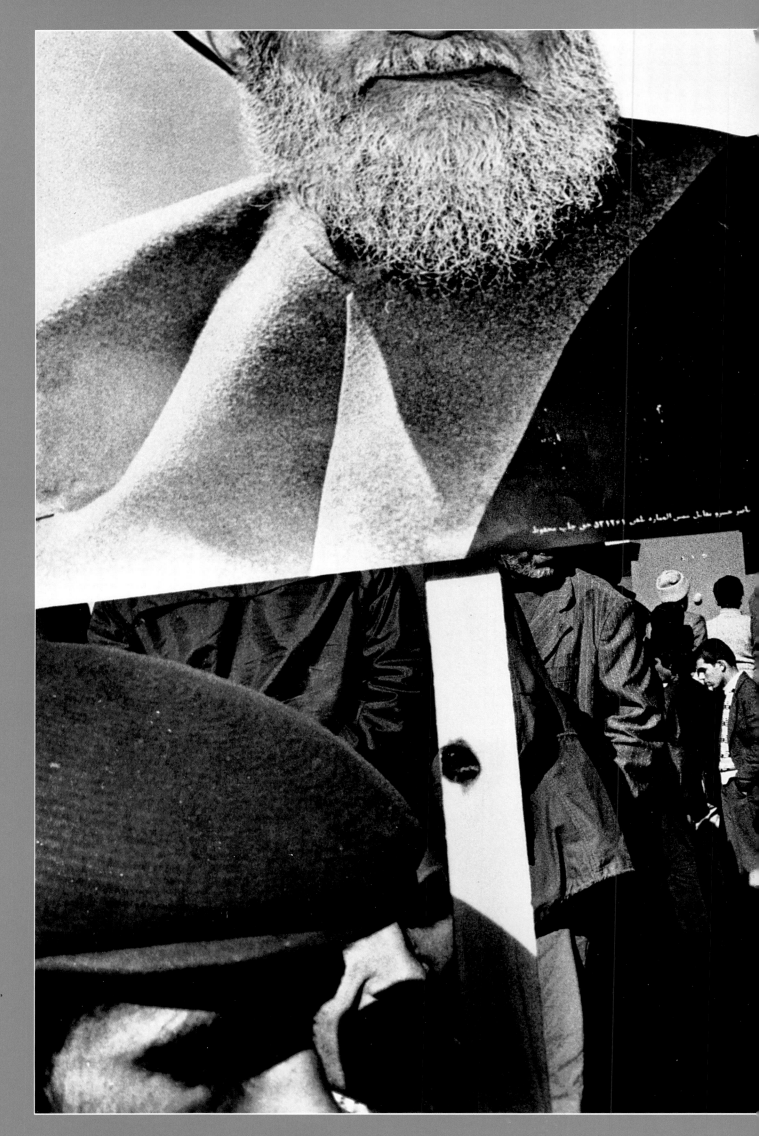

"Middle East Series, 1979"

Pro-Sharat Madari

demonstration,

Tabriz, Iran

©1979 **GILLES PERESS**

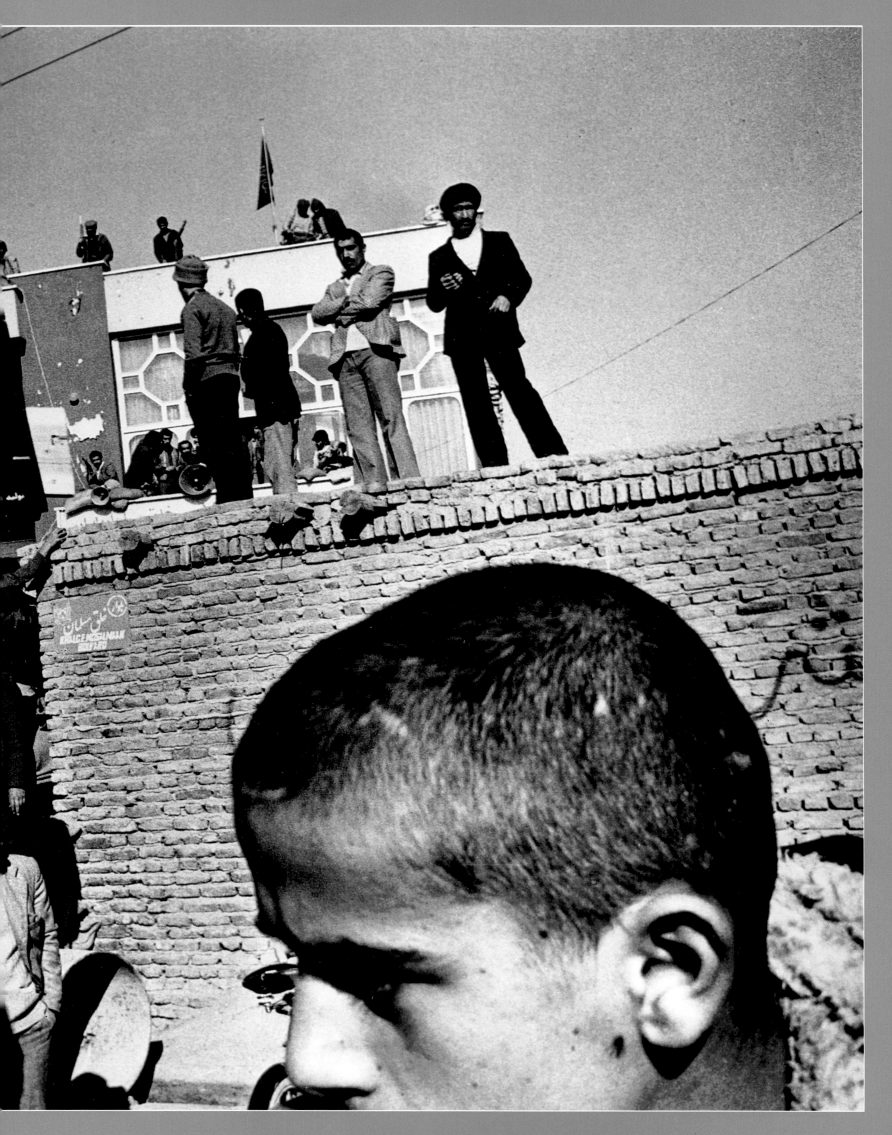

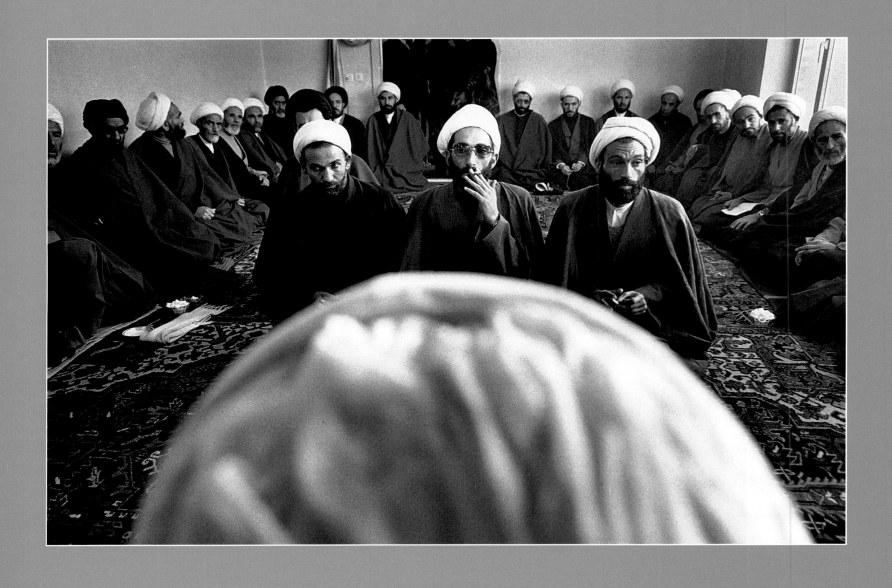

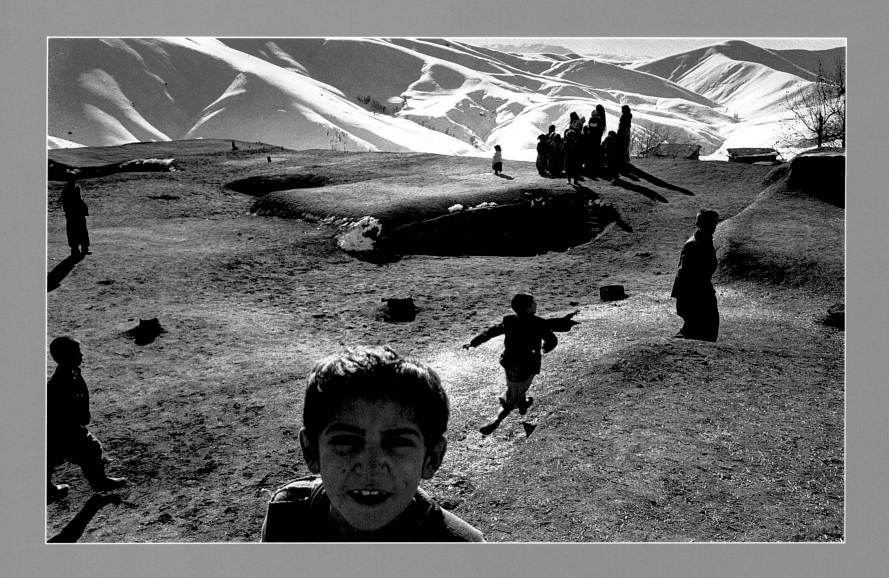

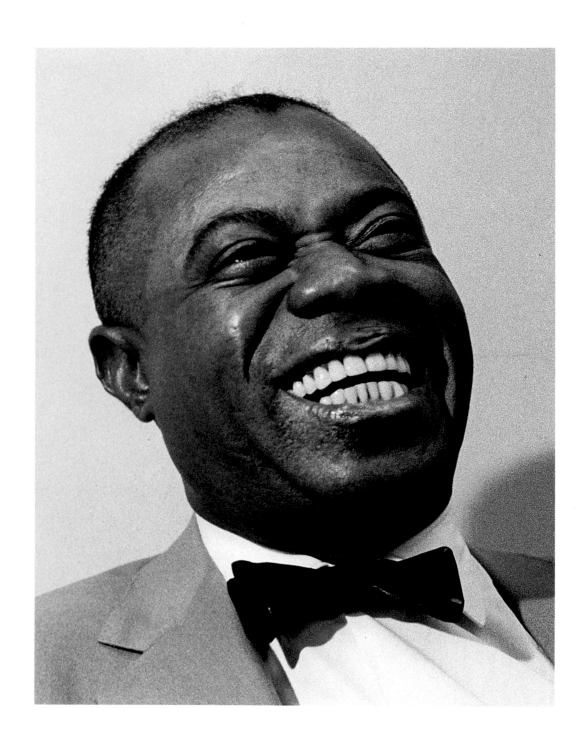

Louis Armstrong,
Miami Beach, 1957

Billie Holiday, with
pianist Art Tatum, at the
Onyx Club on New York's
52nd Street, 1944

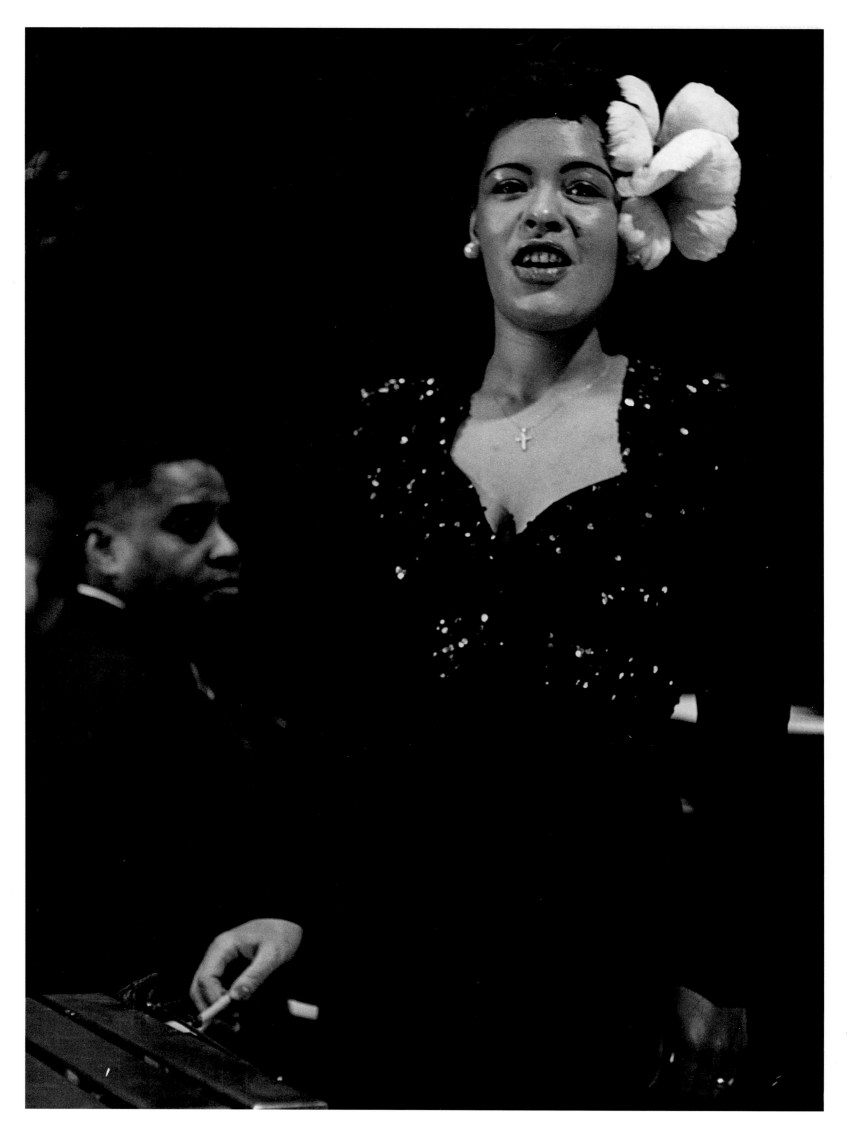

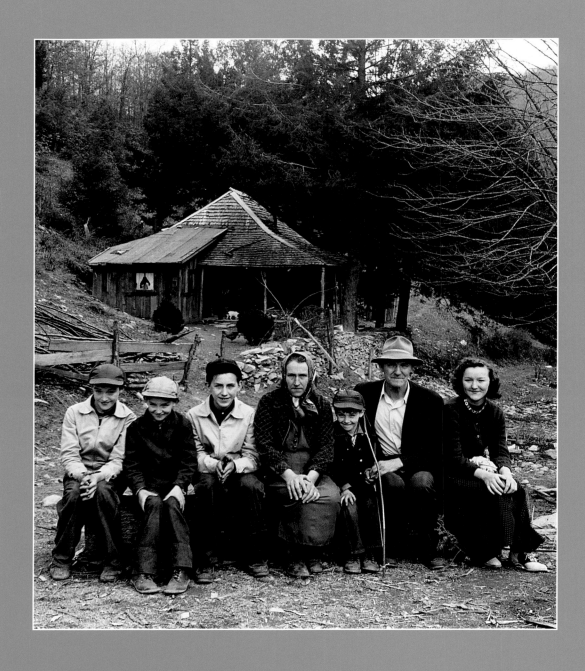

From a series of portraits:
"The Bob Miller Family,
Lost Cove, North Carolina"
Ross spent five days
documenting this small,
isolated town in the
Unaka Mountains. It
had no electricity, no
telephones, no store, no
doctor, and no crime.

©1953 **BEN ROSS**

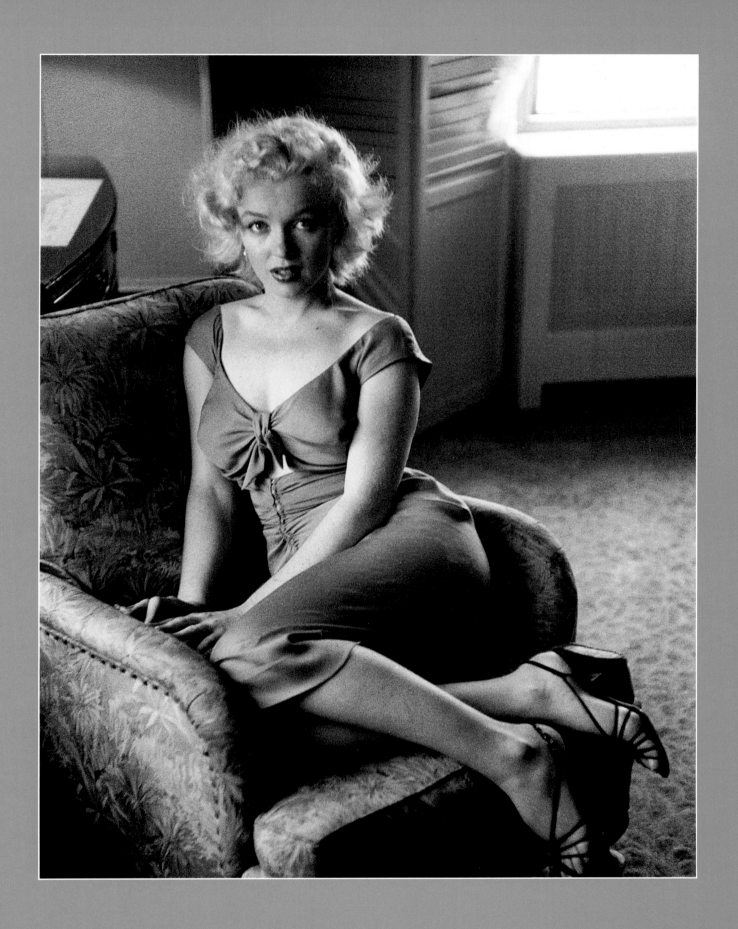

Marilyn Monroe,
Atlantic City,
New Jersey, 1952

© 1991 **BEN ROSS**

"In the last analysis, man himself is seen

as the actual medium of

—*Edward Weston*

expression. Guiding the camera,

as well as the painter's brush,

there must be a directing

intelligence—the creative force."

"Coho," a selenium split-toned print hand altered by binding Armenian bole (red earth) and 23-karat gold leaf to the print with gelatin

©1989 **DIANNE KORNBERG**

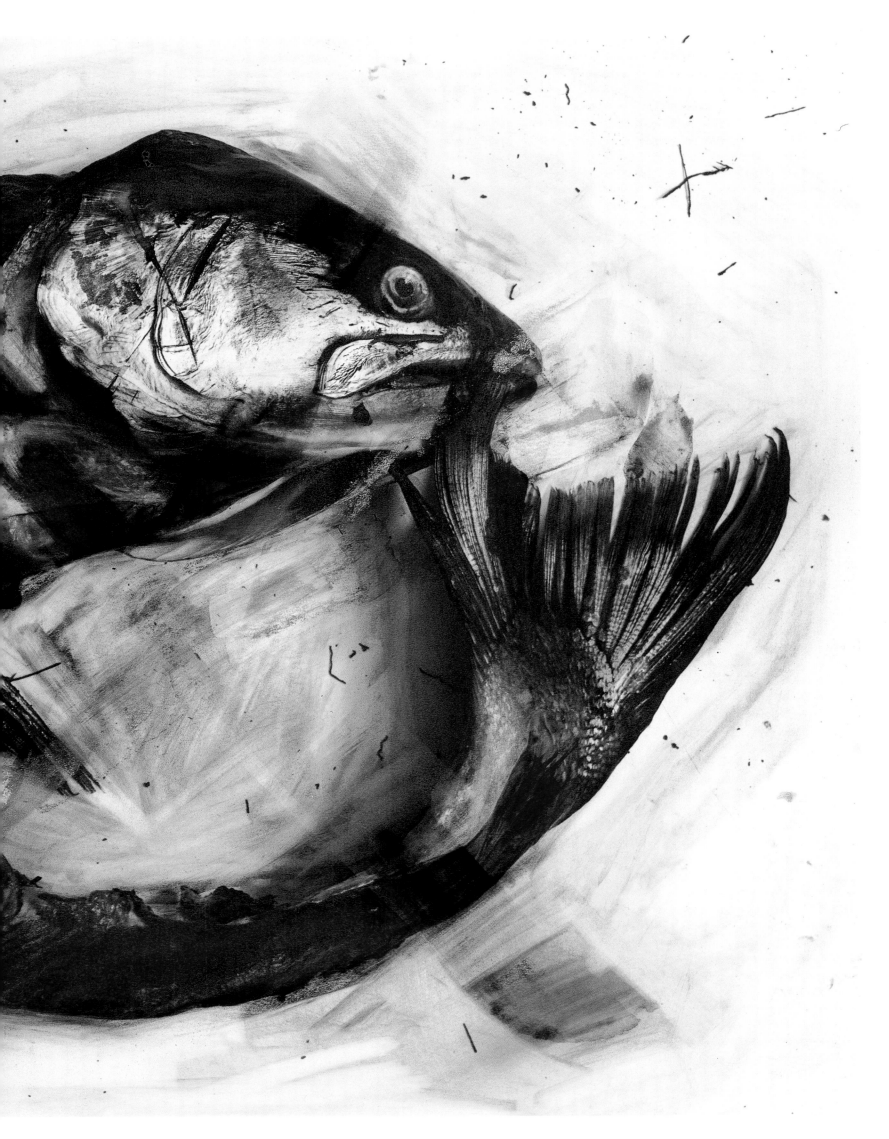

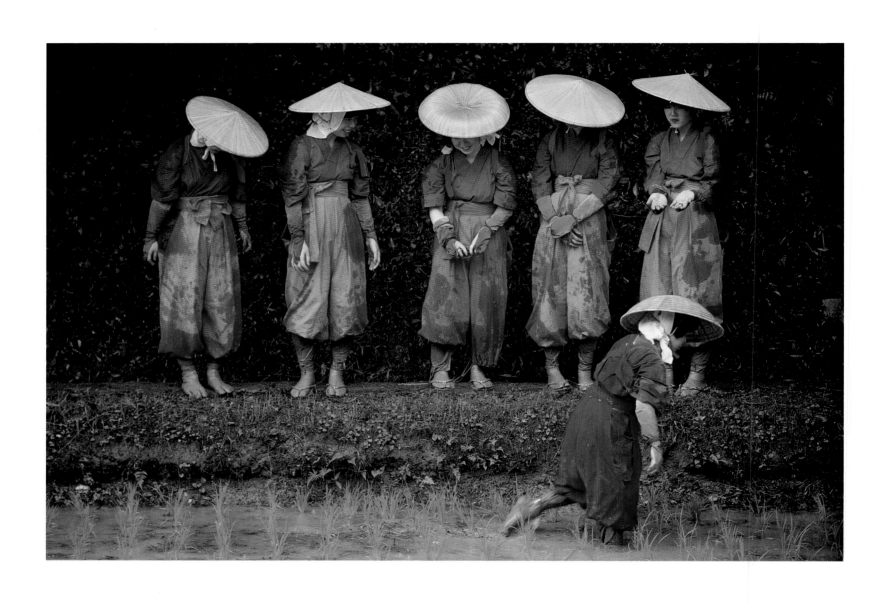

Rice planting festival,

Kyoto, Japan

ARTHUR MEYERSON

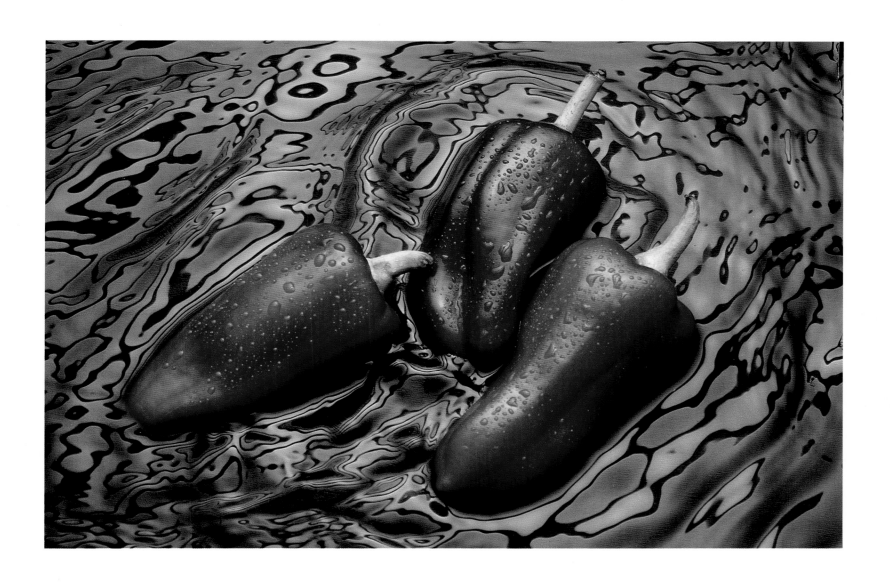

Peppers combined with water, reflected materials, and bursts of canned air

©1990 **ROB BARTEE**

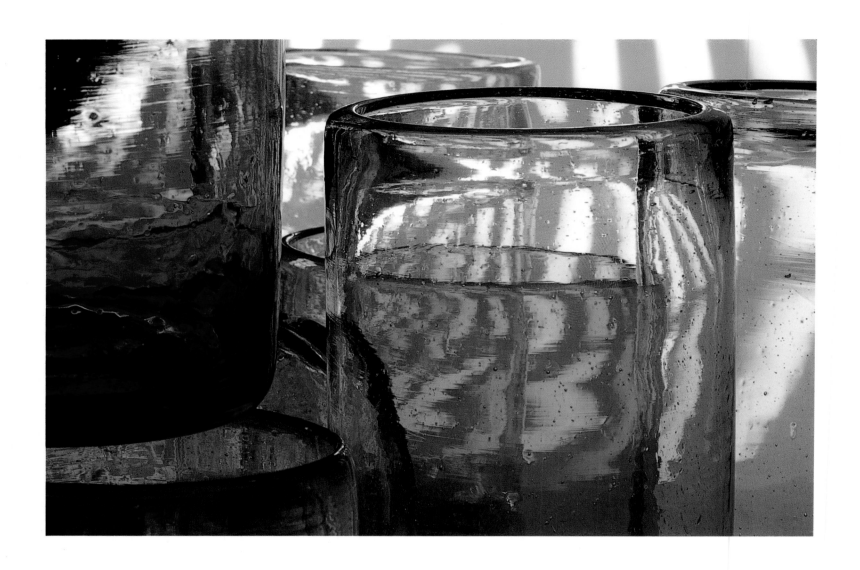

"Mexican Glasses"

ROGER FOLEY

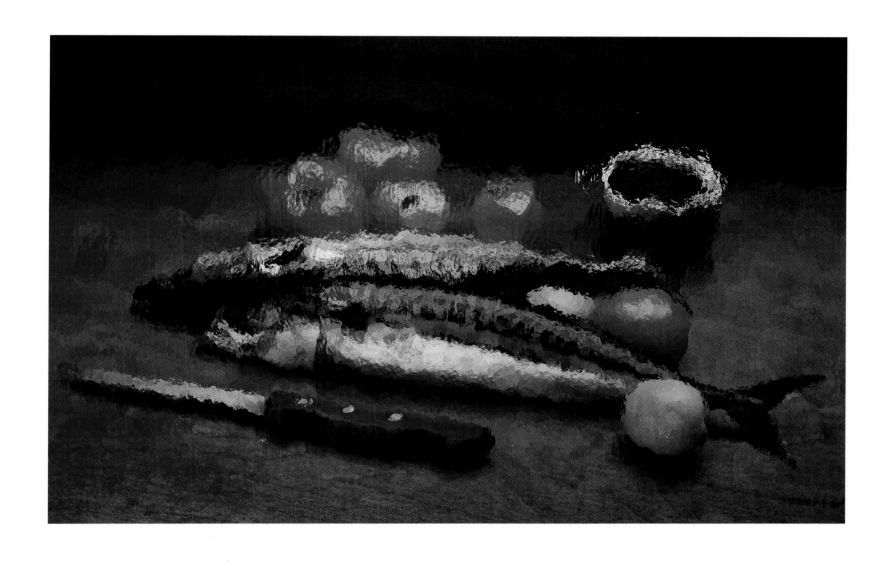

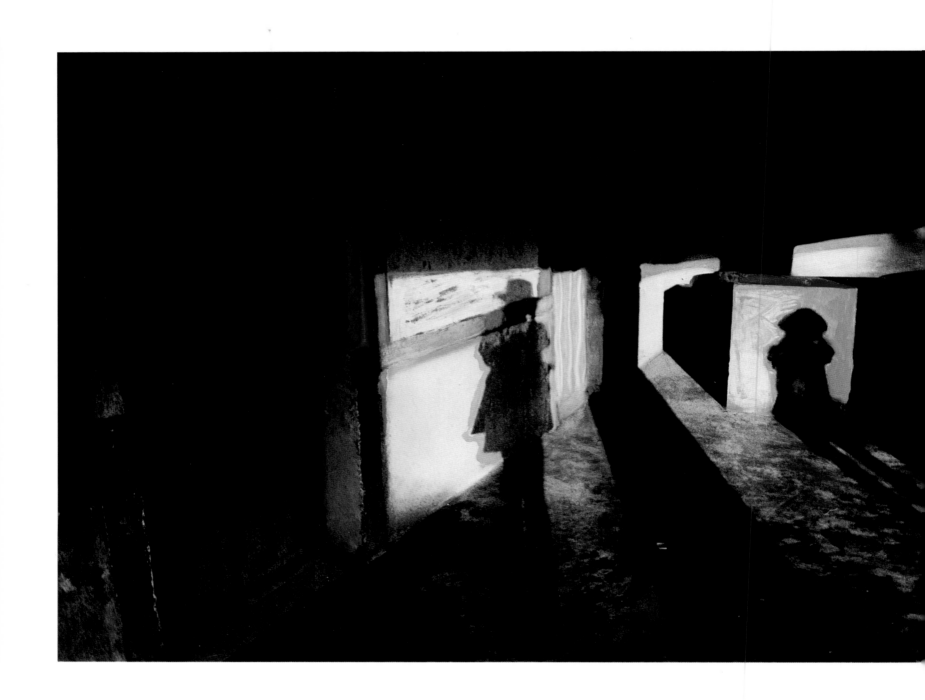

"¿Qué Pasa?"
a hand-painted
silverprint diptych,
photographed at
Chichen Itza, Mexico

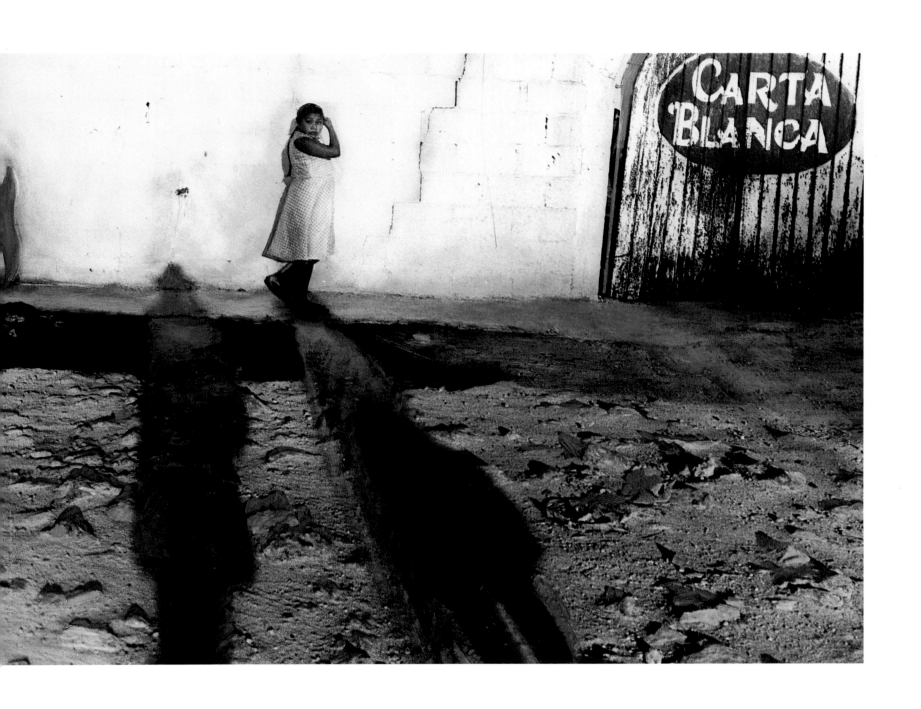

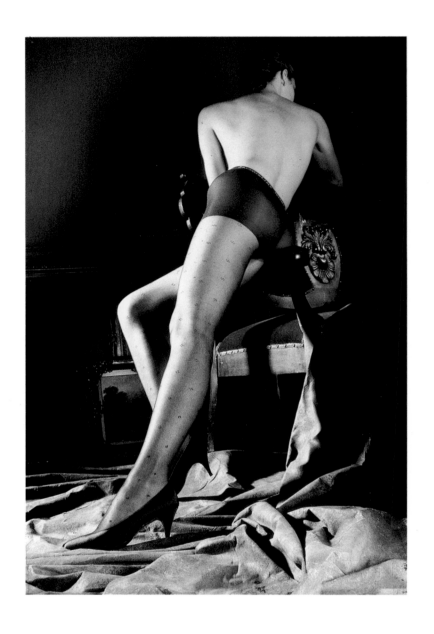

Pantyhose ad

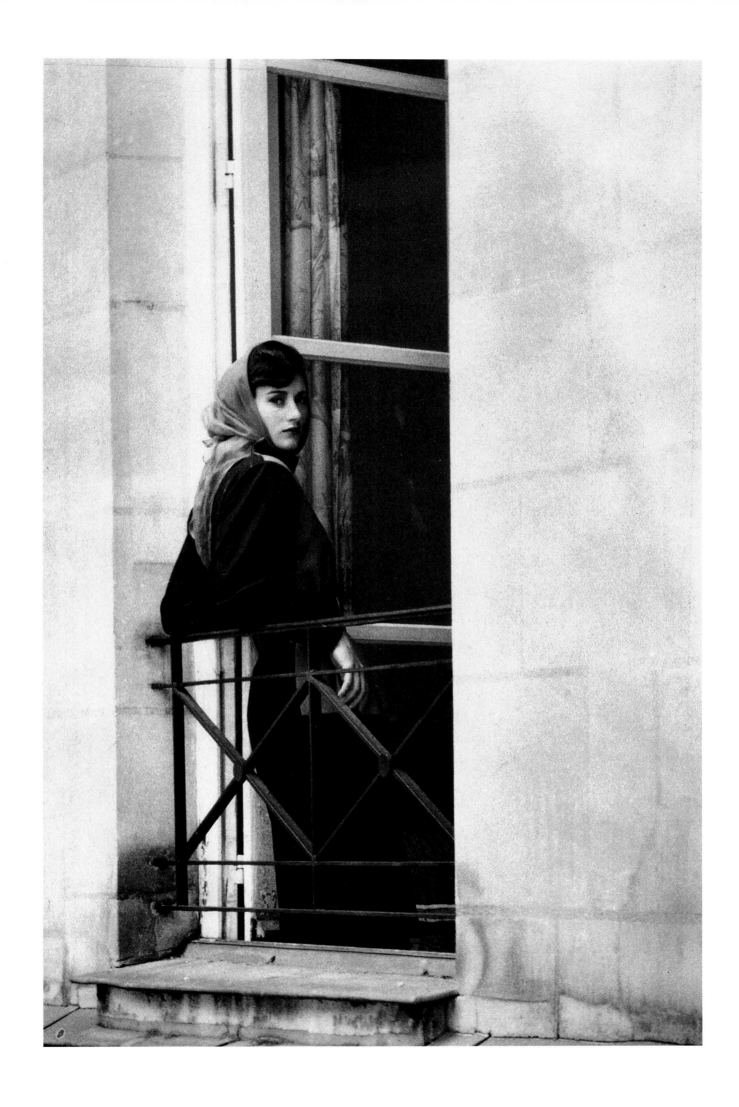

"Paris Courtyard"

NANCY LeVine

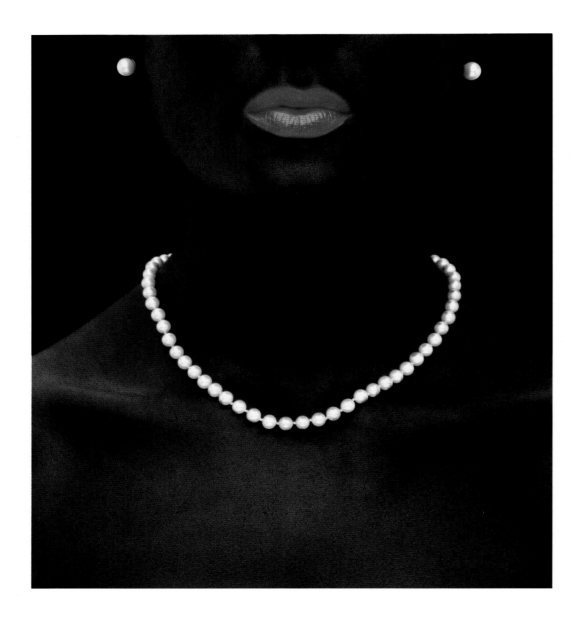

"Pearls on Black"

"Juleen"

©1985 **BOB GIANDOMENICO**

©1990 **DONALD GRAHAM**

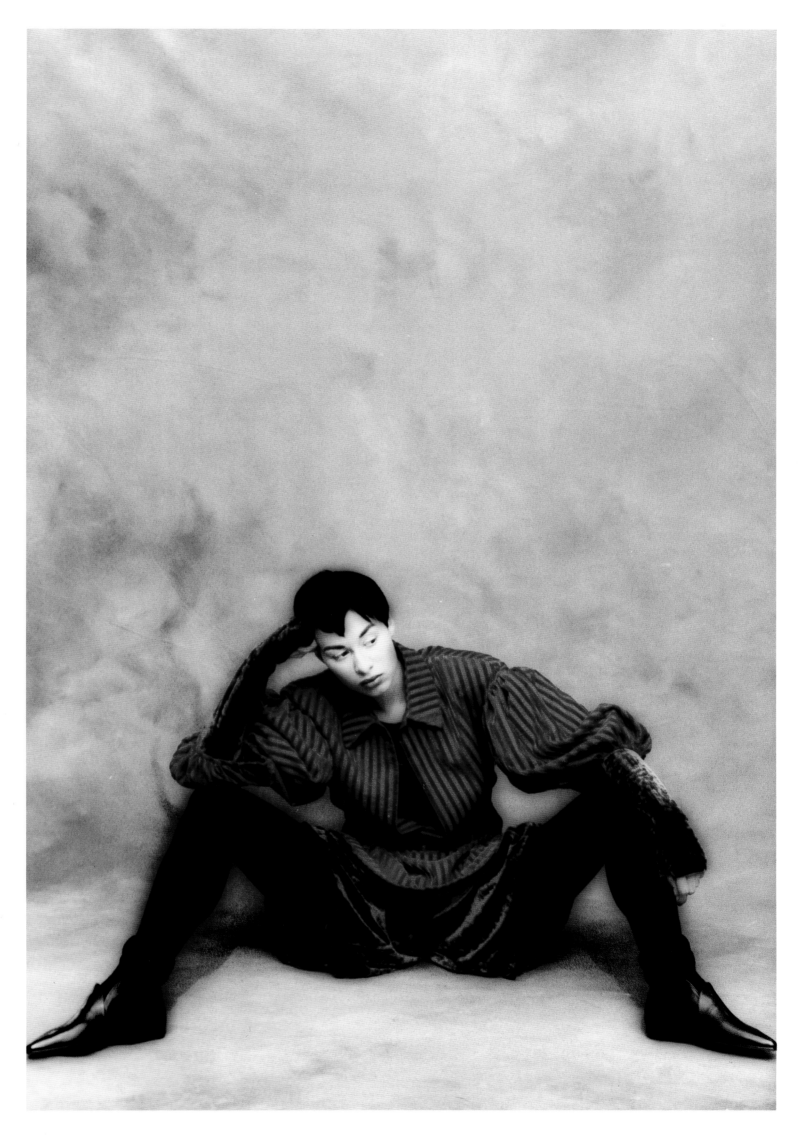

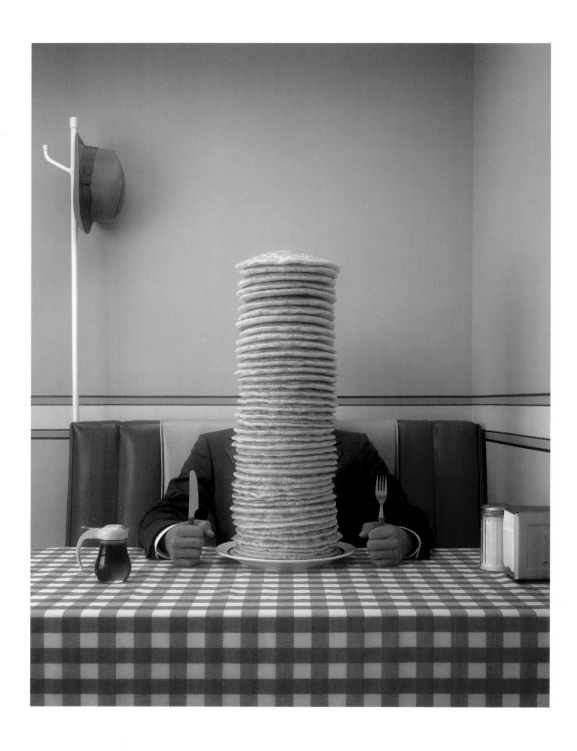

"Pancakes, 1983,"
photographic inter-
pretation of an airbrush
illustration by the artist
David Wilcox

HUGH KRETSCHMER

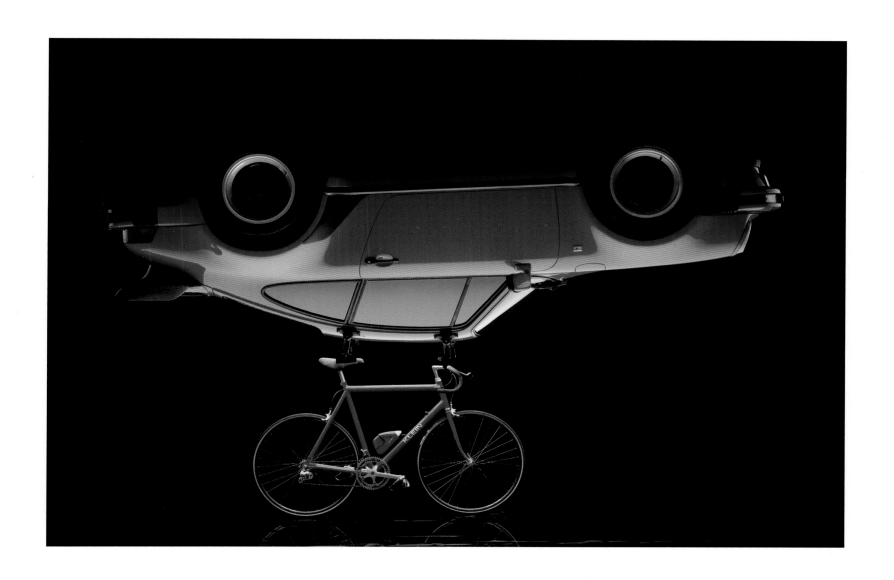

Bicycle ad, combined digitally from two 8x10 transparencies

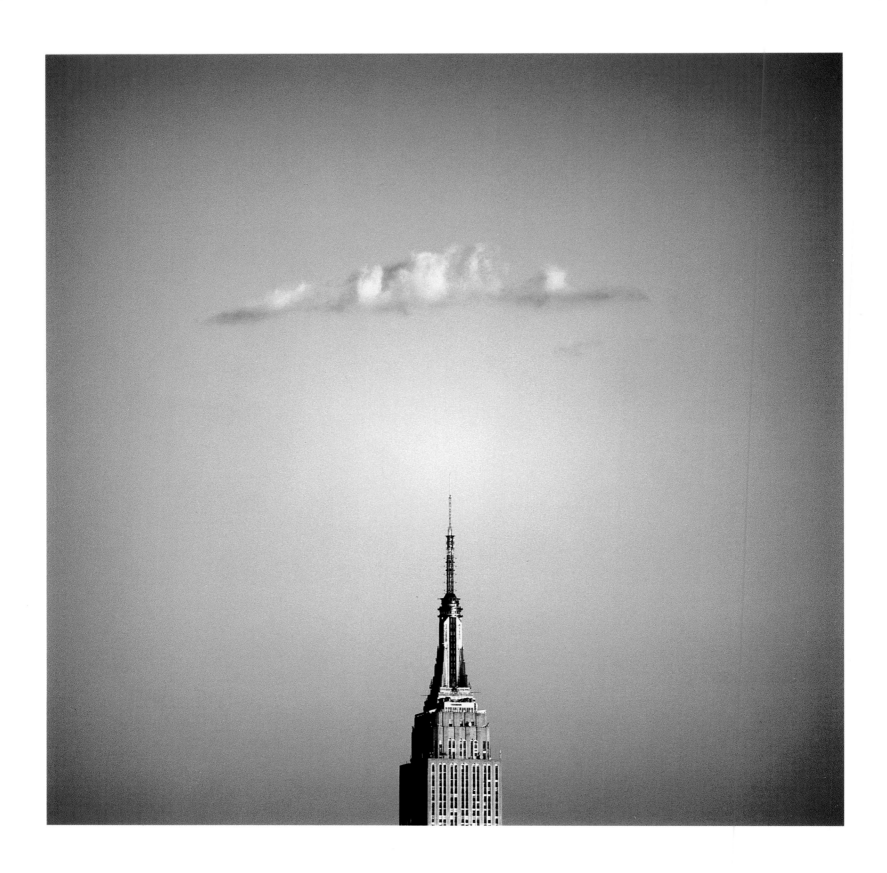

Empire State Building,
New York City

© 1990 **KIM DUCOTÉ**

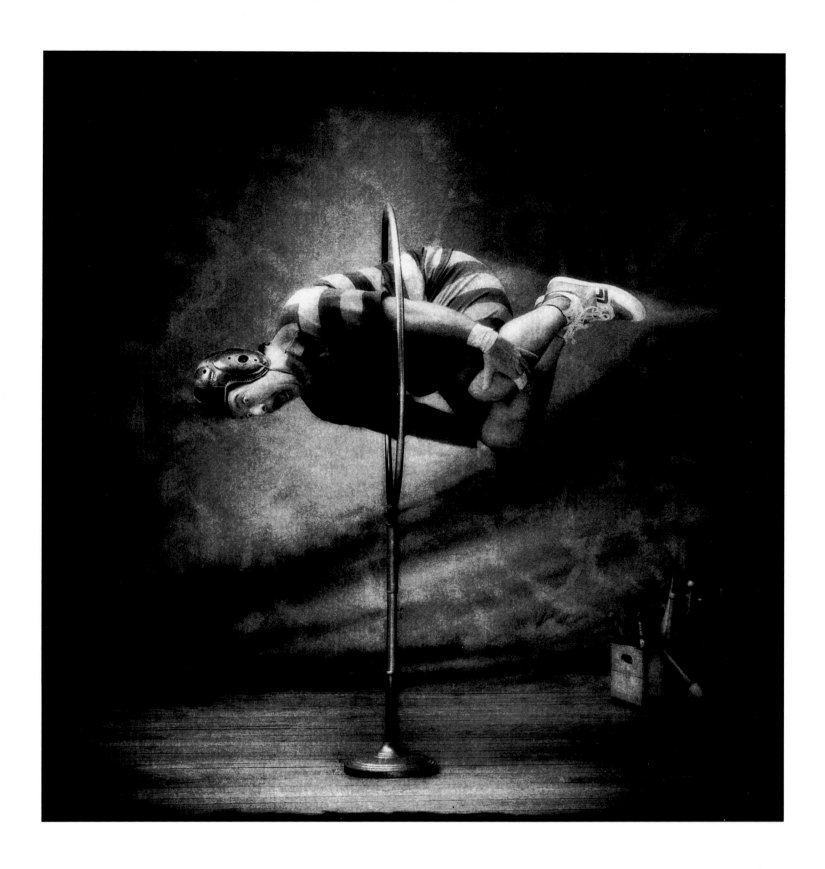

"The Hoopmaster,"
used for a Kansas City
Art Directors Awards
Show poster

©1990 **NICK VEDROS**

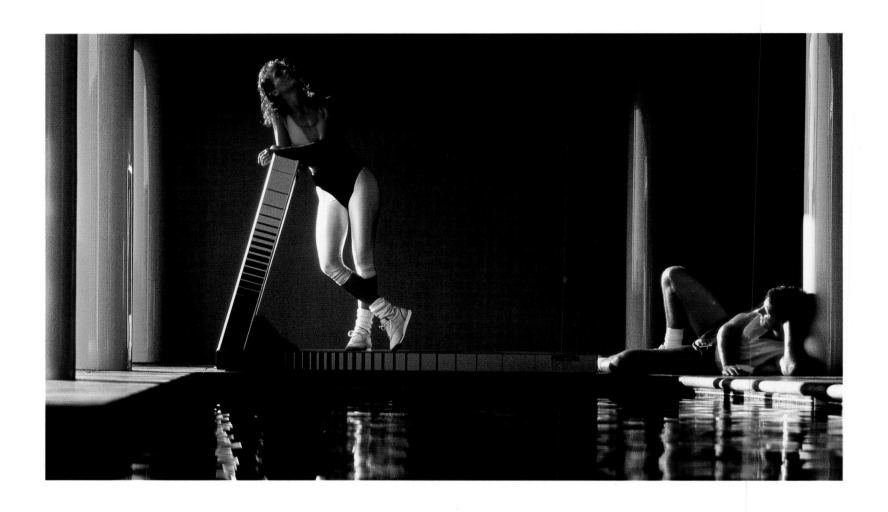

*Image for exercise
equipment advertising
campaign*

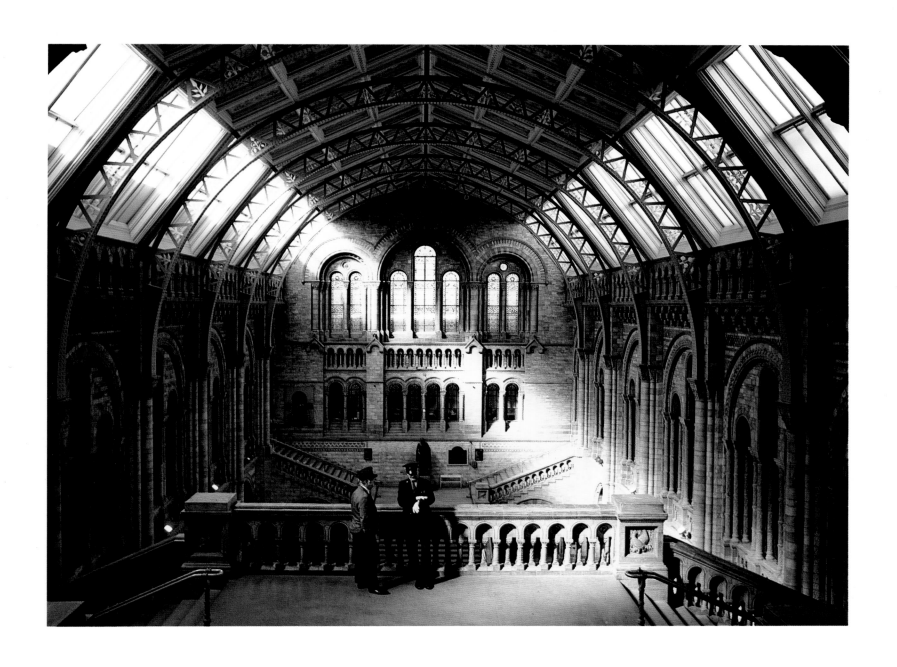

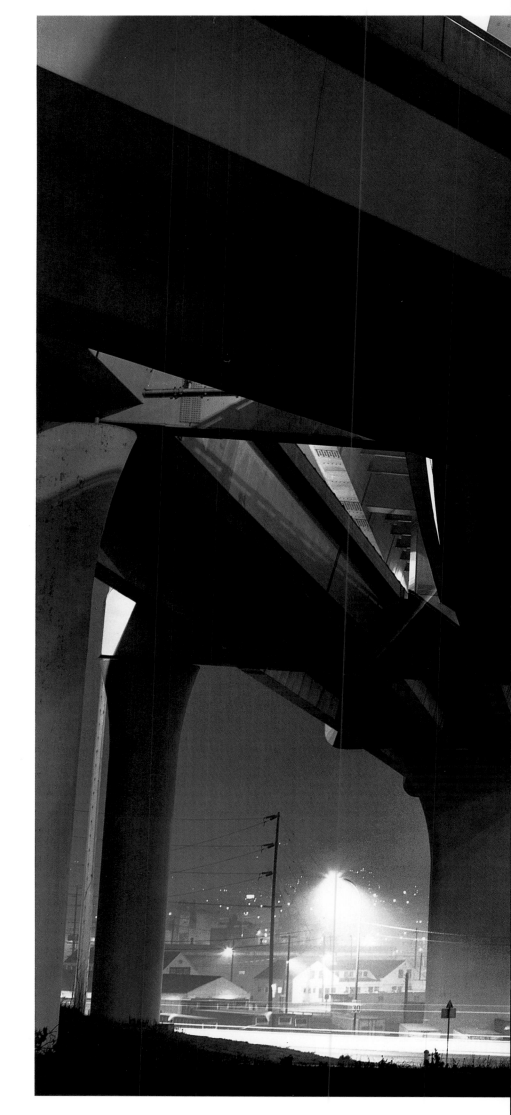

Fremont Bridge,
Portland, Oregon

© 1989 **PETER ECKERT**

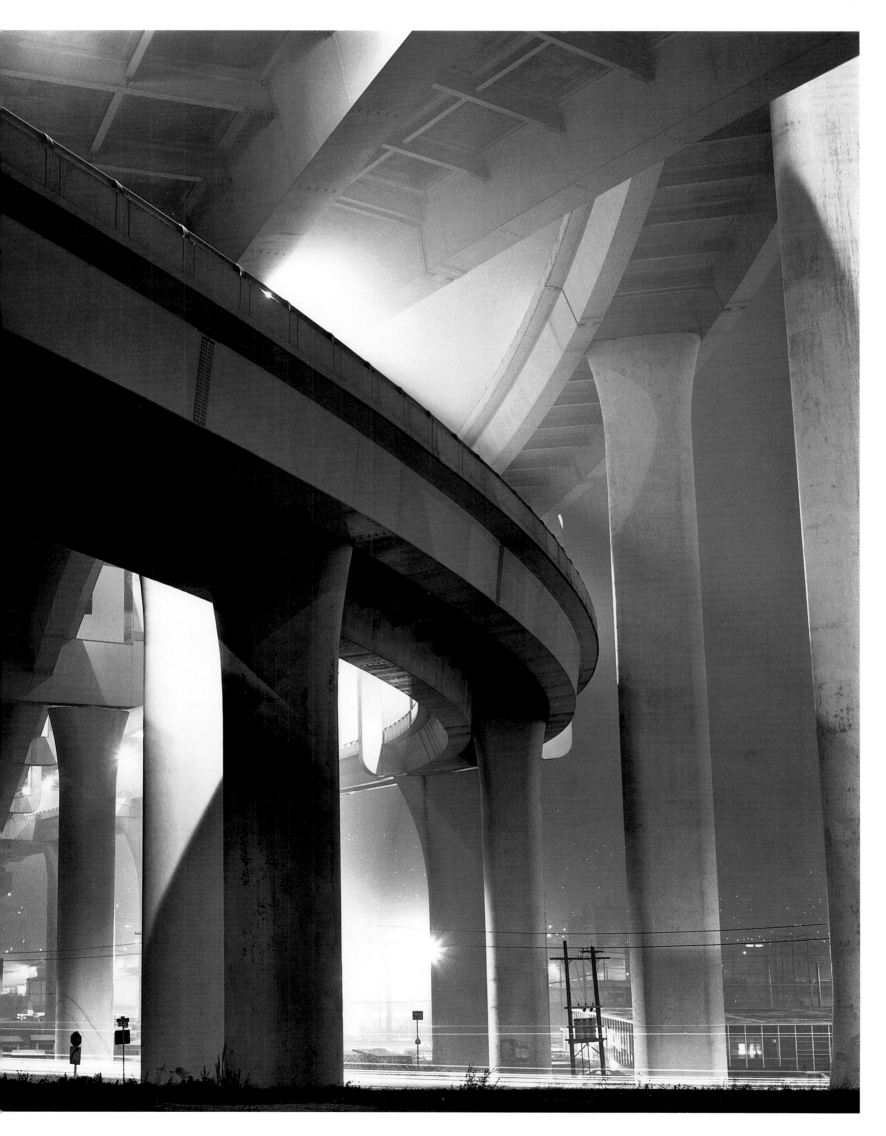

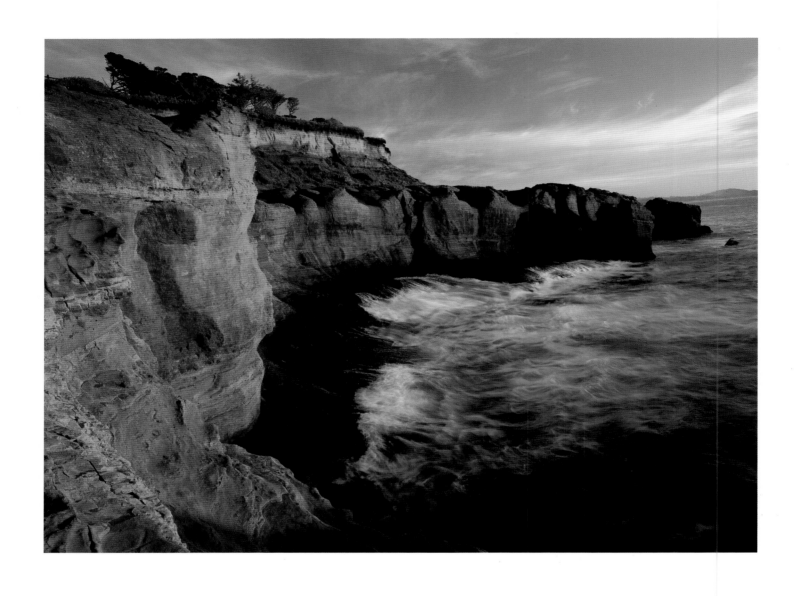

Yellow sandstone cliffs,

Otter Crest Wayside,

Oregon

©1990 **WAYNE ALDRIDGE**

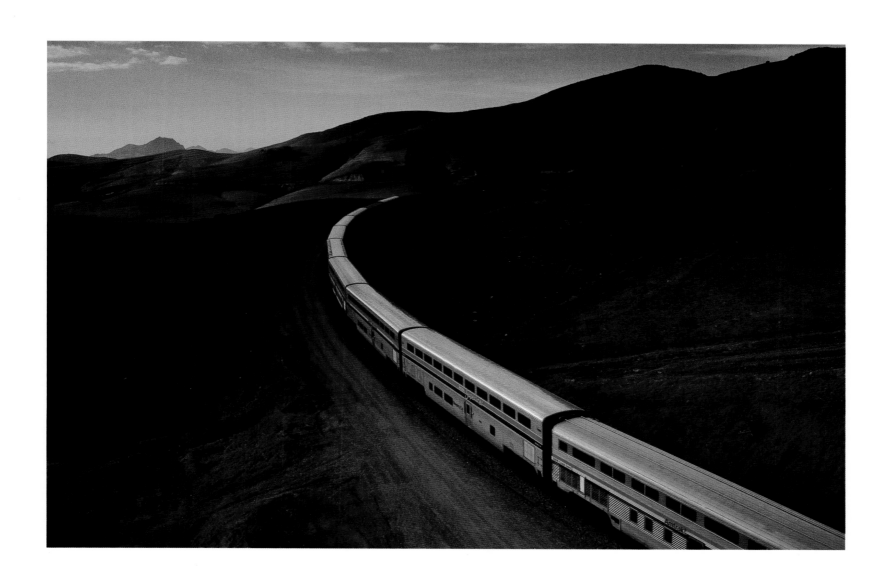

*Amtrak passenger train
near San Luis Obispo,
California*

© 1984 **DICK DURRANCE II**

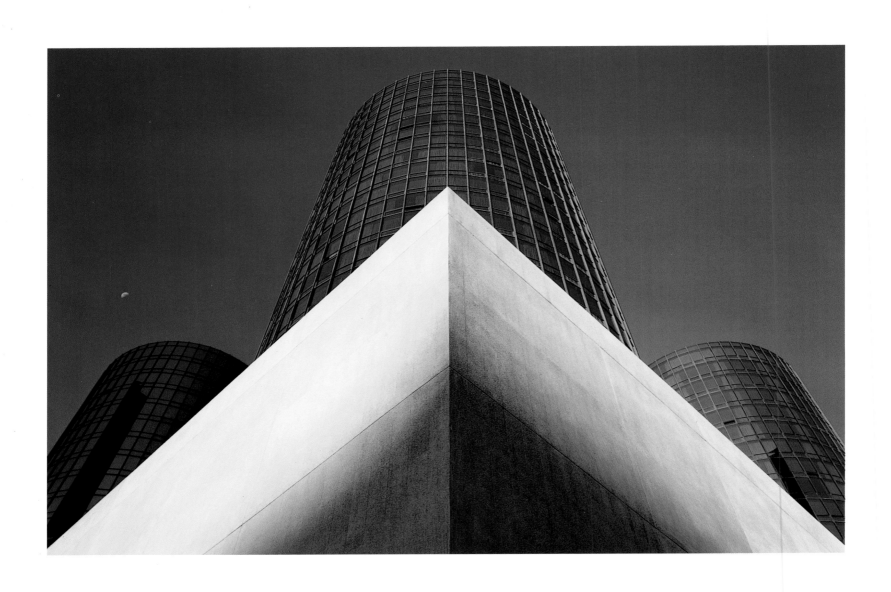

Hotel Bonaventure,

Los Angeles

DAVID QUINNEY

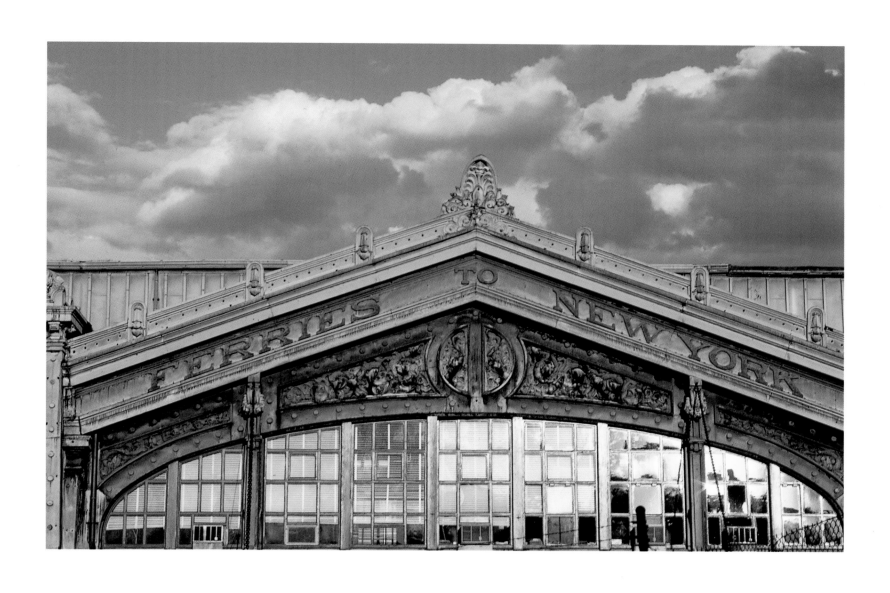

Erie Lackawanna Terminal,
Hoboken, New Jersey

© 1977 VIRGINIA ROLSTON PARROTT

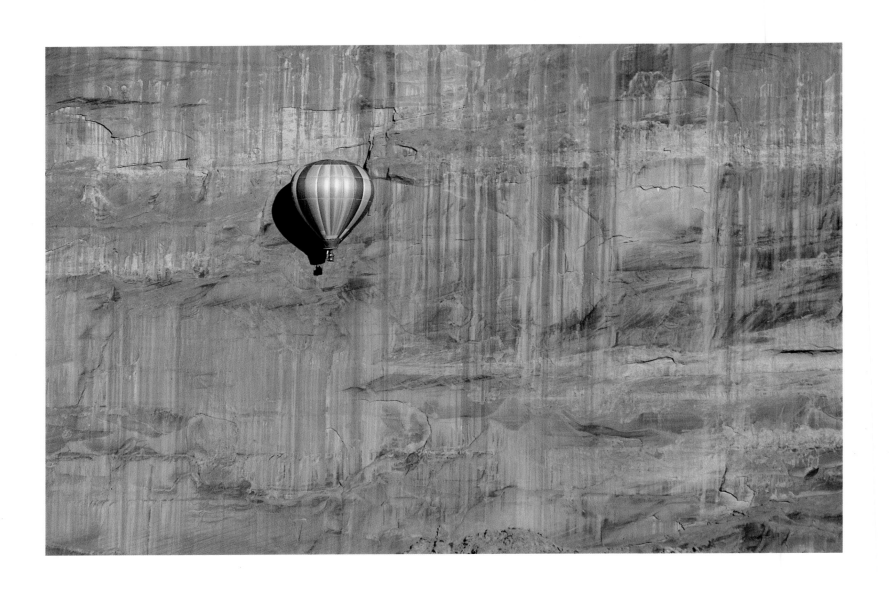

Balloon ascent,

Monument Valley, Utah

VINCE STREANO

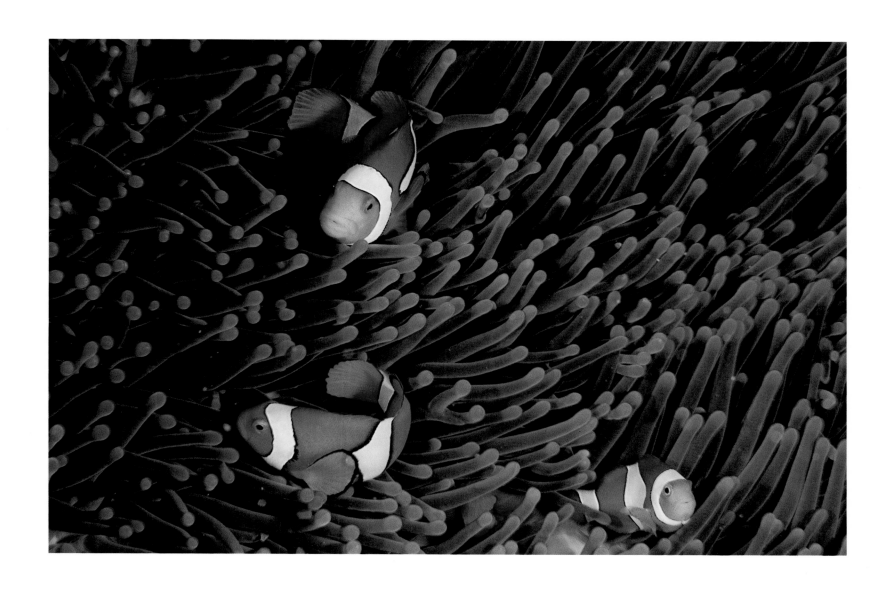

© 1986

Clown anemone fish,
Anuha Island,
Solomon Islands

© 1986 **LOUISA PRESTON**

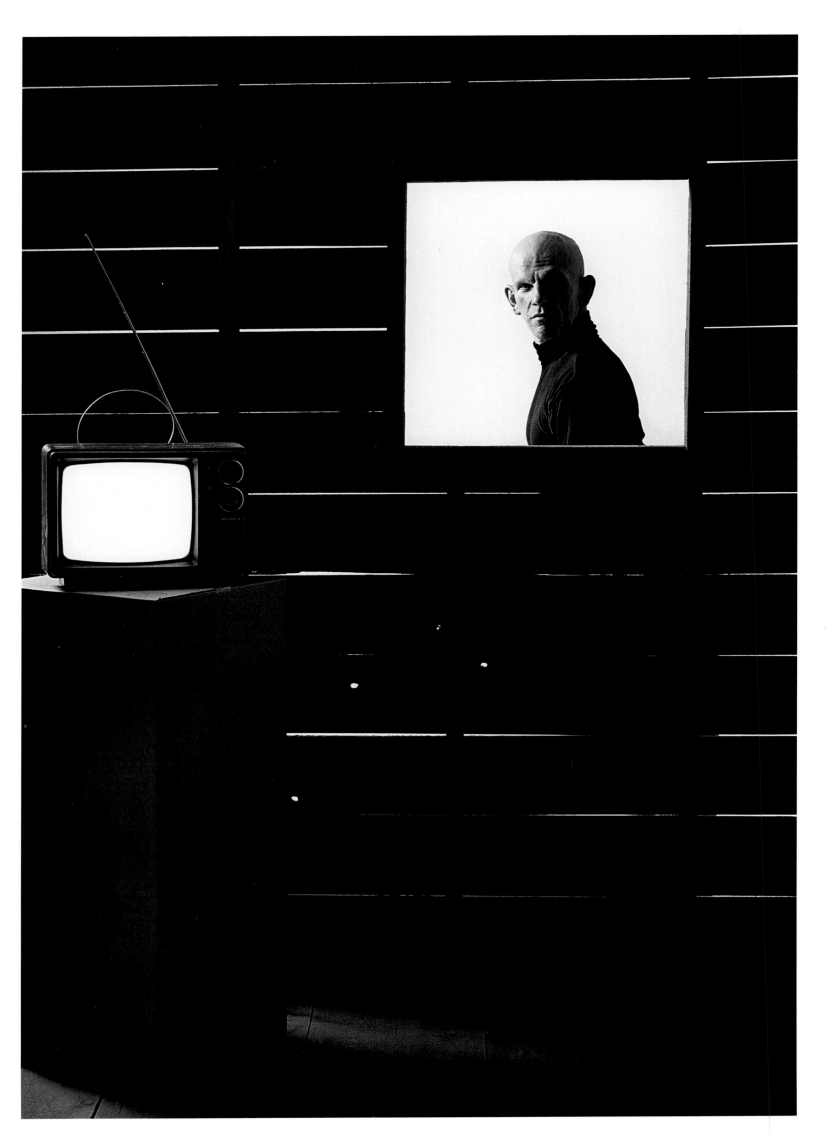

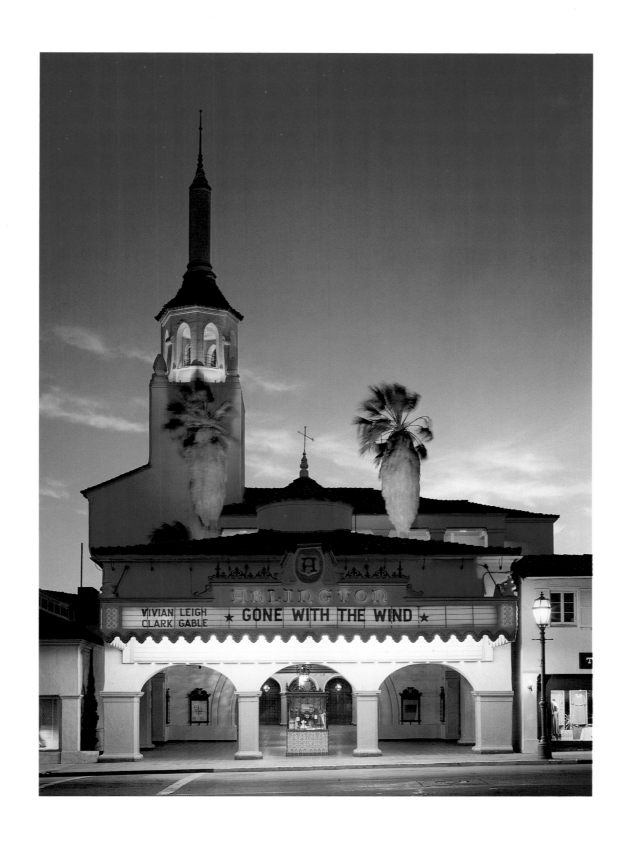

Two exposures, two hours apart, were required for this photograph of the exterior of the Arlington Theater, Santa Barbara, California.

"Steve"

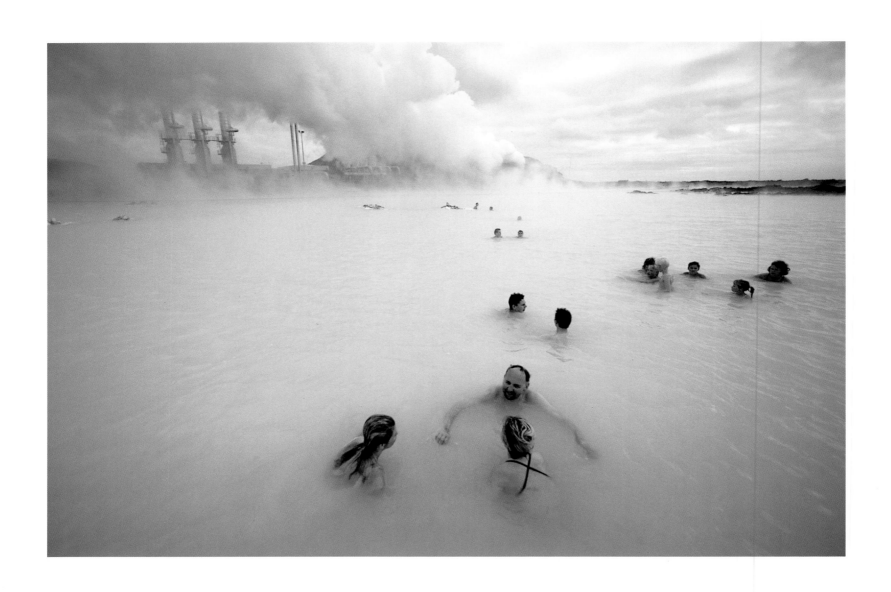

"The Blue Lagoon"
At Keflavik's Svartsengi
geothermal power plant,
Icelanders take the waters
for their therapeutic value.

BLAINE HARRINGTON III

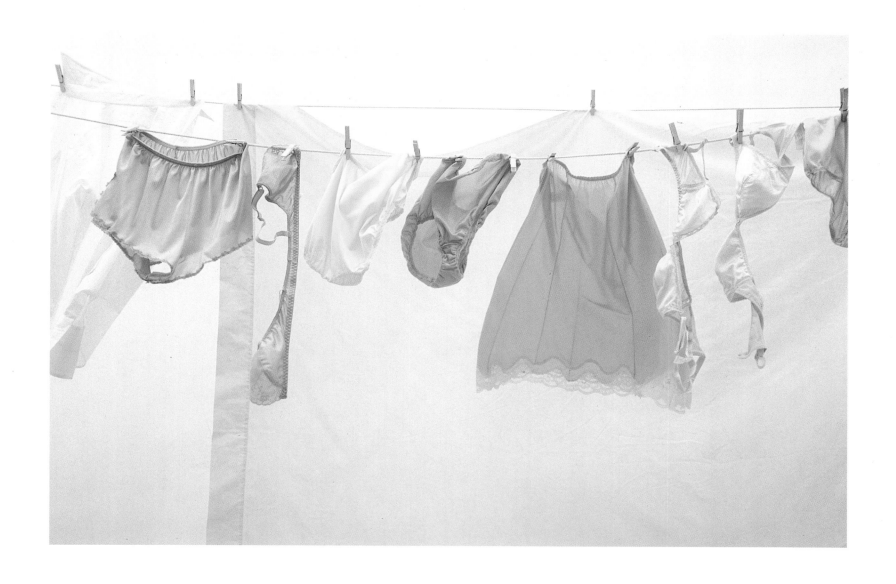

"Floating in the Breeze"

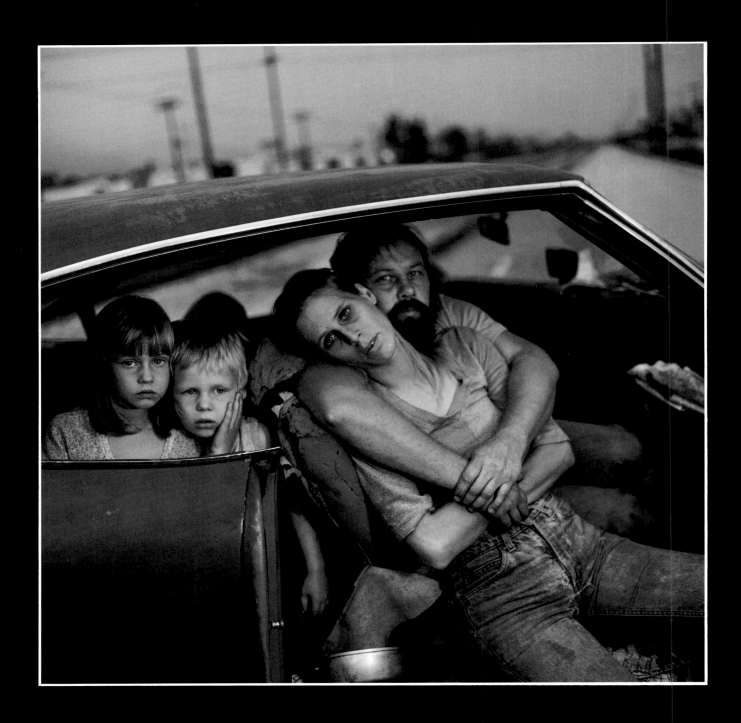

Homeless Damm family:
Crissy, 6; Jesse, 4; their
mother, Linda, 27, a
former nursing-home
aide; and their stepfather,
Dean, 33, an ex-trucker;
Los Angeles

©1987 **MARY ELLEN MARK**

"I am trying here to say something

about the despised,

—*Dorothea Lange*

the defeated, the alienated.

About death and disaster,

about the wounded,

the crippled, the helpless,

the rootless, the dislocated

About finality.

About the last ditch."

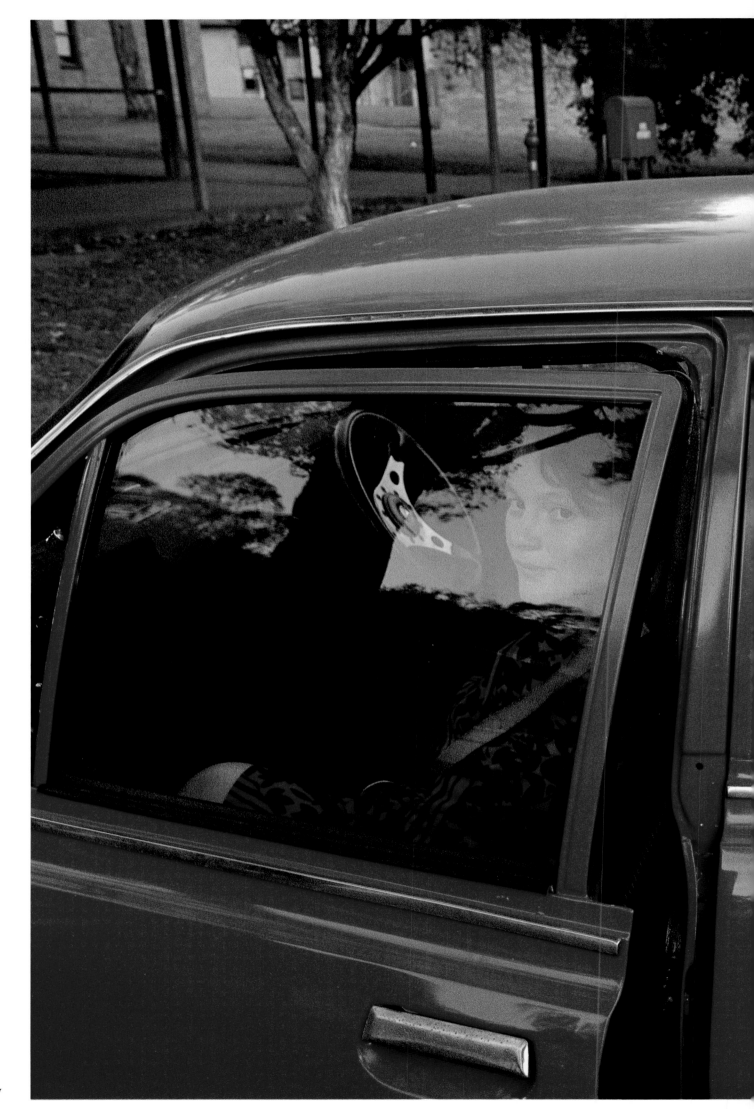

Jenneta Mostovy, age 8, and her mother, Yelena, who fled the nuclear contamination of Chernobyl in early 1988, photographed in a refugee camp in Sydney, Australia, 1989

CATHERINE KARNOW

124

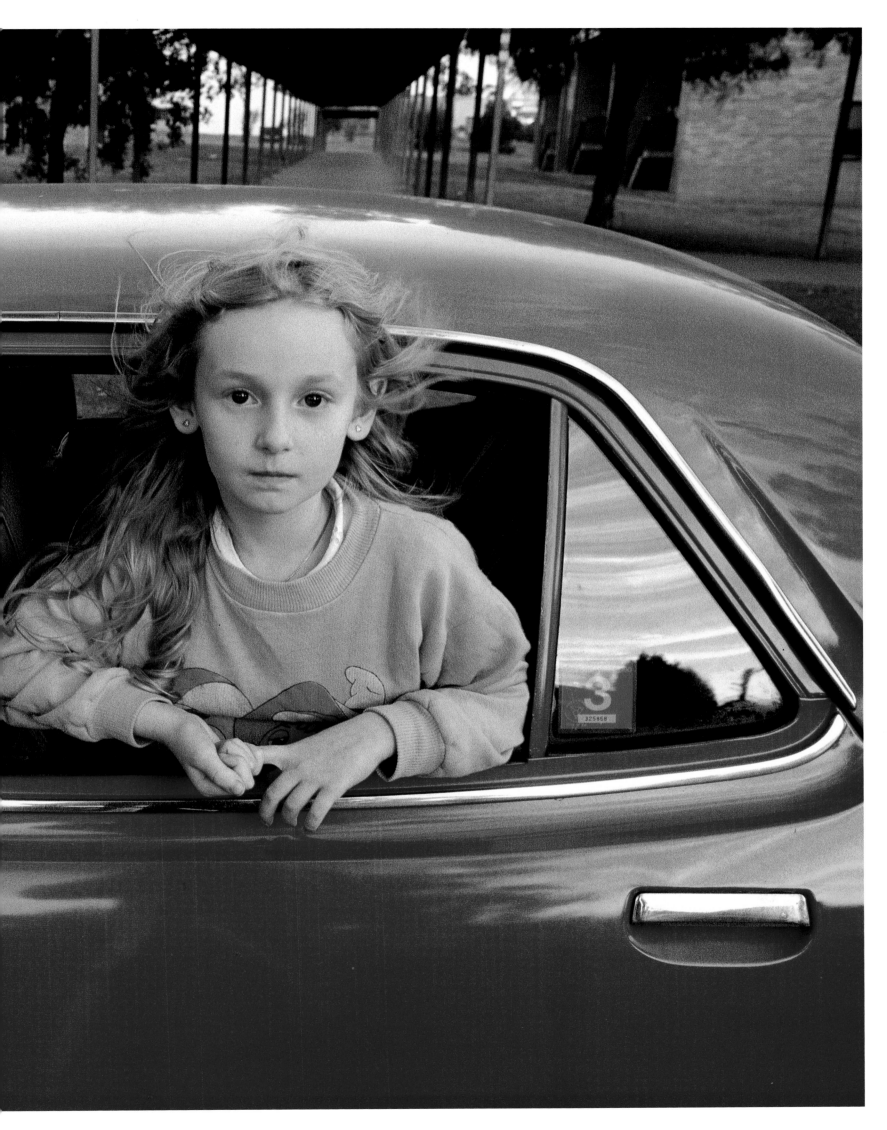

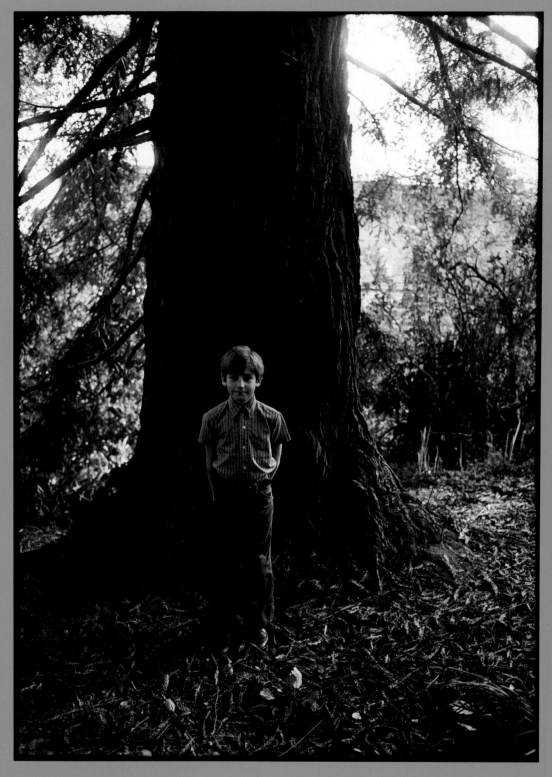

"Stephen, 1976"

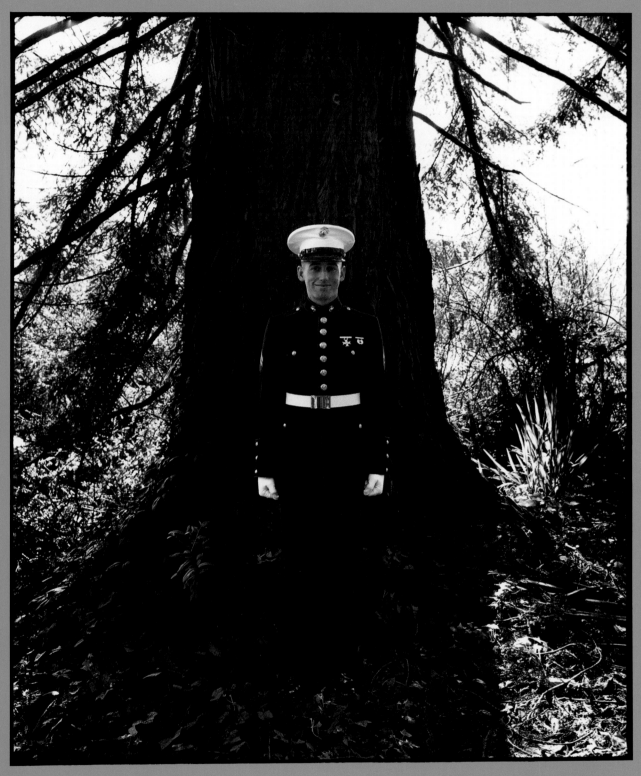

"Stephen, 1988"

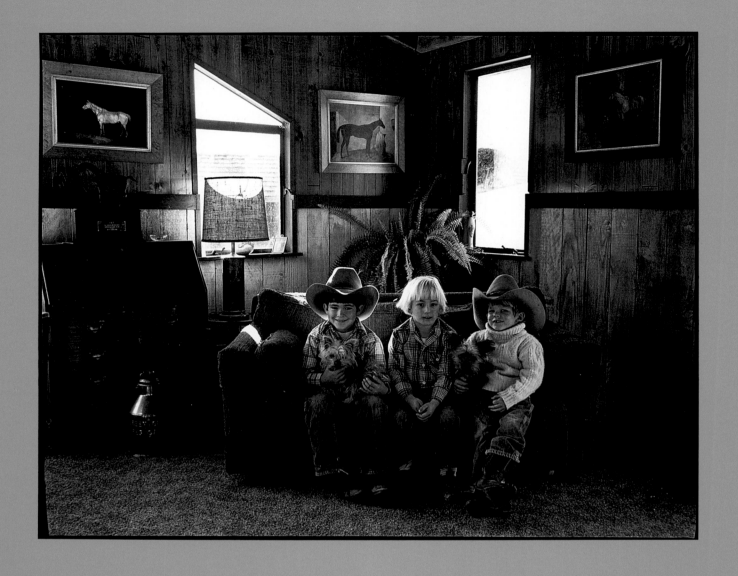

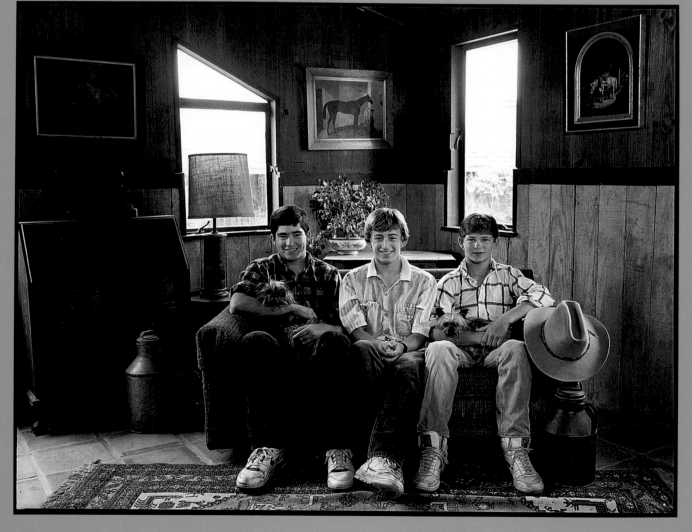

"Three Little Cowboys, 1978"

"Three Little Cowboys, 1988"

© 1978,88

ART ROGERS

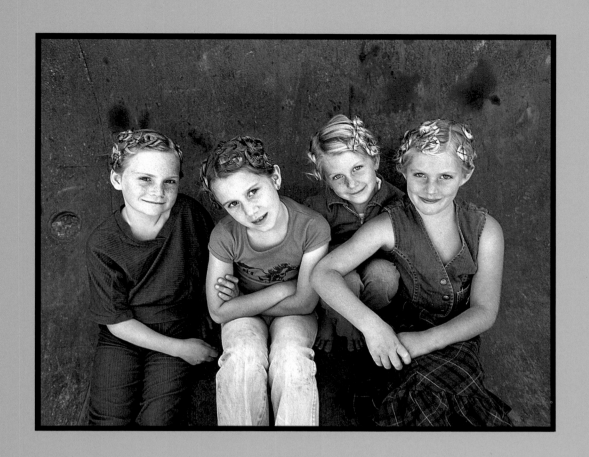

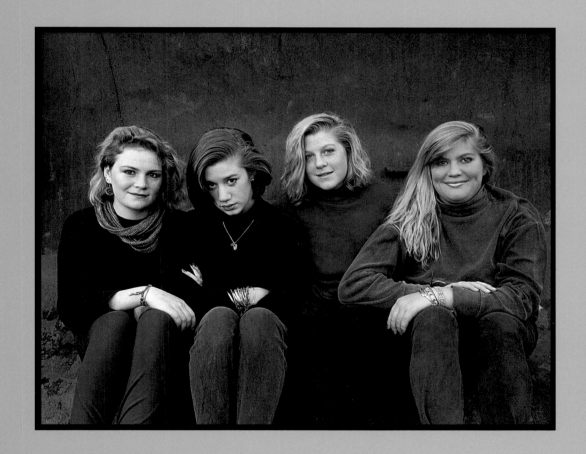

"The Pincurl Girls, 1980"

"The Pincurl Girls, 1988"

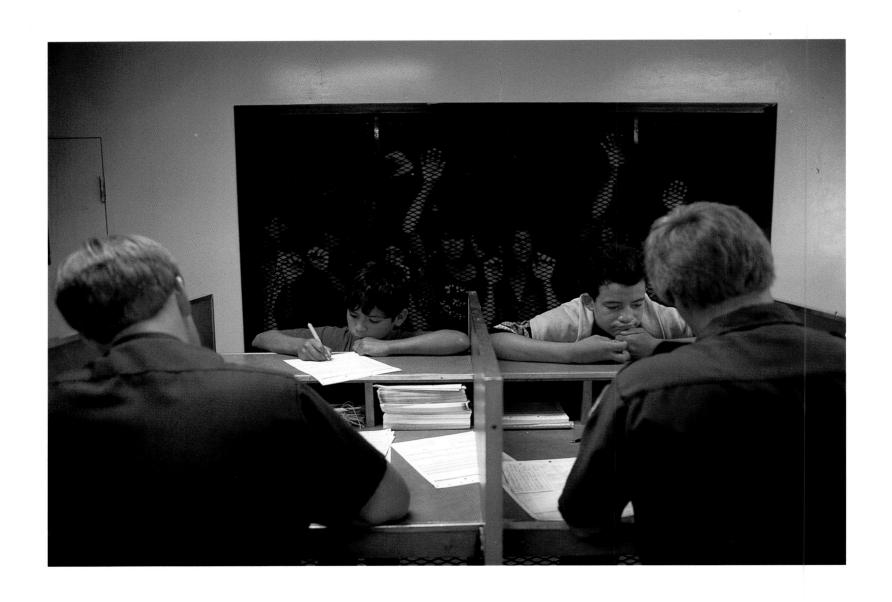

Border Patrol Processing
Center, El Paso, Texas.
Illegal alien minors in
temporary custody waive
their rights to trial before
deportation to Mexico.

ZIGY KALUZNY

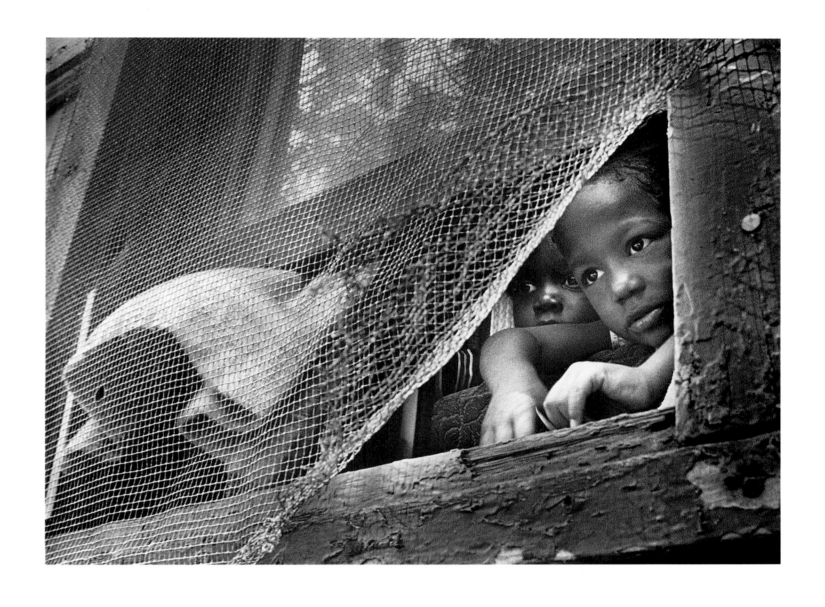

"The Window, Detroit"

©1972 **JUNEBUG CLARK**

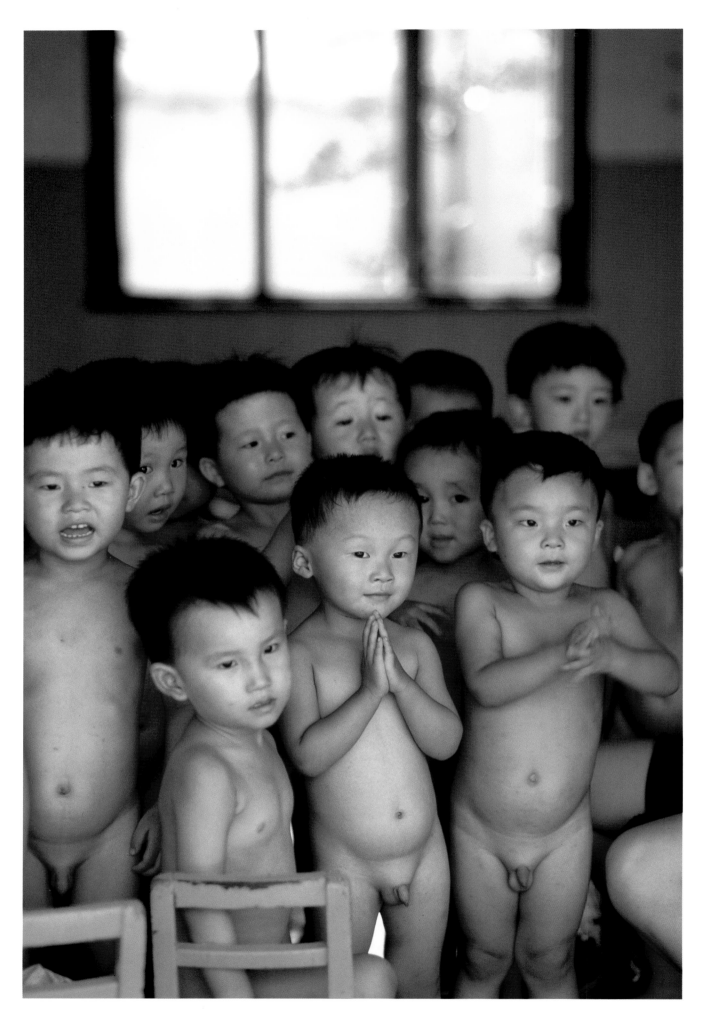

Day-care center,
Shanghai, China
"I'm sometimes asked why
the children are naked. In
the heat and humidity of
Shanghai's summer it
seemed like a most natural
and appropriate state."

© 1985 **MAGGIE O'BRYAN**

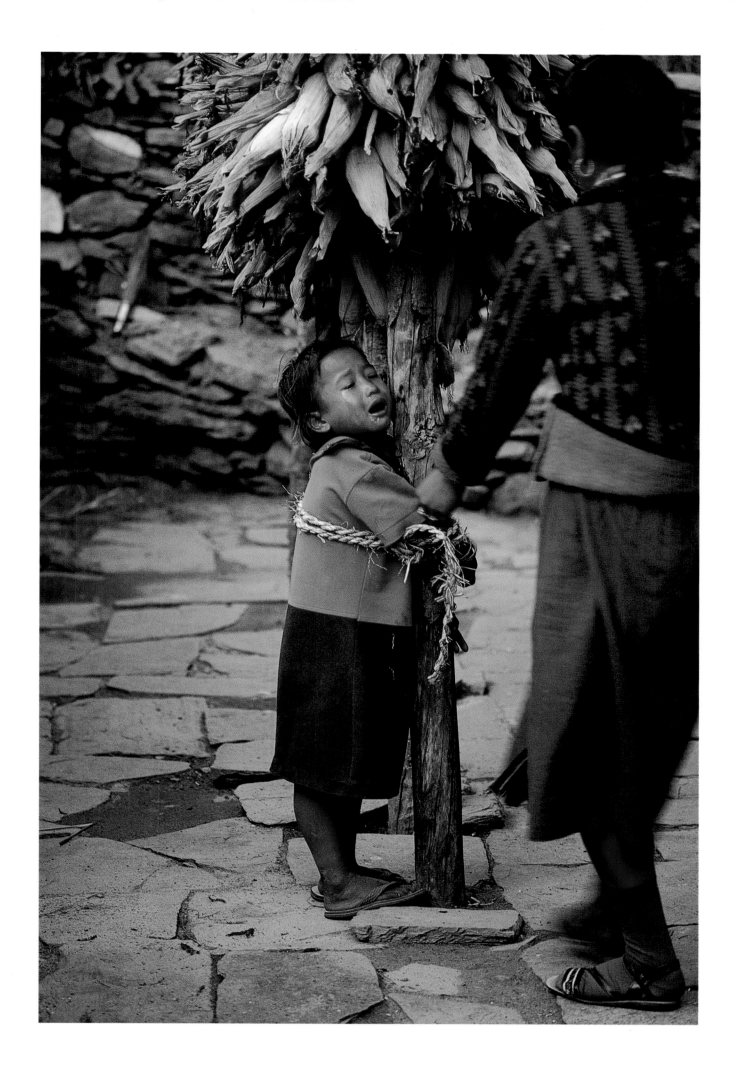

Child being abused, near the Annapurna Circuit, Nepal The child was untied immediately after Austen took this photograph.

DAVID ROBERT AUSTEN

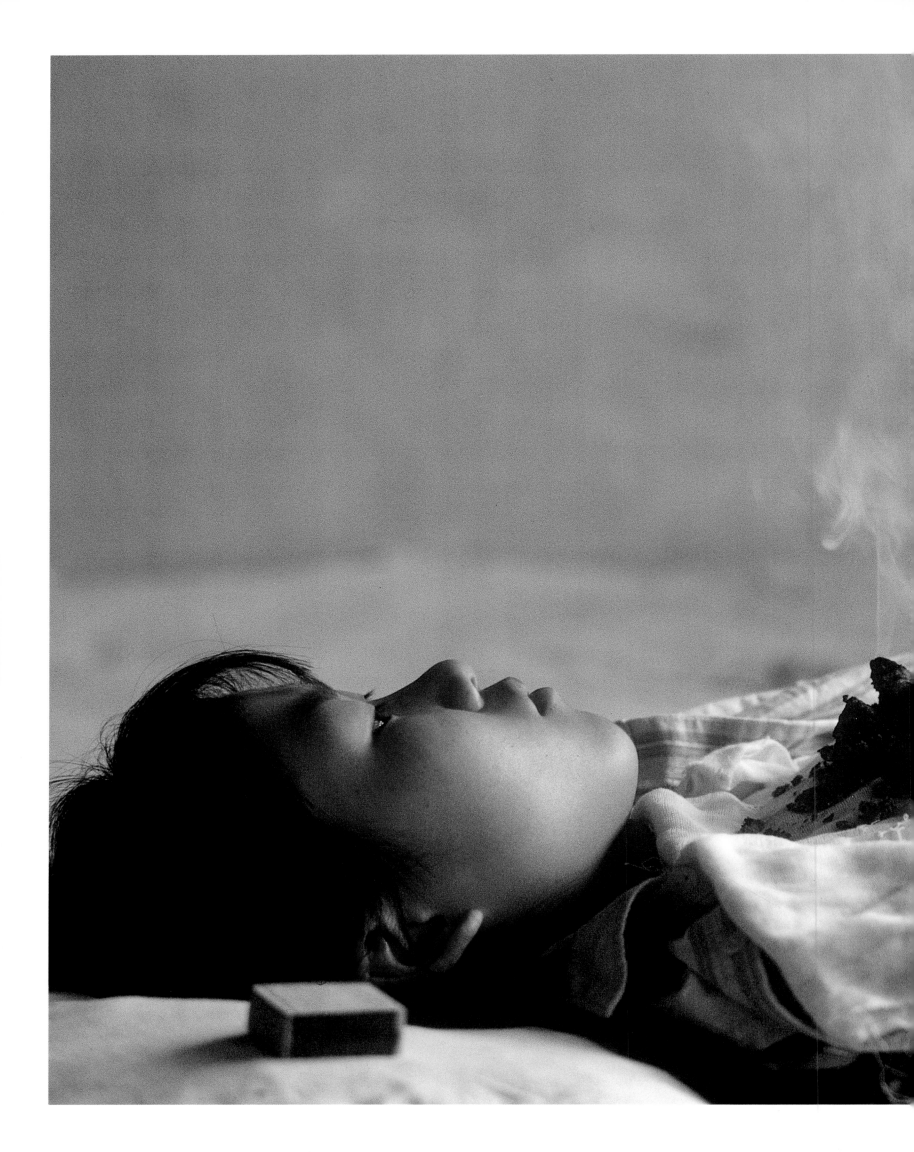

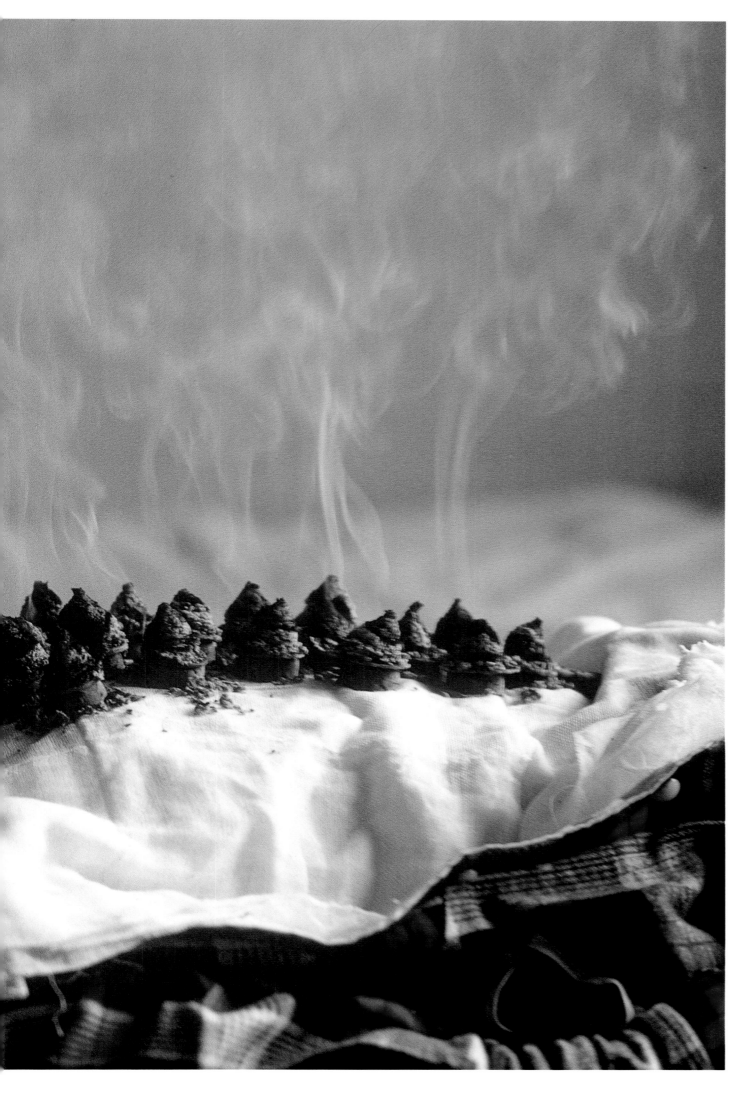

A girl receives moxibustion
treatment, an ancient
herbal remedy for asthma,
Shanghai, China.

© 1983

JEFFREY AARONSON

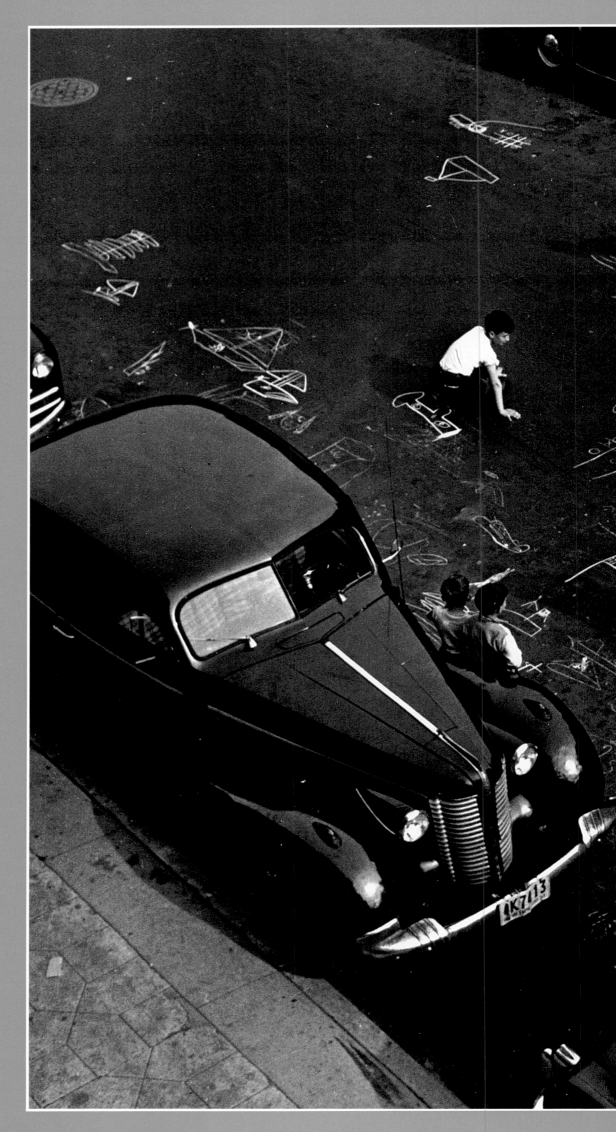

"New York Series"

"Chalk Games,"
from an essay on
children's games based on
a 16th-century painting
by Brueghel

©1950 ARTHUR LEIPZIG

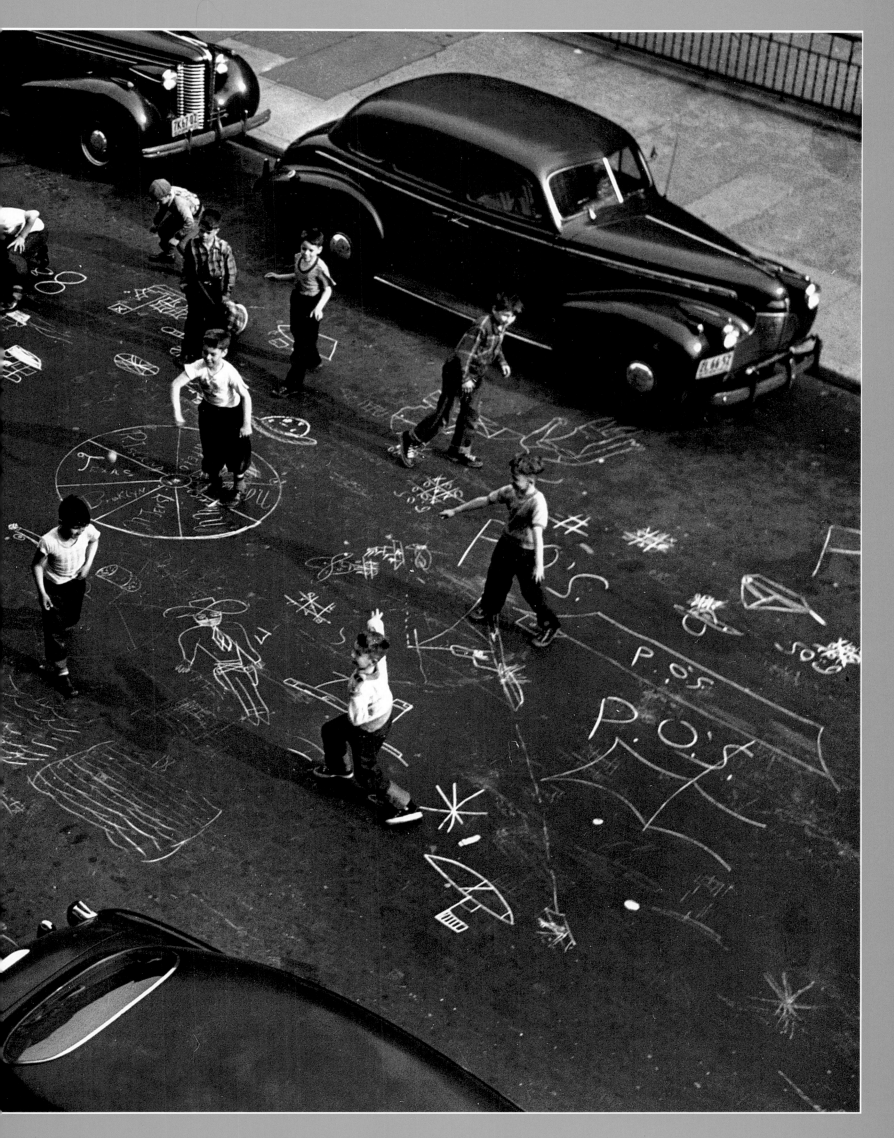

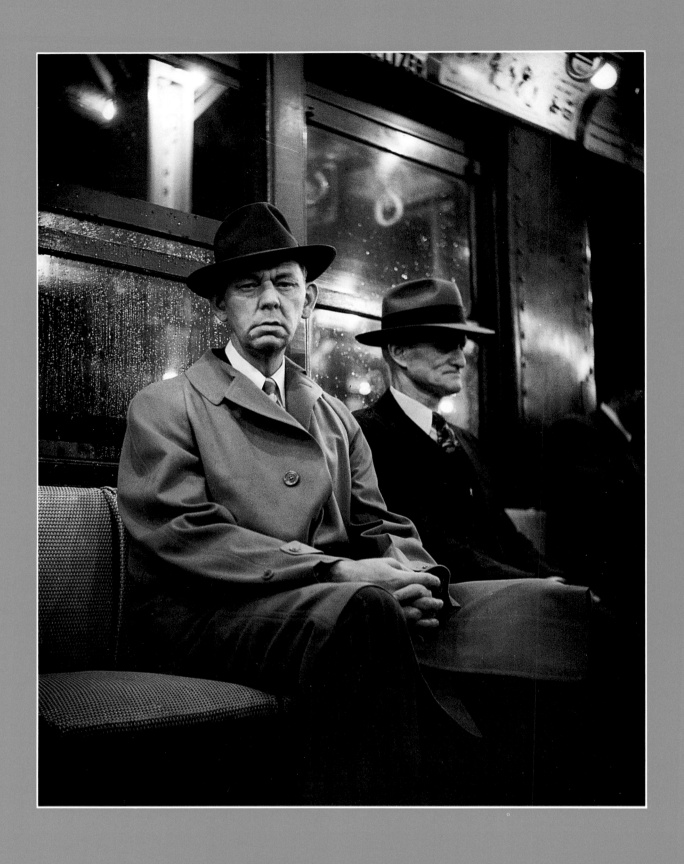

"New York Subways"
Working on an indepen-
dent photo essay, Leipzig
traveled the subways with
a dog-carrying case he
made to conceal his
camera. Pretending to
talk to his dog, he would
focus through a side door.

© 1949 **ARTHUR LEIPZIG**

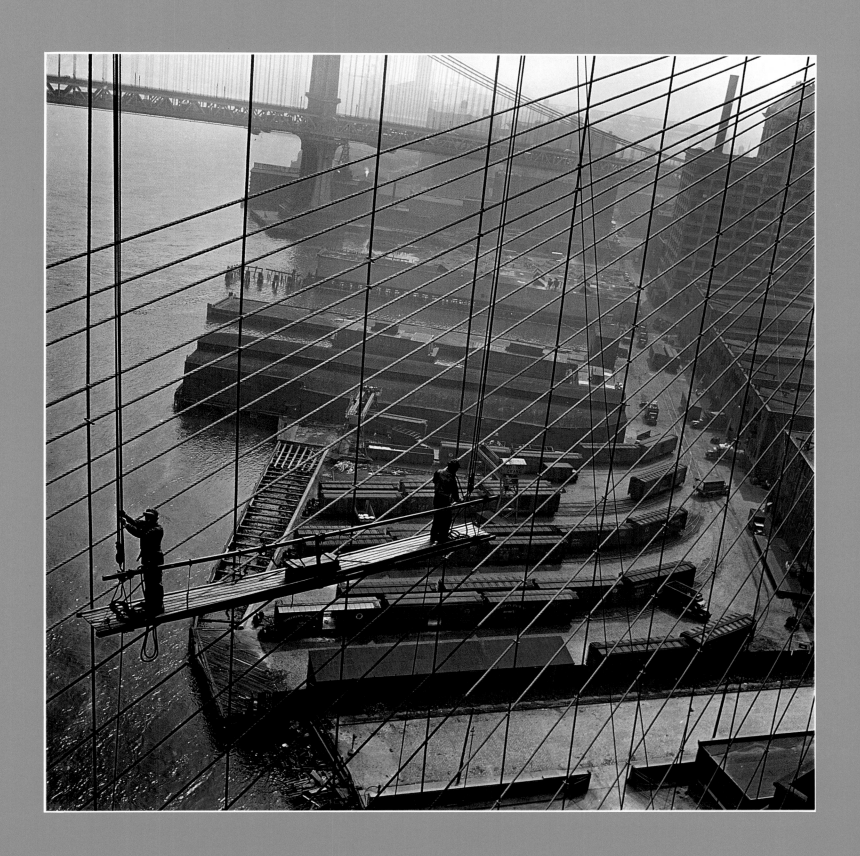

"Brooklyn Bridge"

ARTHUR LEIPZIG

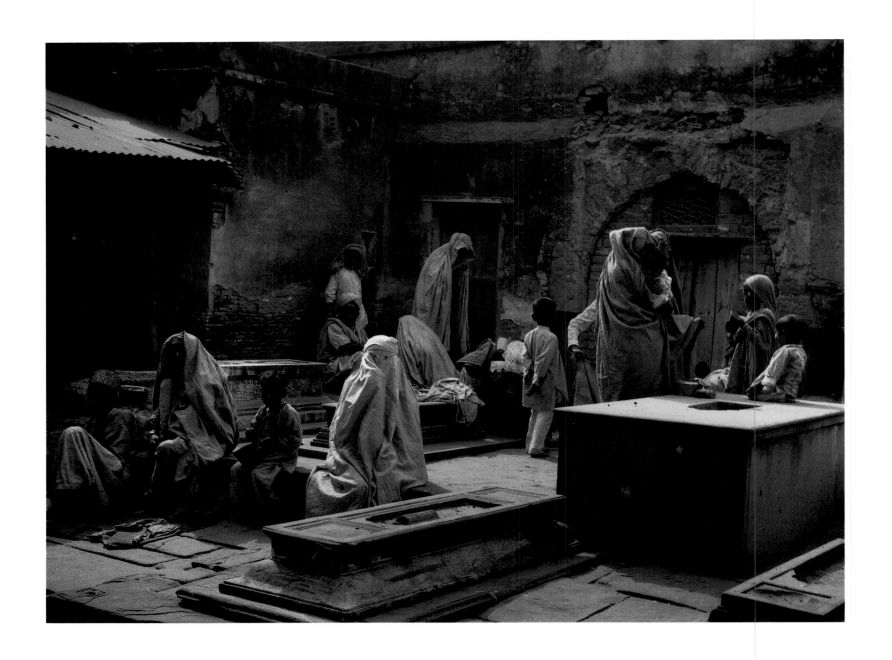

"Place of Sorrow, India"
was made while Witt was
stationed in that country
from 1943 to 1945. Inspired
by the great documentary
photographers of the Farm
Security Administration,
Witt undertook the first
major work on rural
poverty in India.

©1978 **BILL WITT**

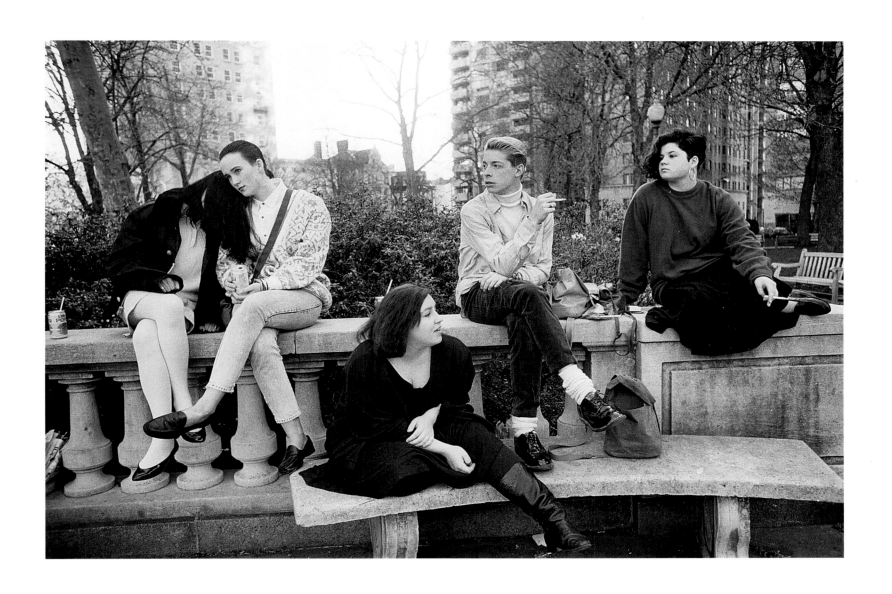

Teenagers,

Rittenhouse Square,

Philadelphia

©1989 **ADELE ARON GREENSPUN**

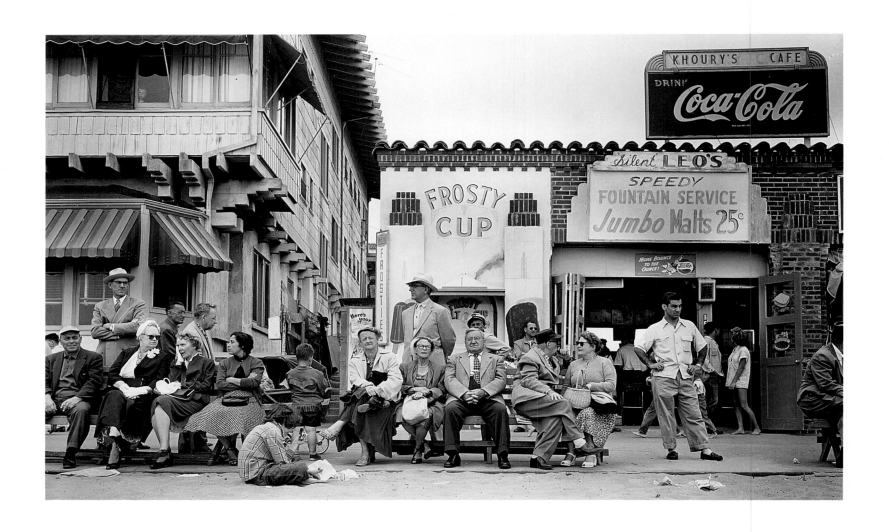

Spectators at the annual

Muscle Beach Physique

Contest, Santa Monica,

California

LARRY SILVER

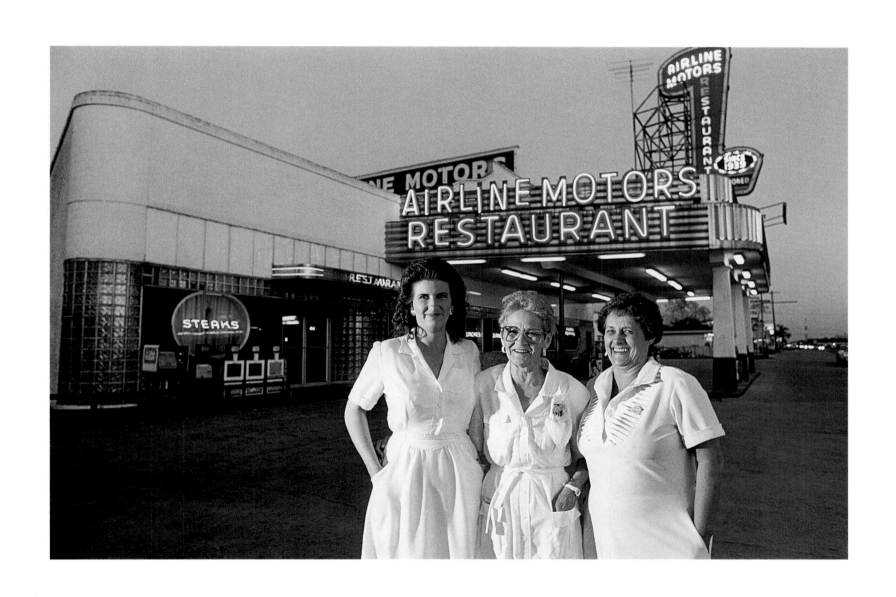

Waitresses, Airline Motors
Restaurant, a mainstay
for nearly 50 years on the
highway between Baton
Rouge and New Orleans,
Louisiana

© 1988 **BEVIL S. KNAPP**

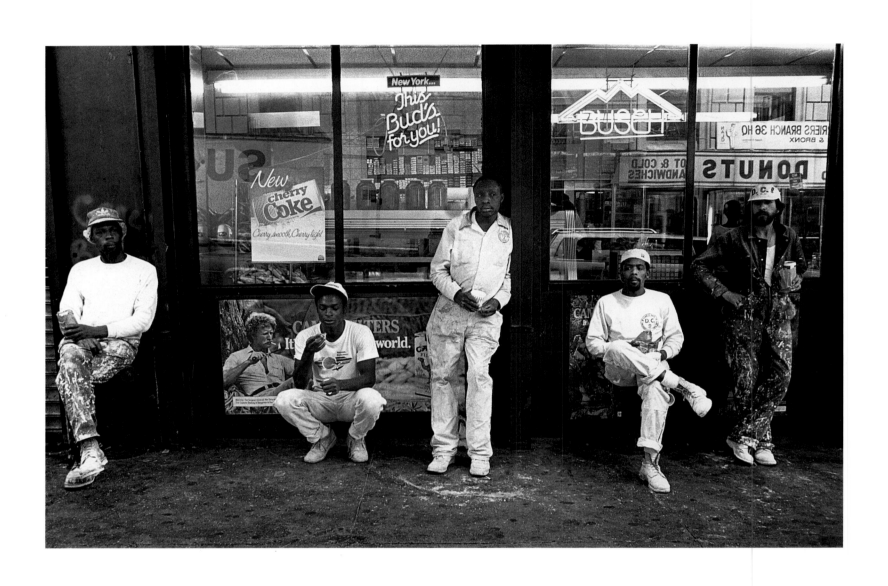

"Painters,

New York City, 1984"

LARA JO REGAN

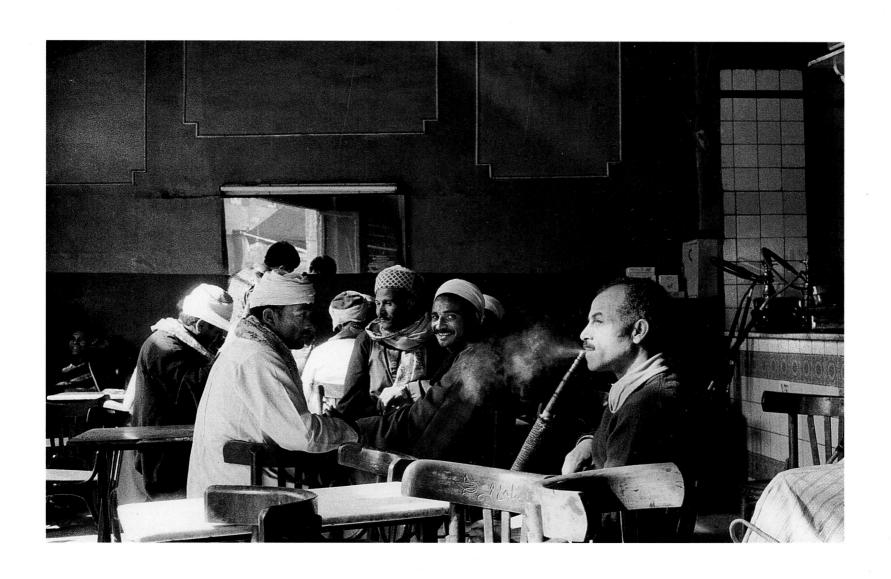

STEVEN BLOCH

Tea shop,
Cairo, Egypt

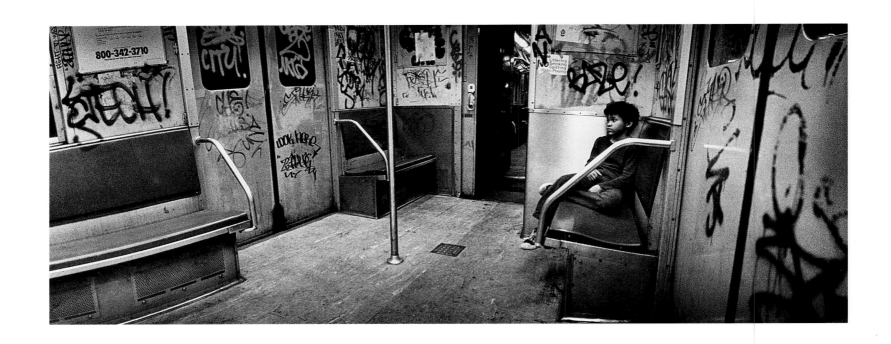

Ten-year-old boy,

New York subway, 2 a.m.

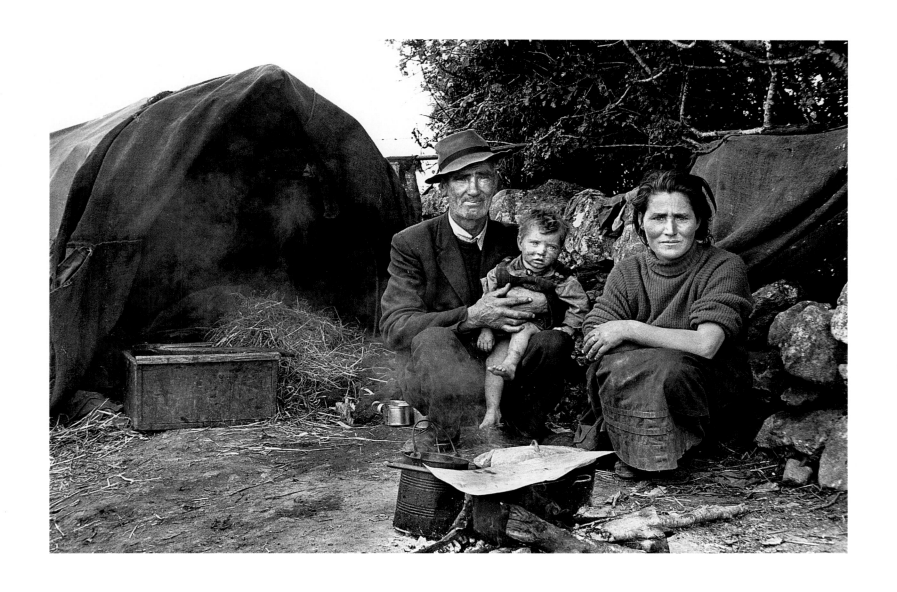

Family of tinkers,
County Clare, Ireland,
1969

MATHIAS OPPERSDORFF

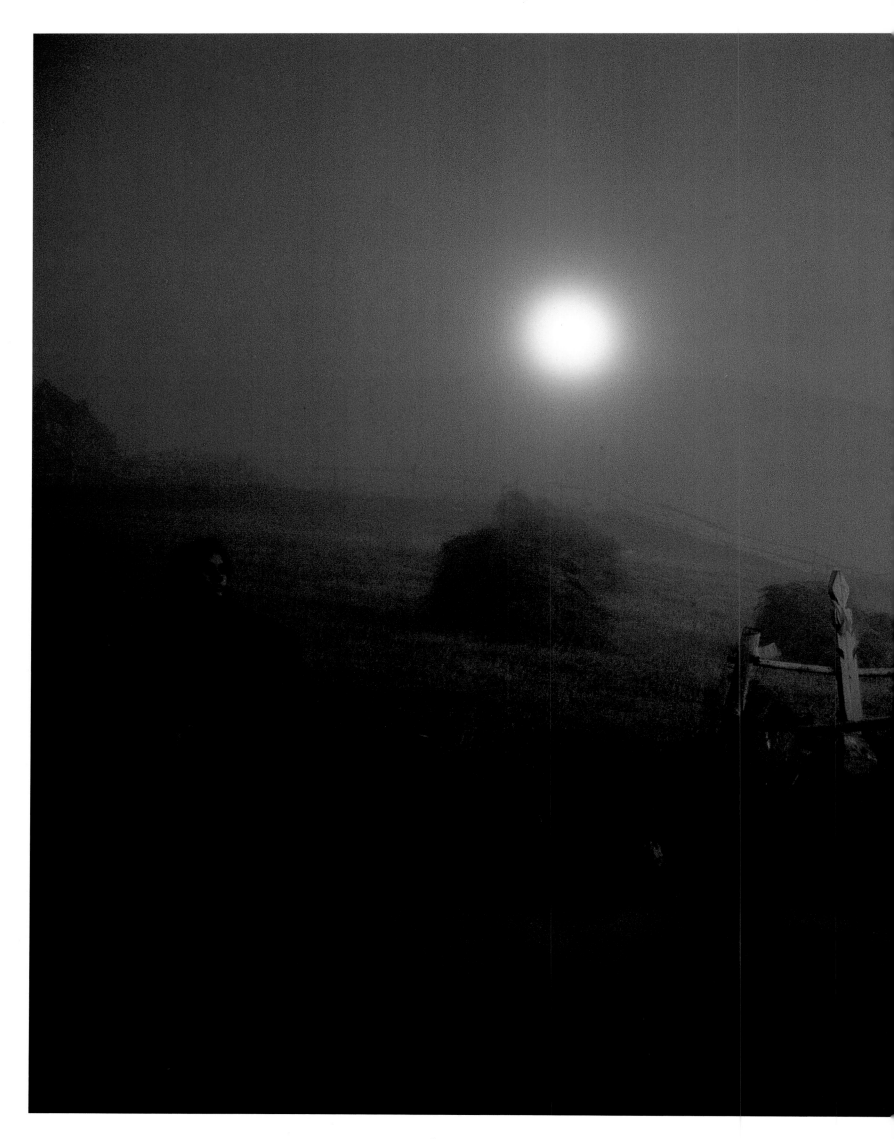

Graveyard, border
between Turkey and Iran

. .

© 1971

Larry Barns

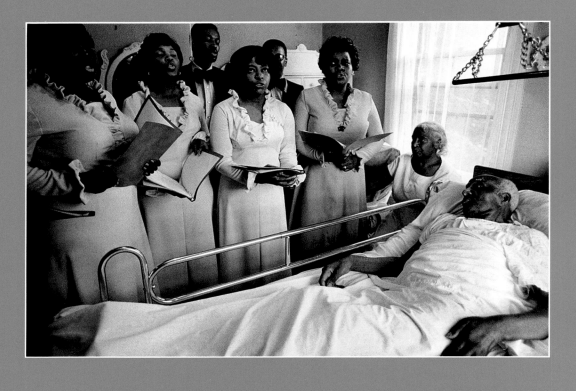

*From a series on the
New Haven (Connecticut)
Home Care program
and hospice:*

*Waddy Williams, 79,
with wife, Alice, is visited
by the choir from a
neighboring church
shortly before his death.*

*Three-year-old Krissa
kisses grandfather Frank
German goodnight.*

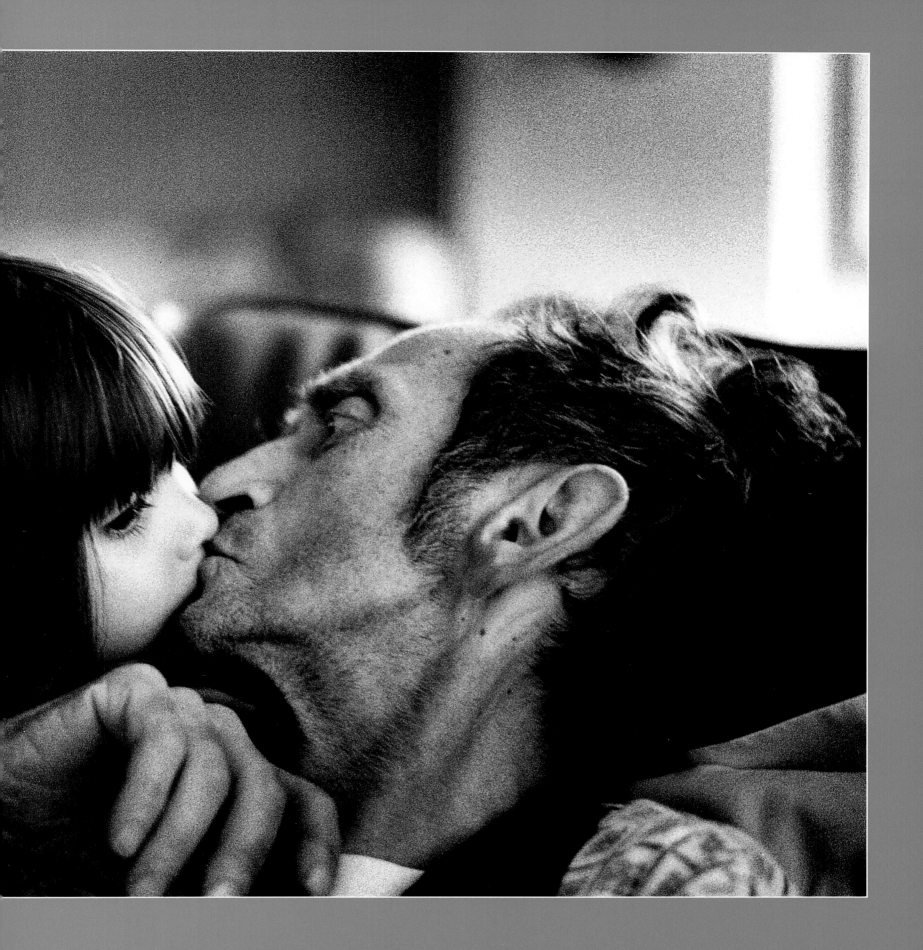

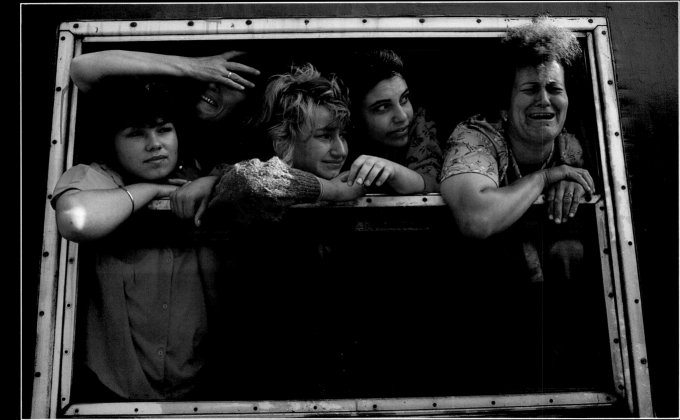

"*I* have no photographic

specialties, but would like

—*Philippe Halsman*

to make pictures destined

to last more than a week."

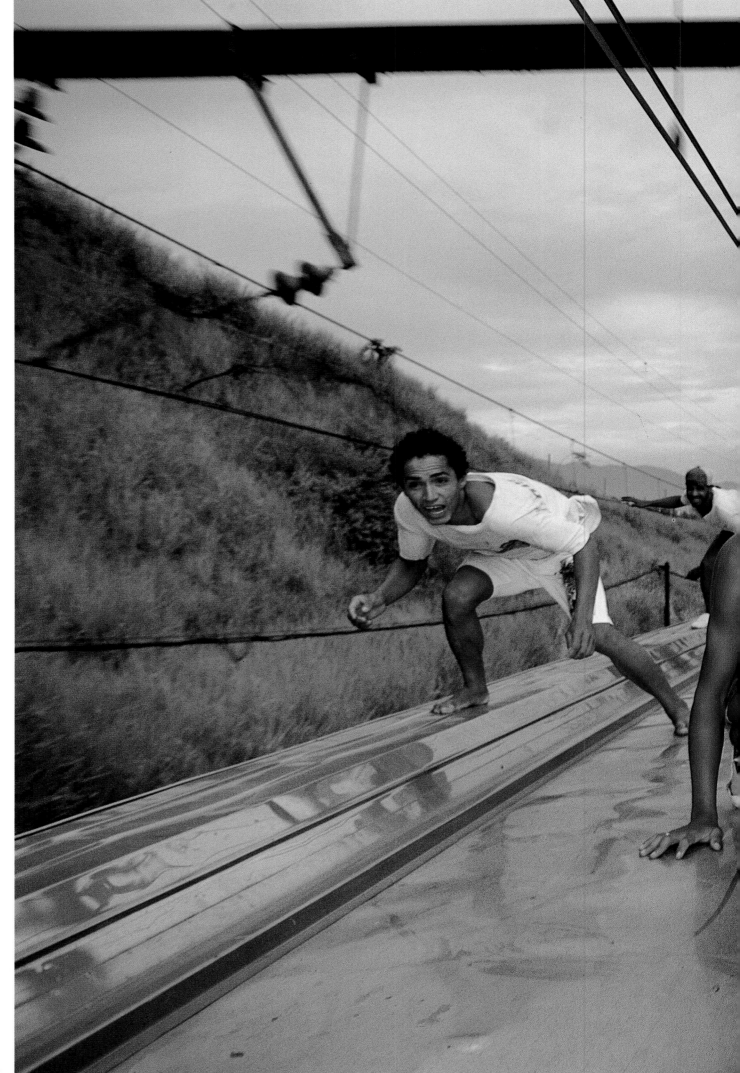

"Train Surfing,
Rio de Janeiro, Brazil"
Nicknamed "McDonald"
for his past employer, a
thrill-seeking youth from
the Baixada Fluminense
slums rides atop the
electrified trains of Rio.
Low-hanging high-
tension wires charged with
3,300 volts of electricity
account for hundreds of
deaths and injuries per
year for the "Surfistas."
Fairbanks made this
image while train surfing
backward at 60 mph.

©1989 MIGUEL LUIS FAIRBANKS

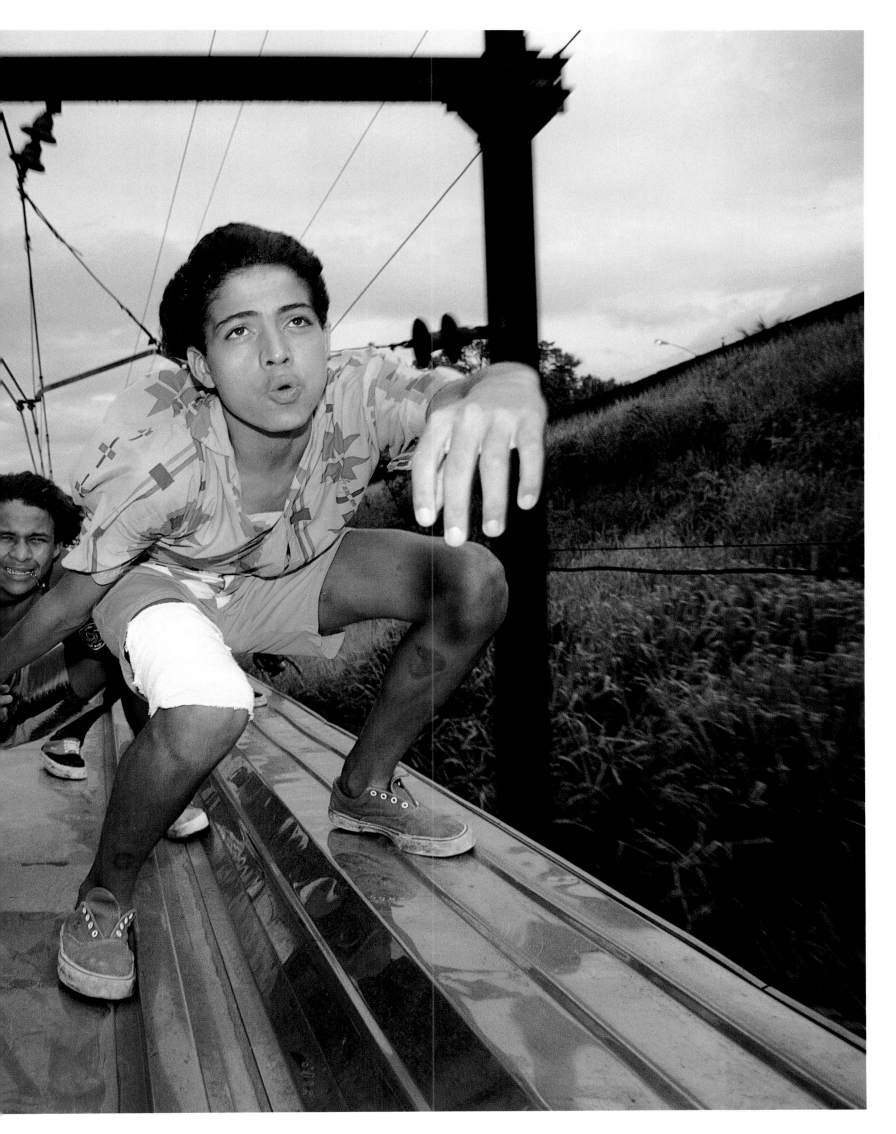

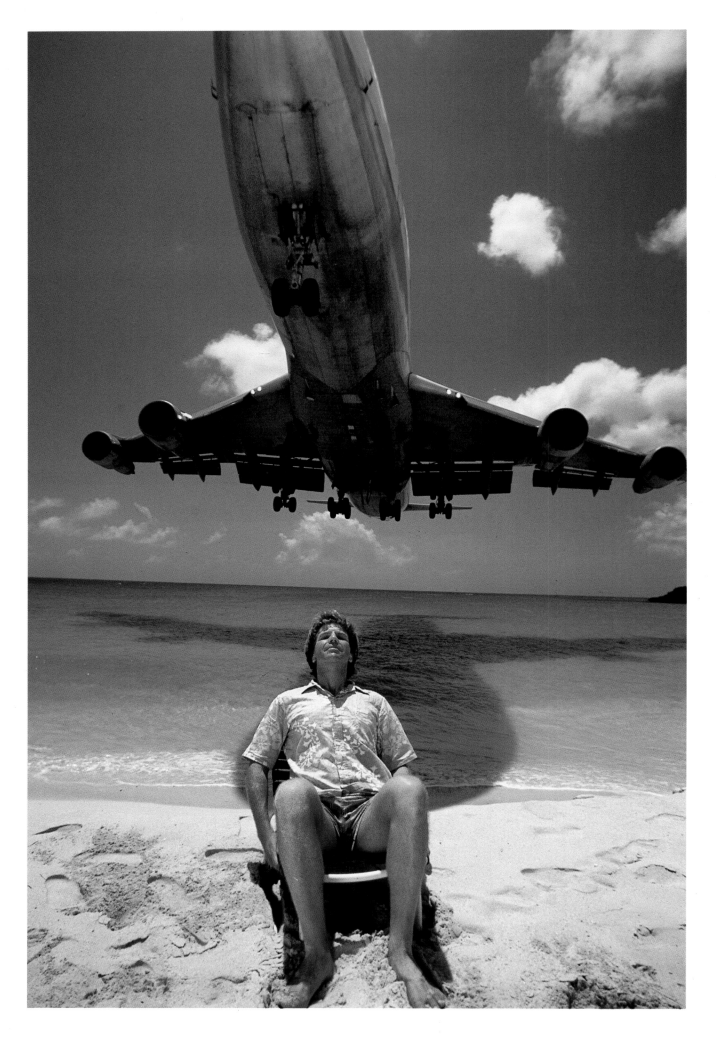

During a trip around the world by air, Wexler made a series of self-portraits. The 747 was only 30 feet above his head (he had on earplugs) as it prepared to land in St. Maartens, the Netherlands Antilles.

MARK S. WEXLER

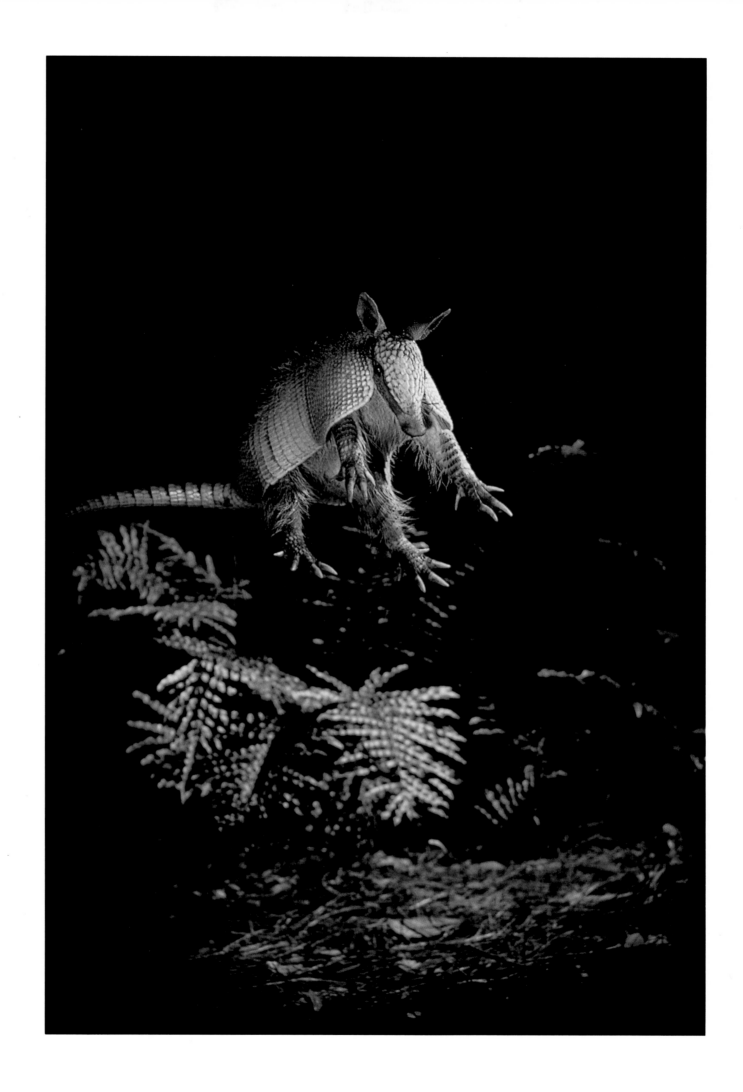

"It's an Armadillo!"

........................

BIANCA LAVIES

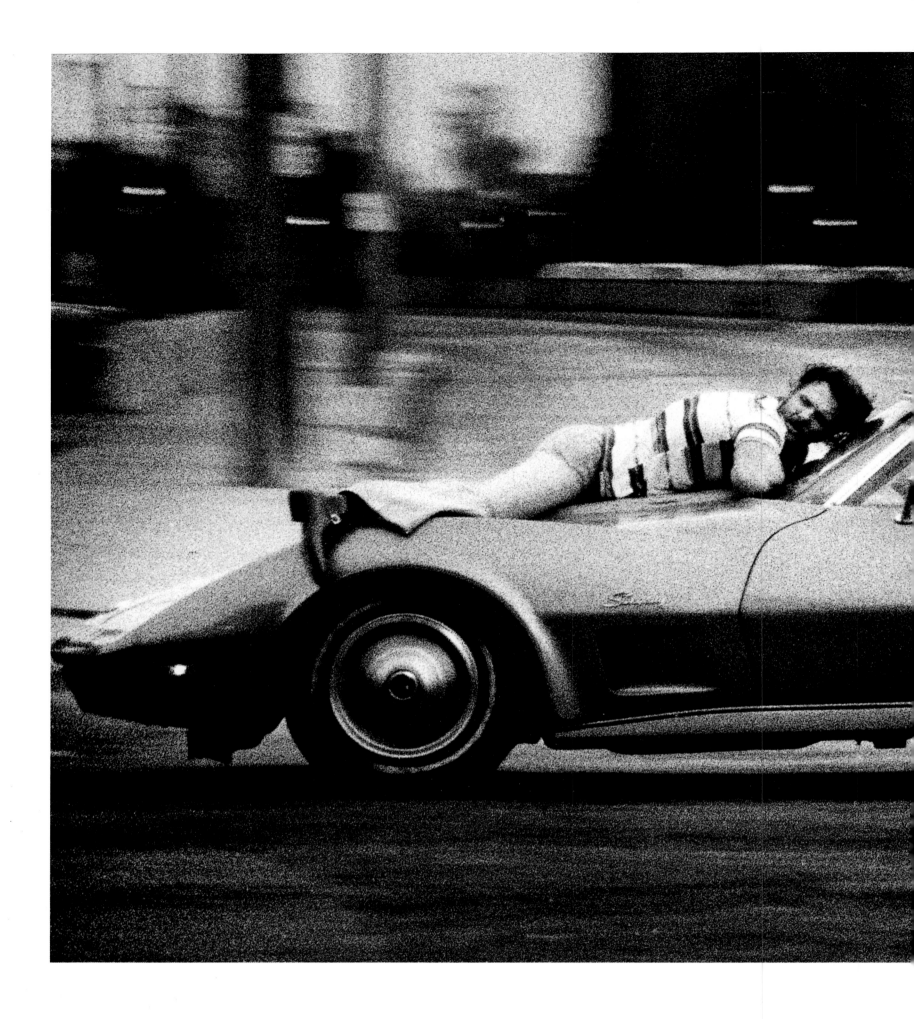

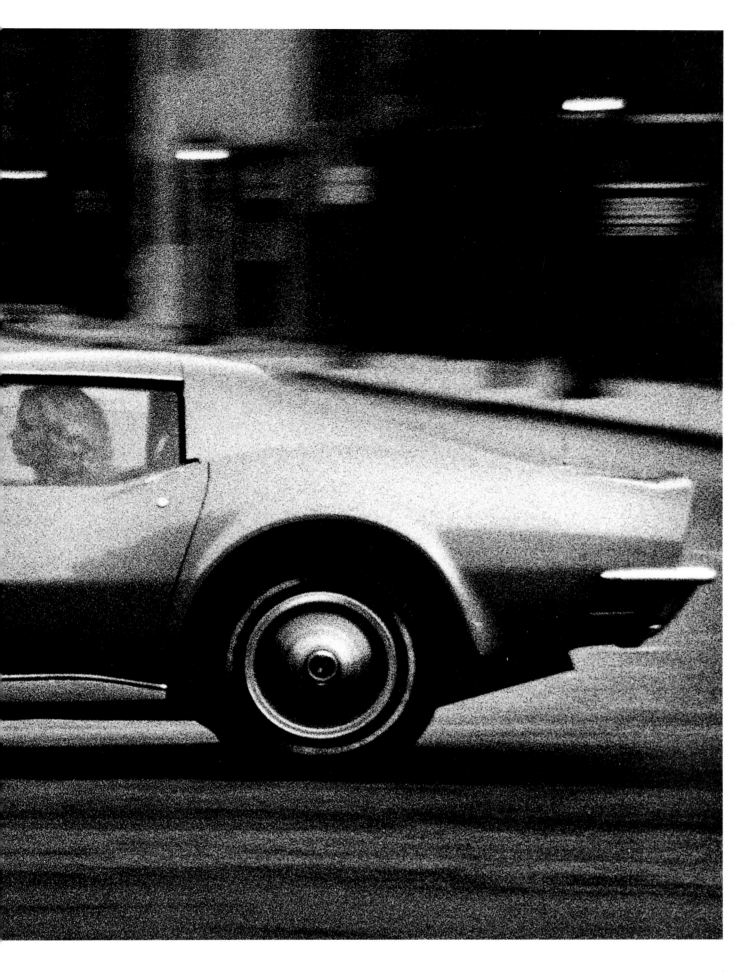

"The Honeymoon's Over" A newlywed clings to the Corvette driven by his no-less-obstinate wife during a marital spat that culminated in their arrest for disorderly conduct in Mobile, Alabama.

© 1976 **DEAN DIXON**

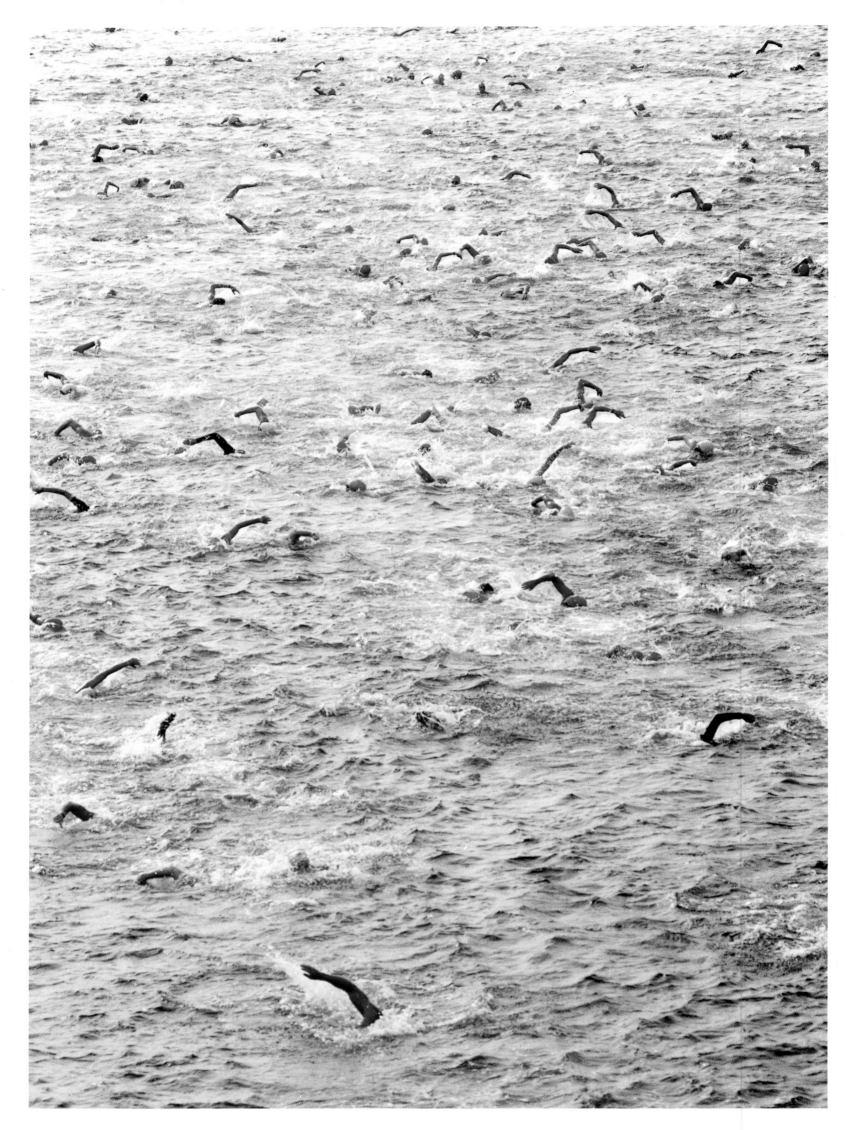

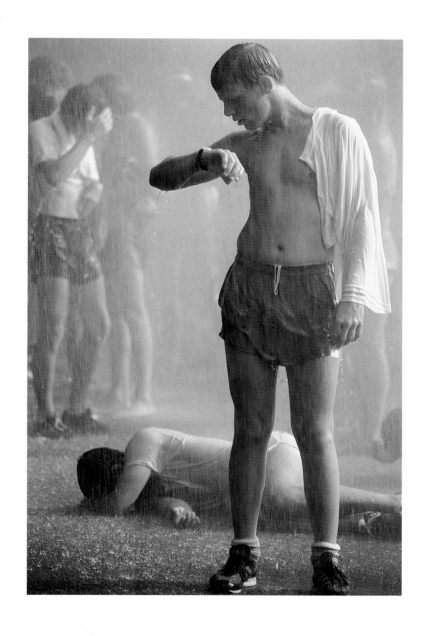

Participants in the
annual open-ocean swim
between Hermosa Beach
and Manhattan Beach,
California

Atlanta Road Race finish
line, Piedmont Park
Cooling down with help
from the fire department,
a runner checks his time.

©1989 **JOHN POST**

©1978 **FLIP CHALFANT**

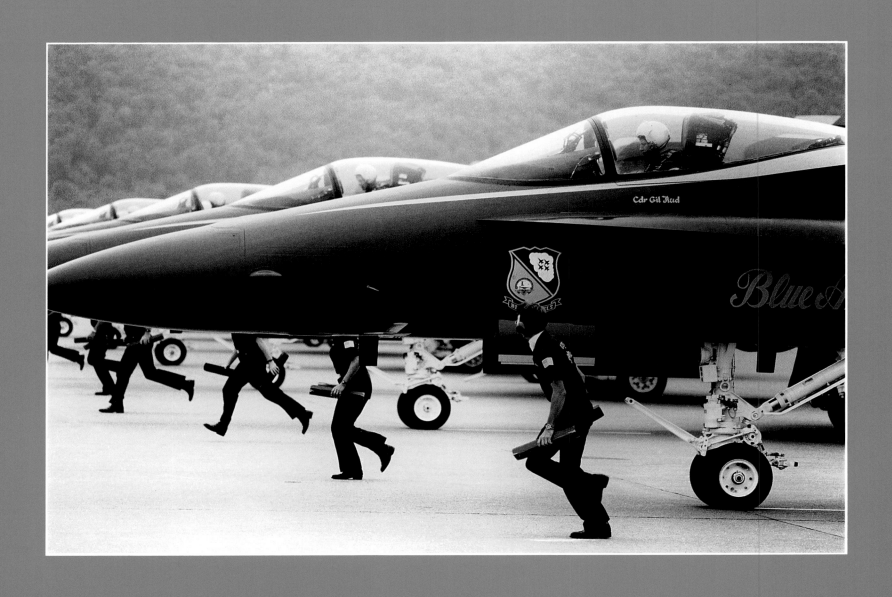

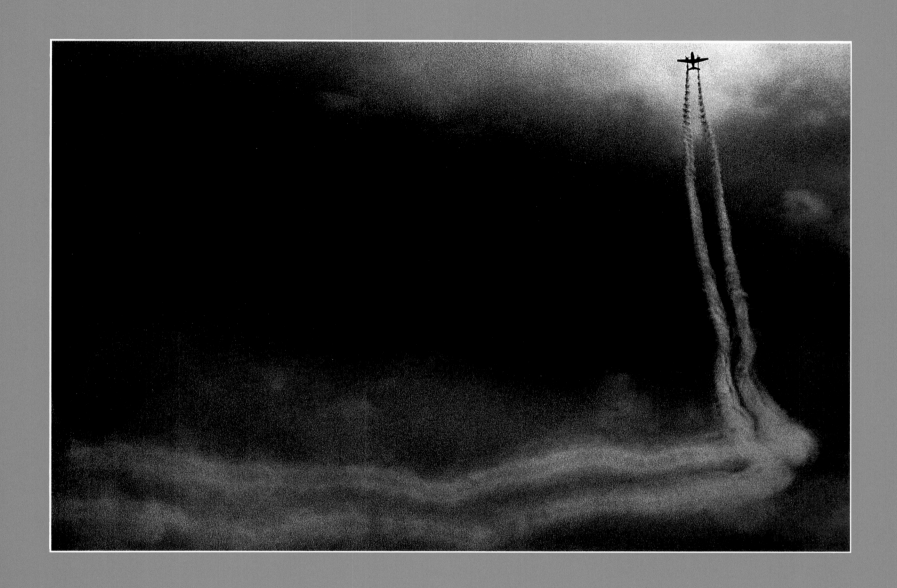

Left: "Blue Angels"
U.S. Navy Flight
Demonstration
Squadron, Harrisburg
Airshow, Harrisburg,
Pennsylvania

Above: "Flight of Fancy"
Sussex Airshow, Sussex,
New Jersey

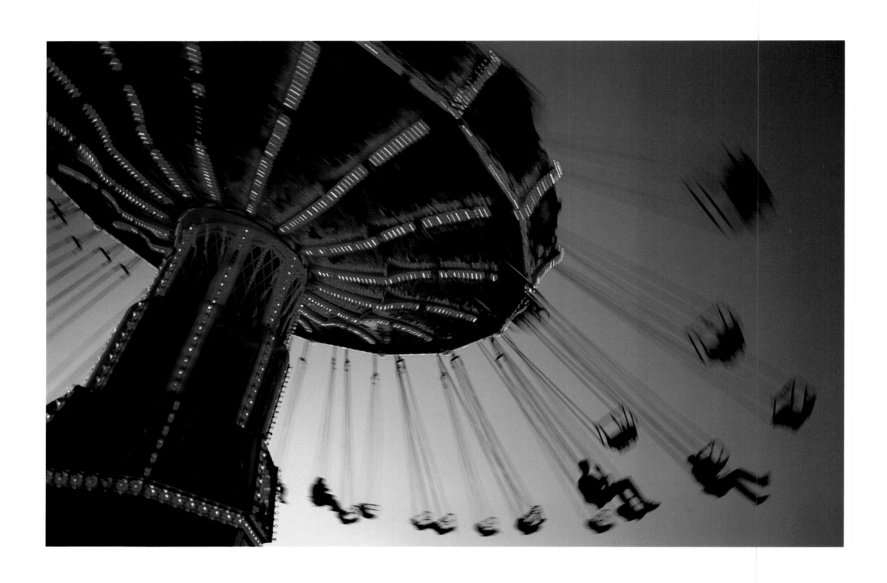

County fair ride,
Fresno, California

THOM DUNCAN

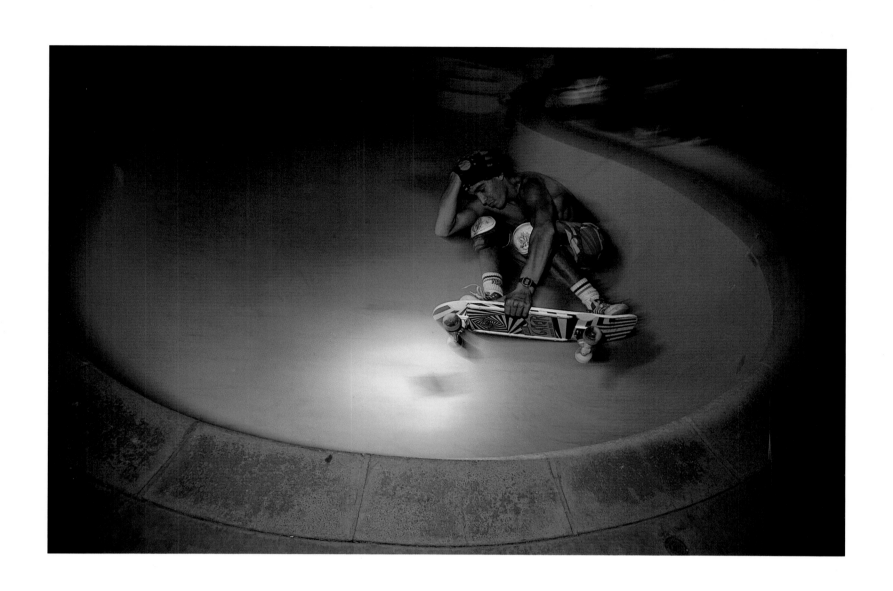

Pro skateboarder Mark "Gator" Rogowski executes a "frontside air" maneuver in a backyard swimming pool, Phoenix.

©1984 **DAVID OMER**

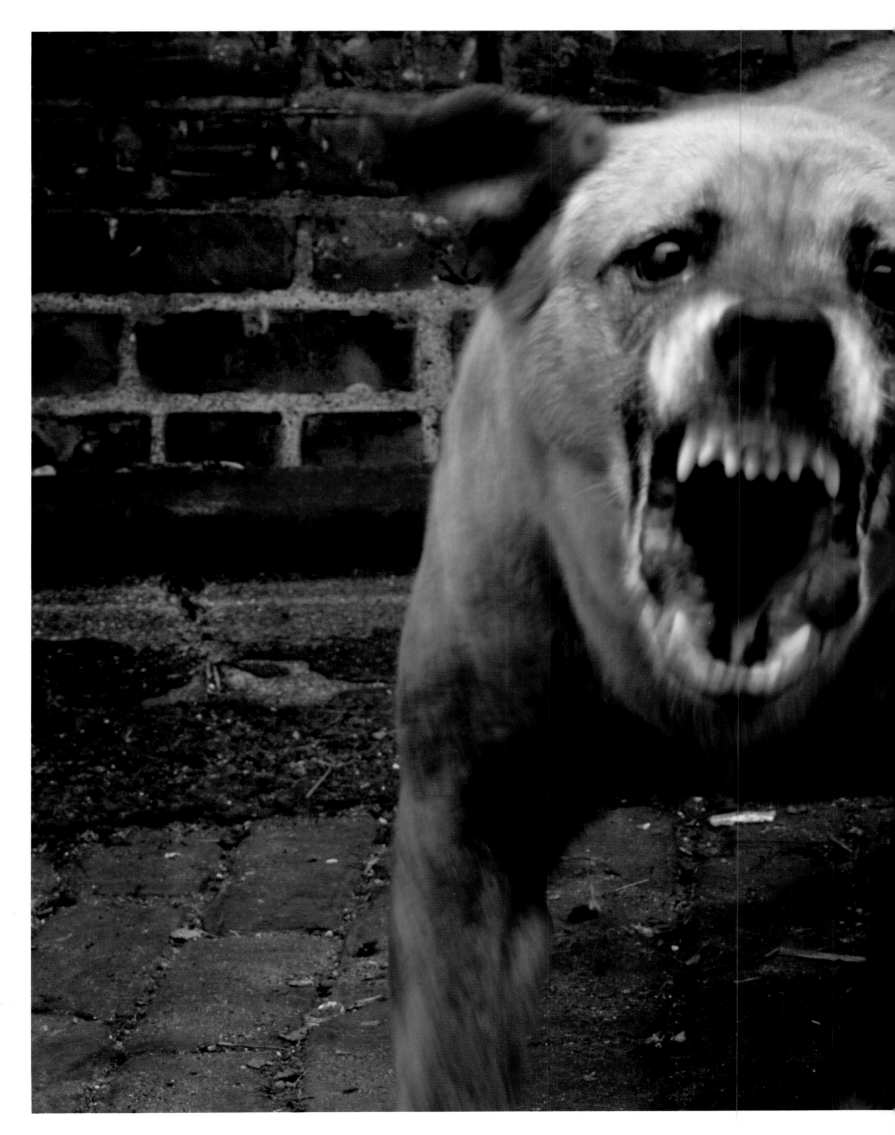

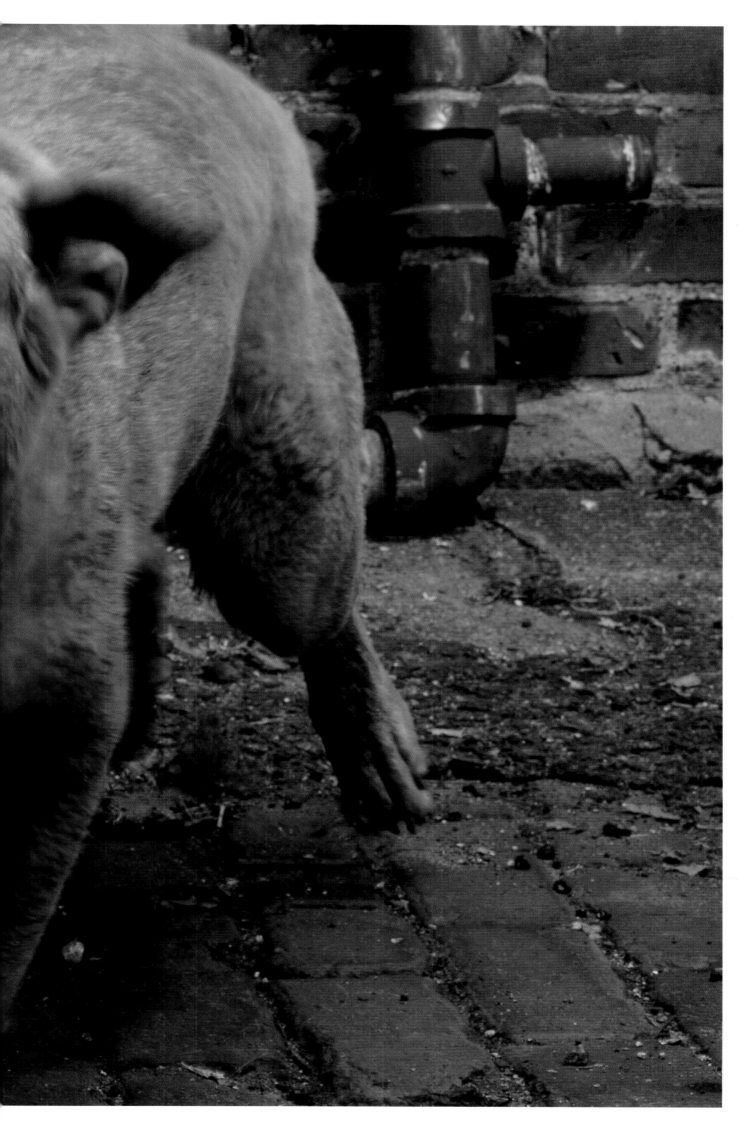

After 80 attacks by
Daisie, a family pet
controlled by her owner,
Umland got this shot for
a national campaign for
running shoes. His 4x5
camera was positioned
through a hole drilled in
a large sheet of Plexiglas.

© 1987

STEVE UMLAND

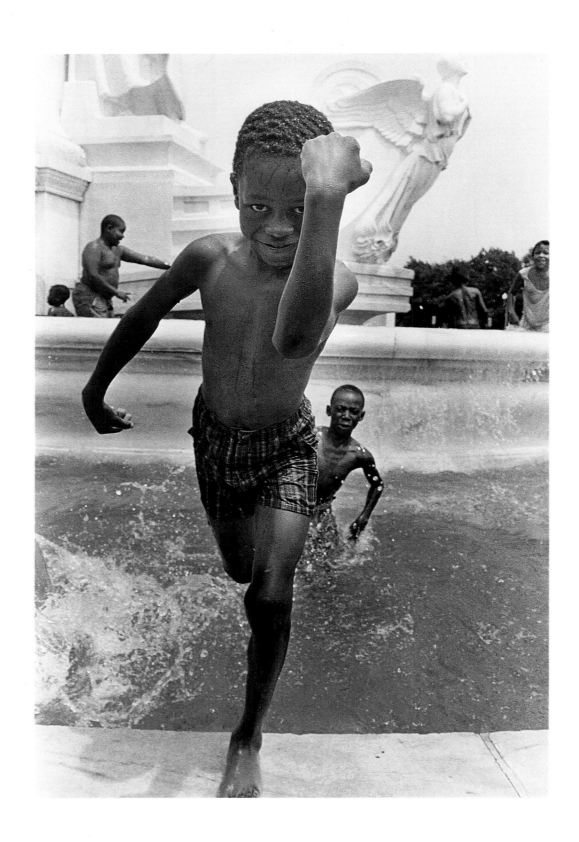

Children playing in a
fountain, Union Station,
Washington, D.C.

© 1969 **ALAN J. GOLDSTEIN**

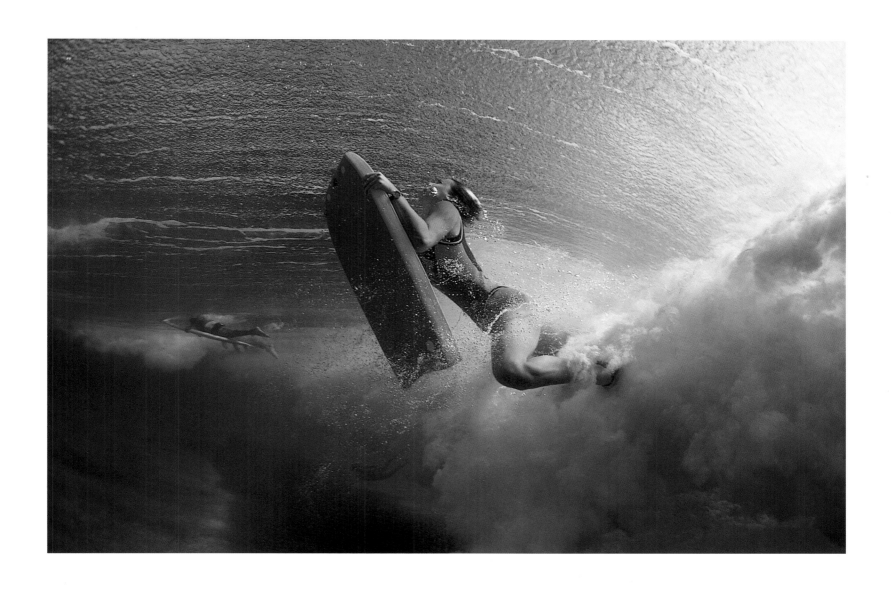

France Hazar, one of Brazil's top women bodyboard riders, in the surf on the north shore of Oahu, Hawaii

AARON CHANG

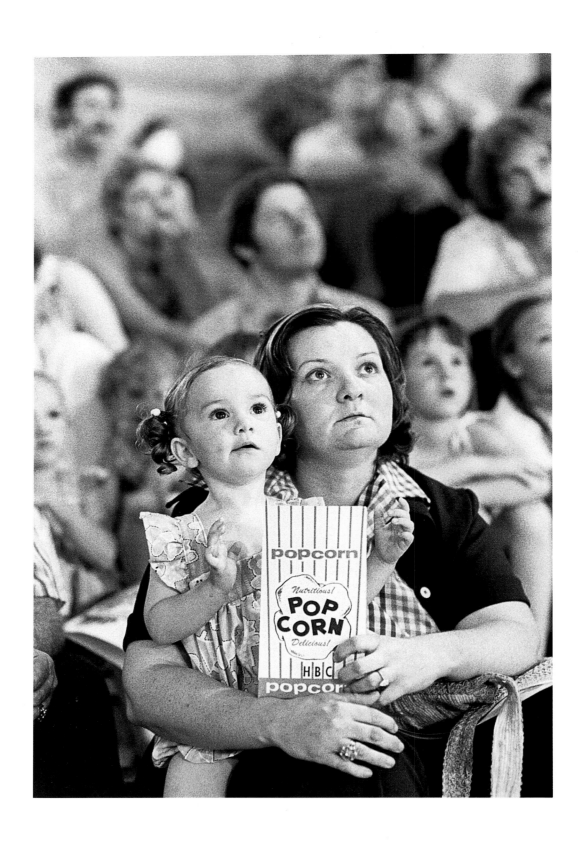

Mother and daughter at

the circus, Marion, Ohio

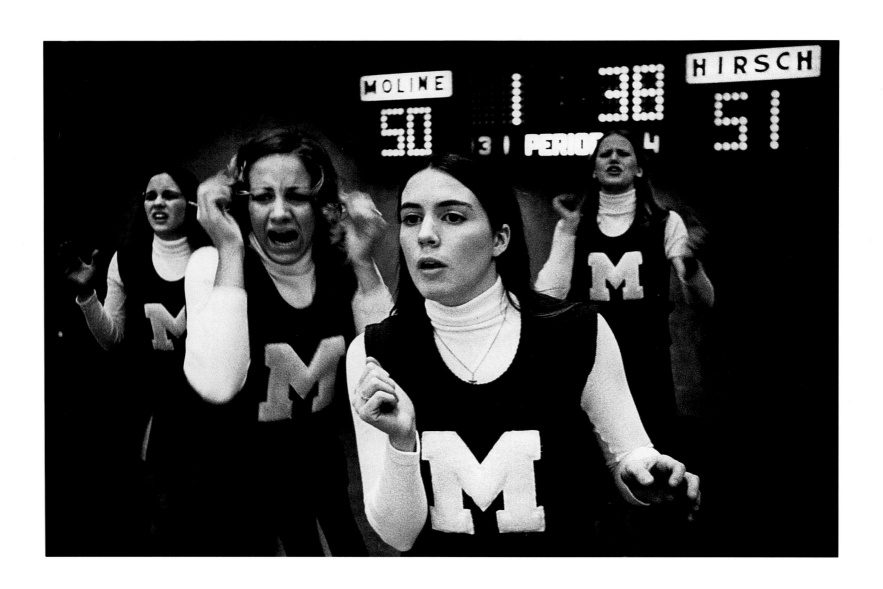

*High school cheerleaders
watch as their team's
fortunes change, Moline,
Illinois, 1973.*

©1973 **JOHN C. HILLERY**

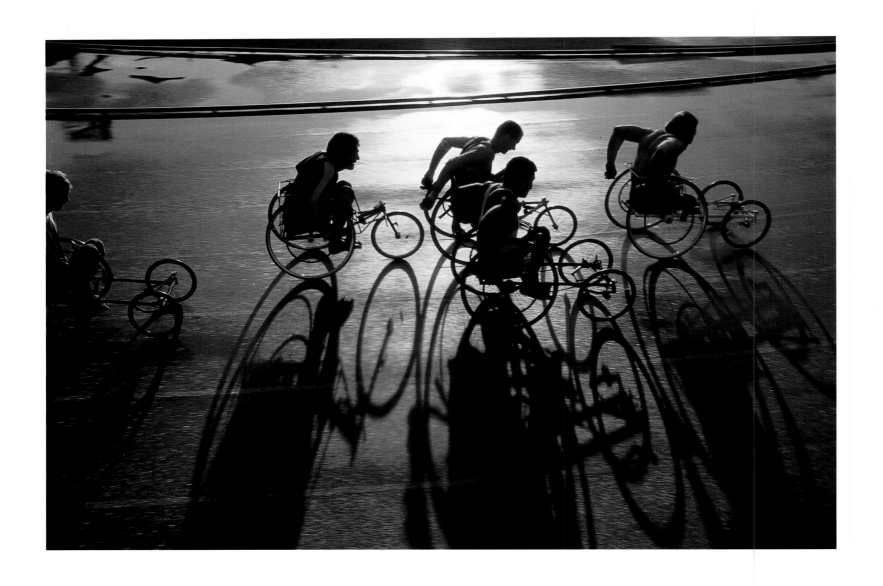

Athletic shoe ad

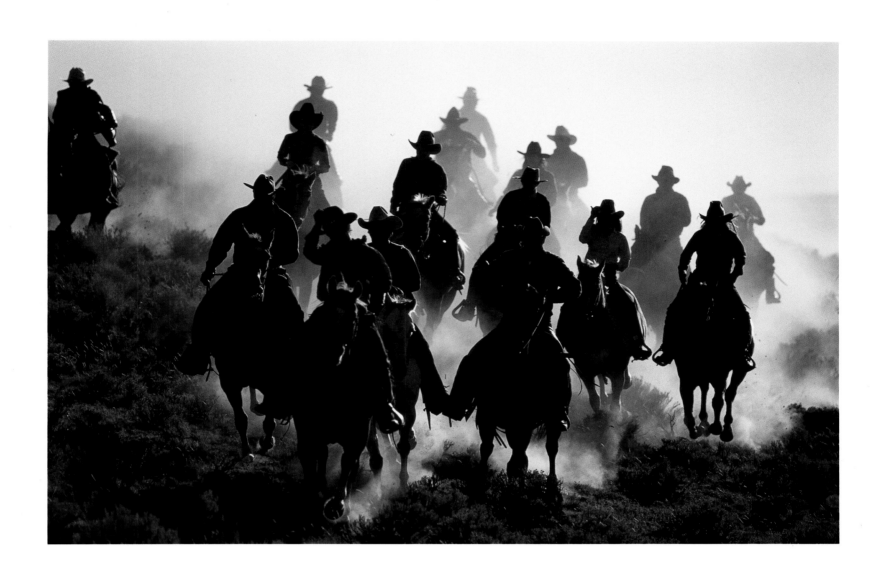

*Wranglers from the
Ellensburg Rodeo
Mounted Posse,
Ellensburg, Washington*

© 1989 **JULES FRAZIER**

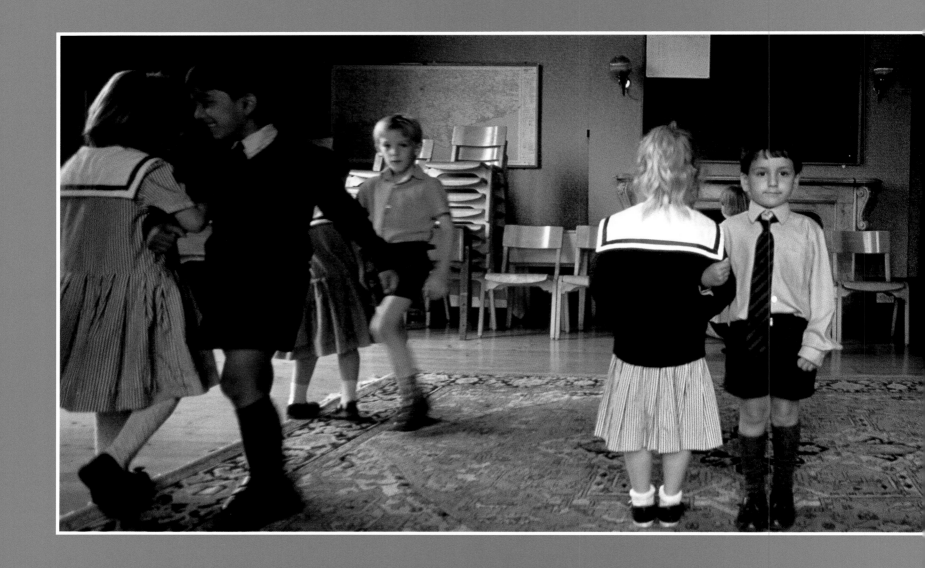

Part of a series of panoramic photographs taken for the Buckswood Grange School, Uckfield, England

© 1990 **LEN RUBENSTEIN**

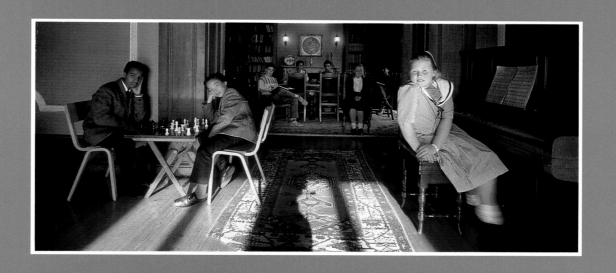

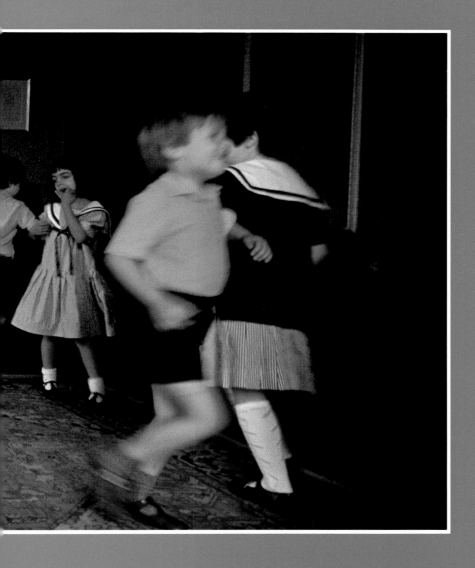

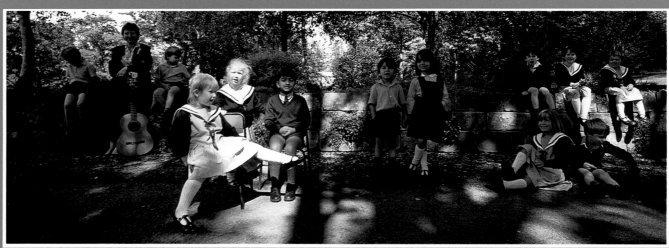

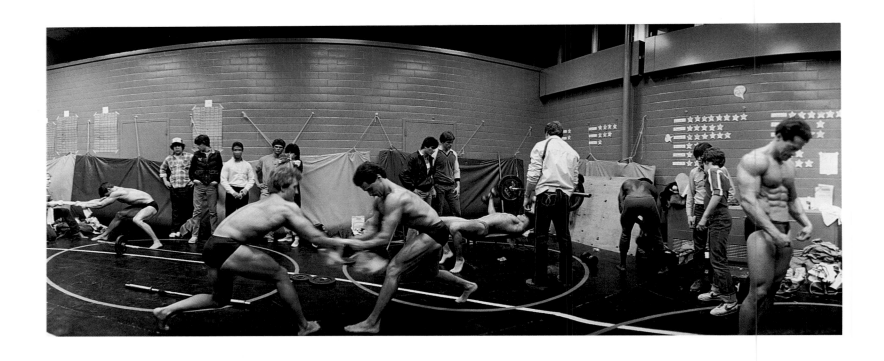

Warmup session,

"Mr. Delaware" body

building competition

DEBORAH PANNELL INGRAHAM

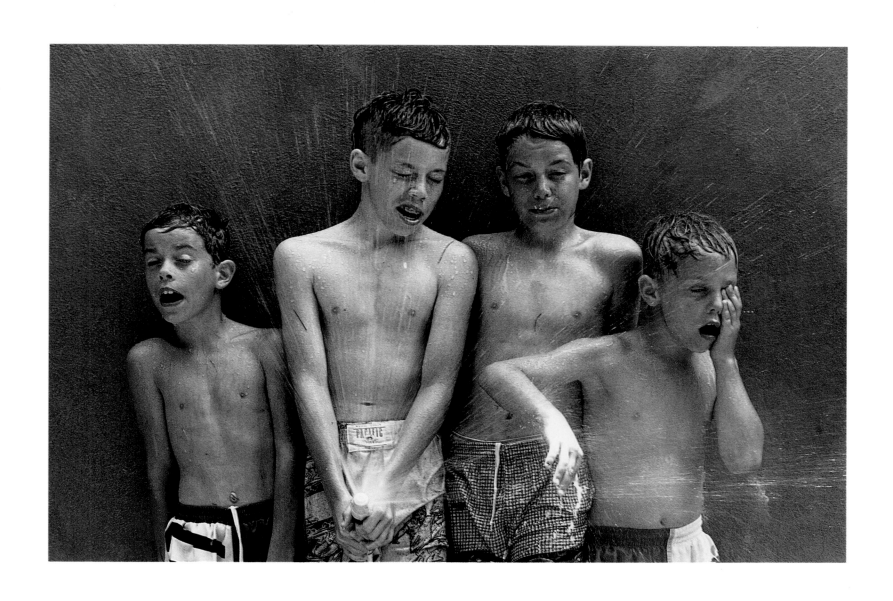

Brothers Kevin, Brian,

Scott, and Keith Fotch,

Belmont Hills,

Pennsylvania

©1990 TONY WOOD

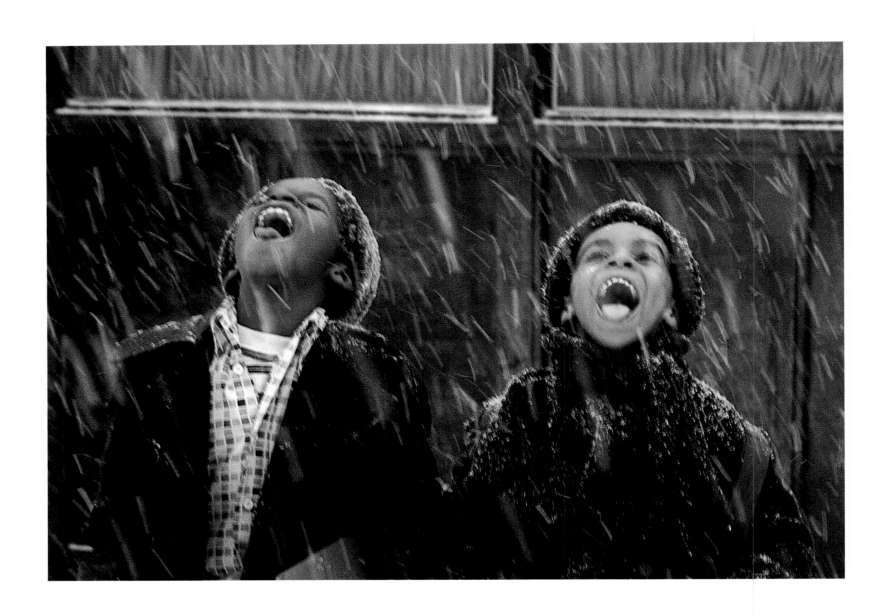

"School's Out!"

New York City

MARION BERNSTEIN

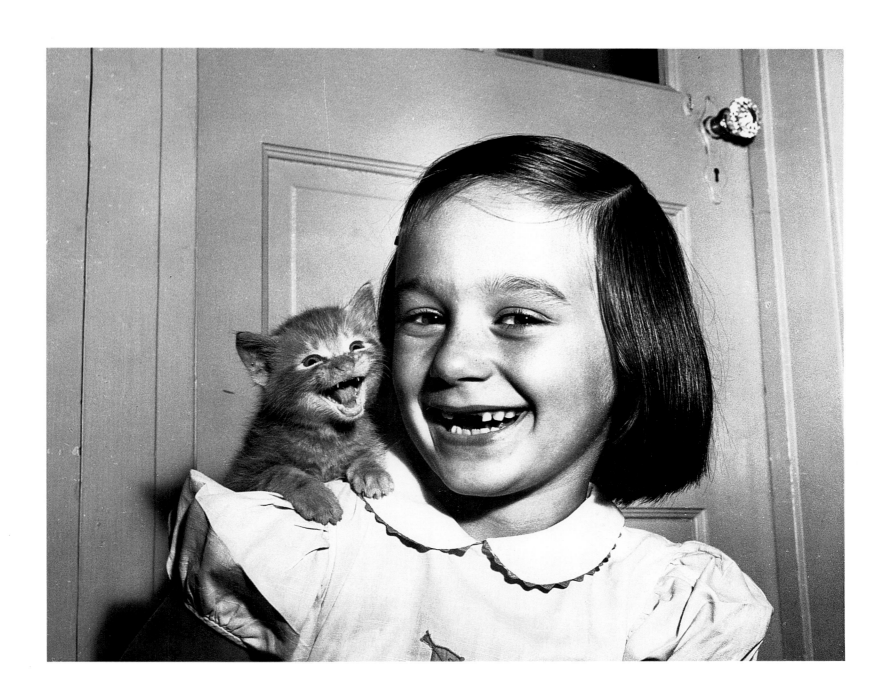

"Toothless Smiles"
resulted when Chandoha's
daughter, Paula, giggled
during a serious photo
session and started the
kitten meowing.

© 1963 **WALTER CHANDOHA**

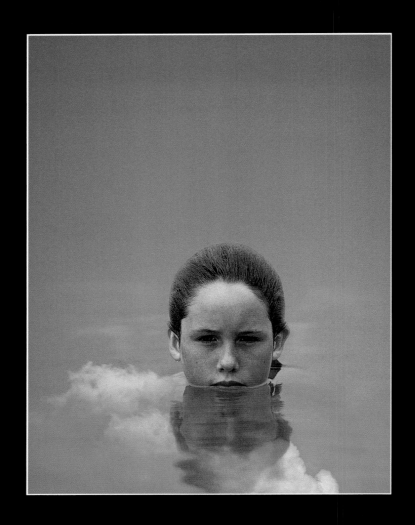

This child in the clouds is
Stephen Graham's young
son, photographed in Lake
Michigan in 1976.
Graham combined the
image with one of clouds
he took later that summer.

"One has to tiptoe lightly and steal up on

one's quarry; you don't swish the

—*Henri Cartier-Bresson*

water when you're fishing."

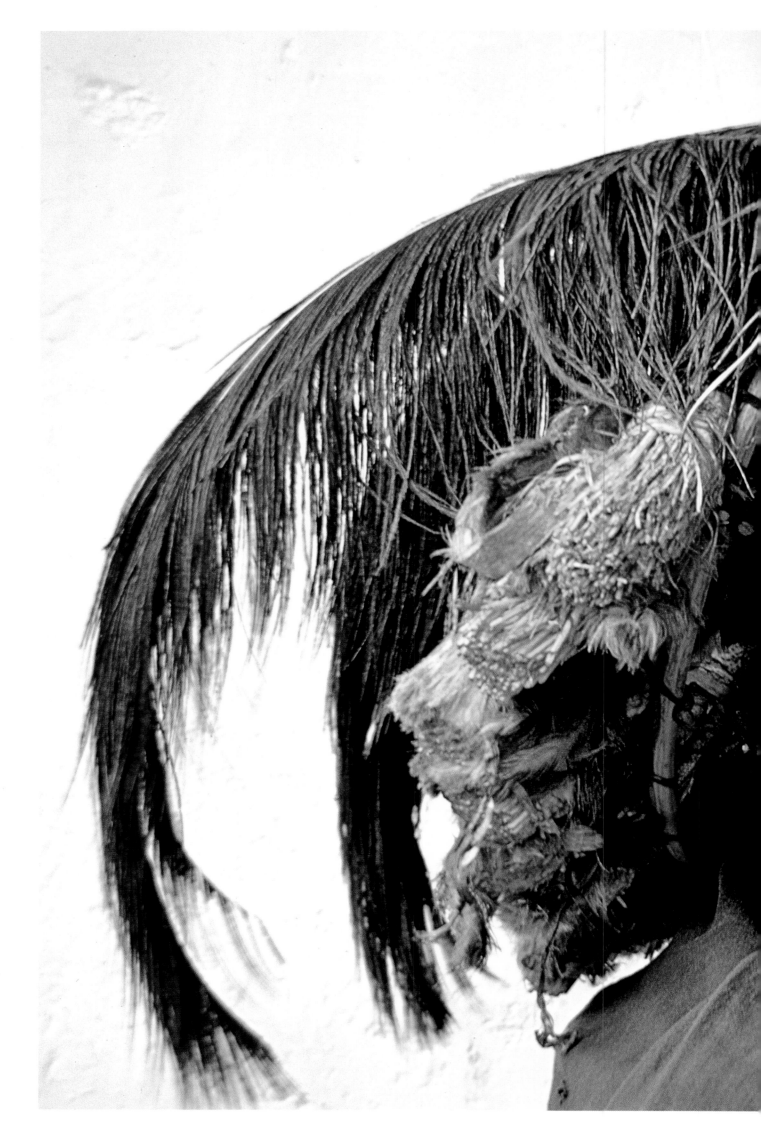

"Electric Earring"
Making portraits in the
small town of Namanga,
Kenya, in 1970, Turner
discovered this Masai
wearing a traditional
headdress and an earring
of copper transmission
wire stripped of
insulation.

©1970 **PETE TURNER**

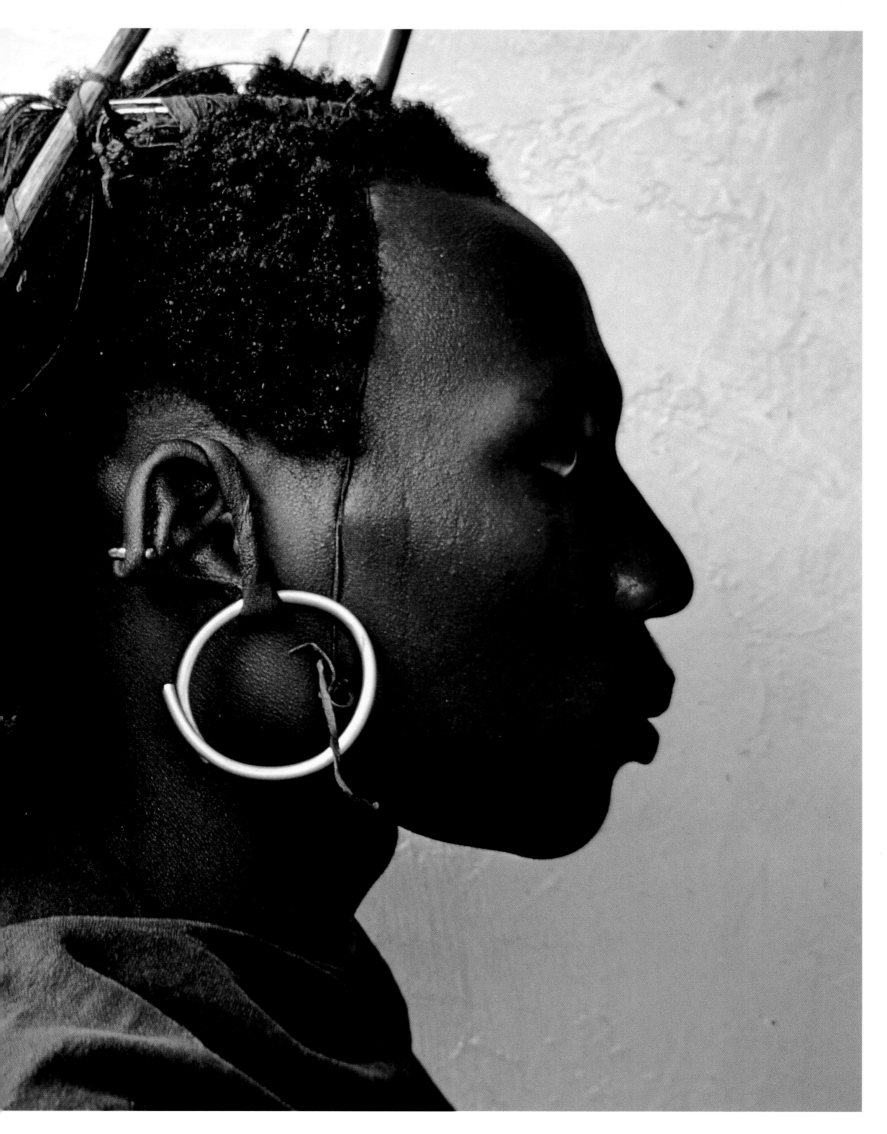

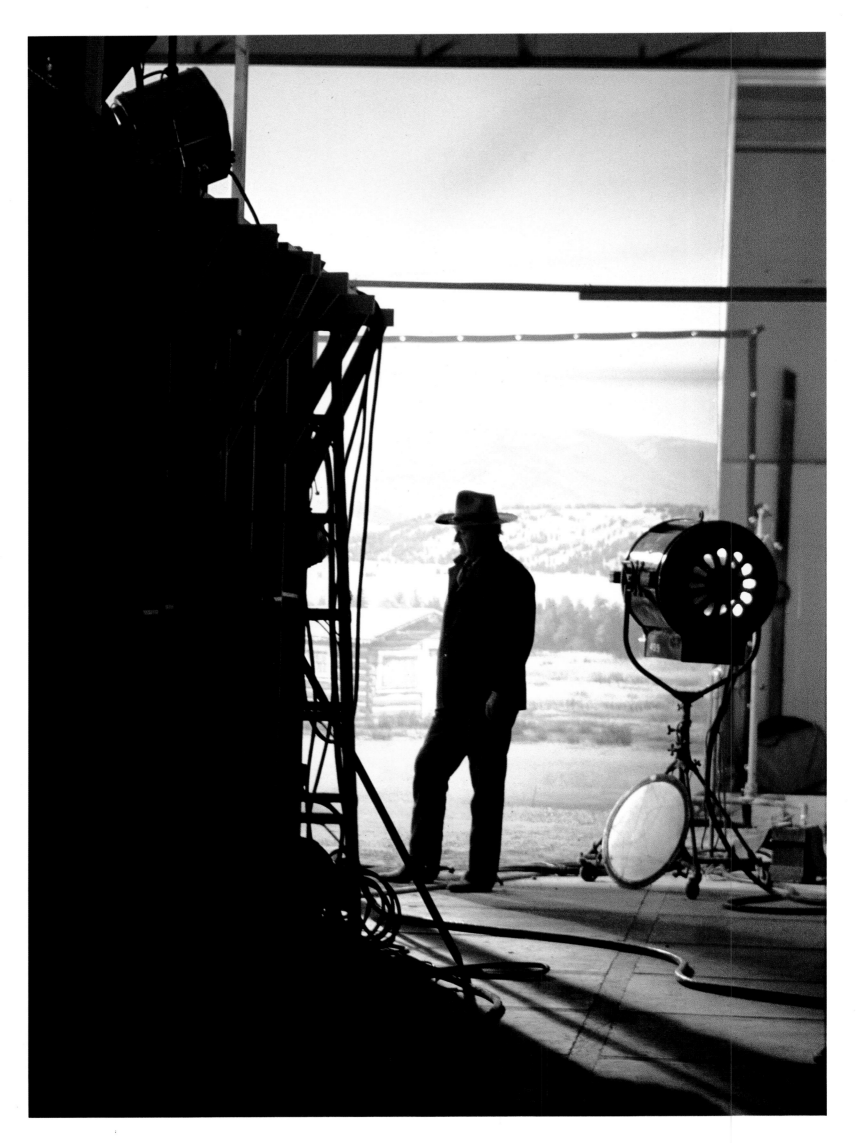

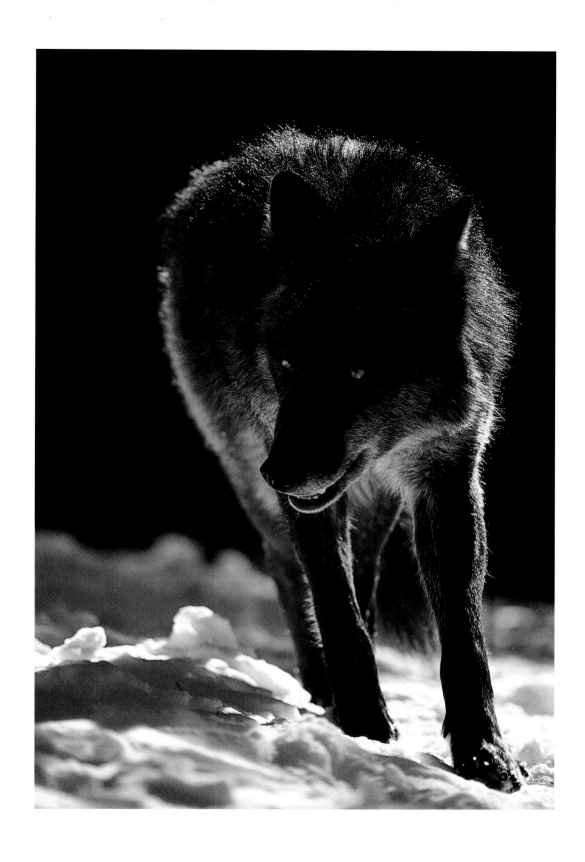

"John Wayne–In the
Wings," during the
filming of The Cowboys,
Sante Fe, New Mexico

DAVID SUTTON

Kathleen, a rare eastern
timber wolf, roams her
enclosure at the Rocky
Mountain Wolf
Sanctuary in Colorado

BOB WINSETT

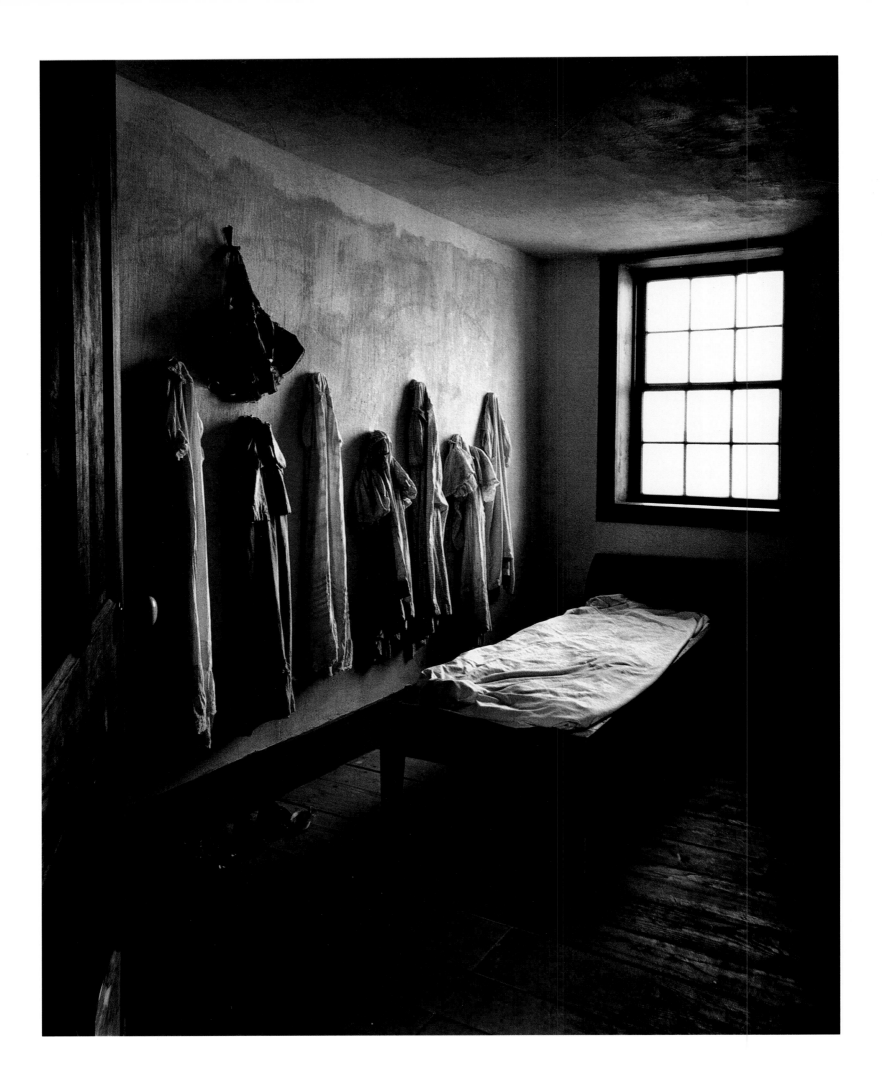

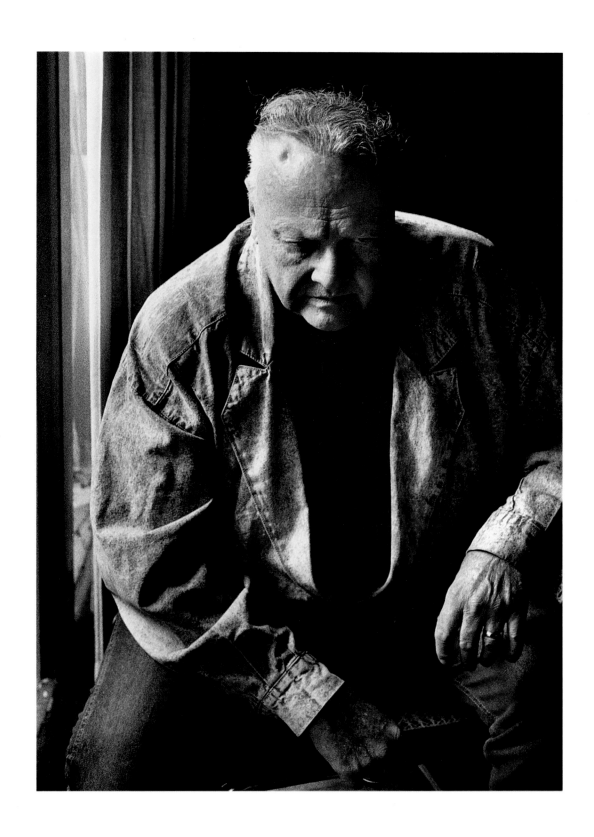

"Bedroom, 1858,"
a room in the meticulously
restored Koepsell House,
Old World Wisconsin
Museum, Kettle Moraine
State Forest, Wisconsin

©1989 **ELIE BERKMAN**

Writer James Dickey
at home in Columbia,
South Carolina

©1990 **MARIA VON MATTHIESSEN**

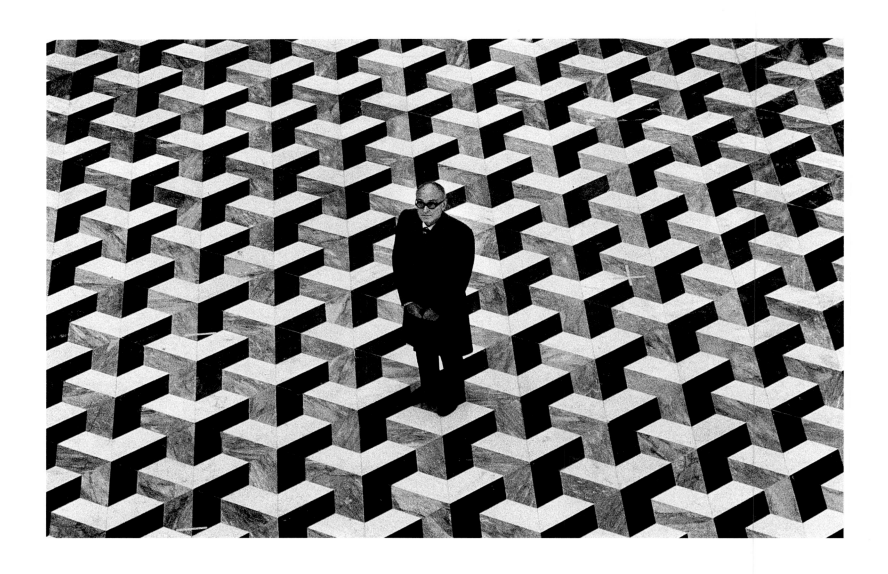

Architect Philip Johnson

on the San Giorgio

Maggiore-inspired

marble floor in the

library he designed for

New York University

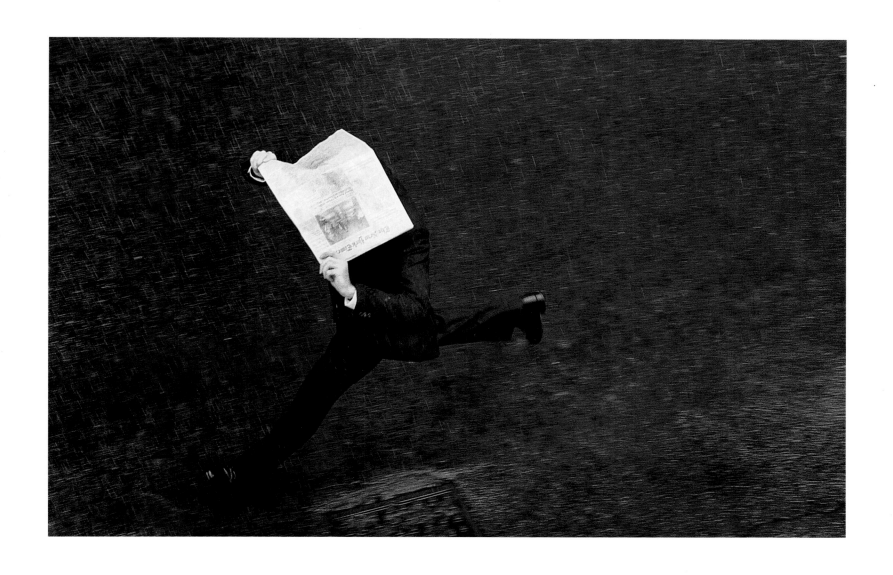

Malyszko's solution to a workshop assignment to photograph "anything with the New York Times" required six newspapers, two assistants, one roof, and one hose.

©1988 **MIKE MALYSZKO**

189

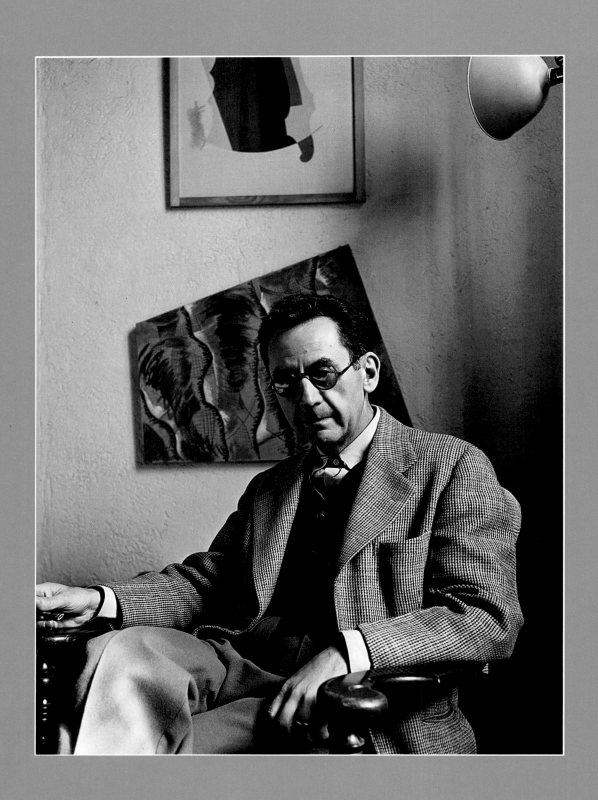

Coal miner, Devonshire,
England, 1955

© 1976 **LOU JACOBS, JR.**

From a series of portraits:

Man Ray, Hollywood,
California, 1949

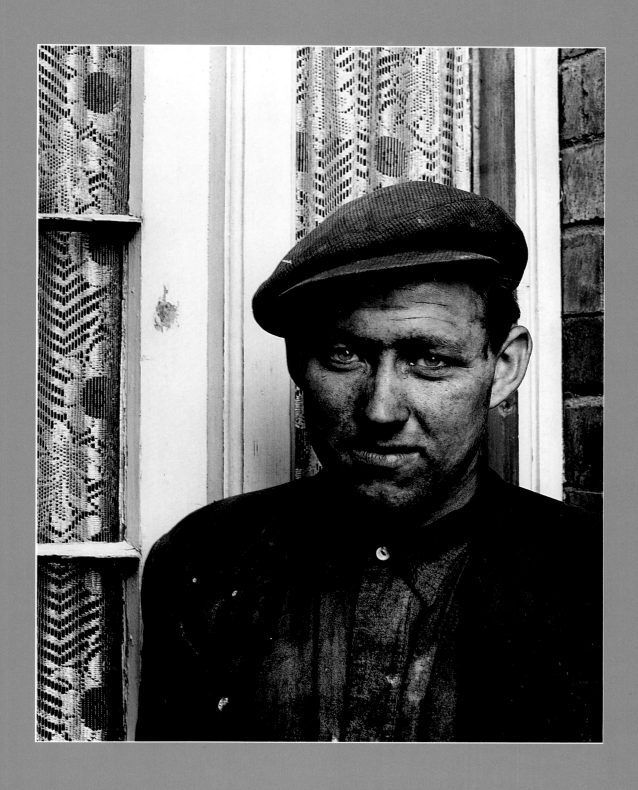

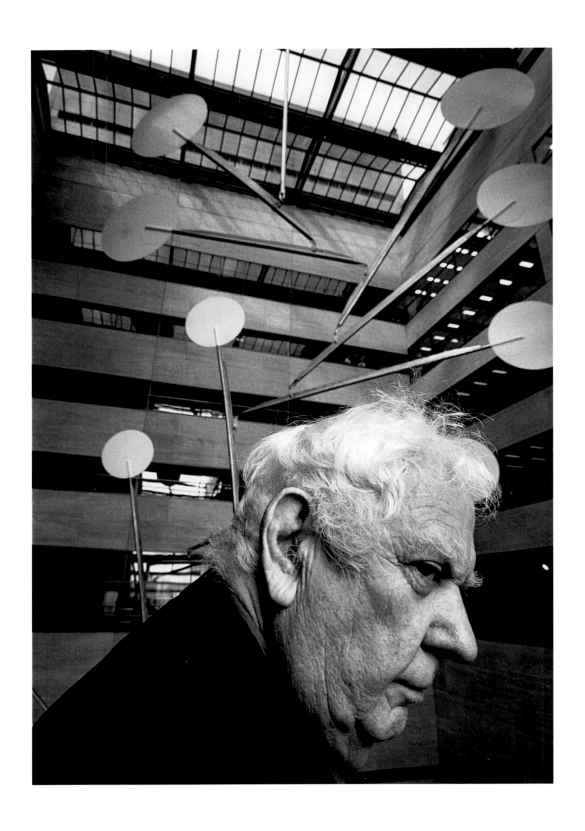

Alexander Calder,
reviewing the installation
of his mobile "White
Cascades" at the Federal
Reserve, Philadelphia

H. SCOTT HEIST

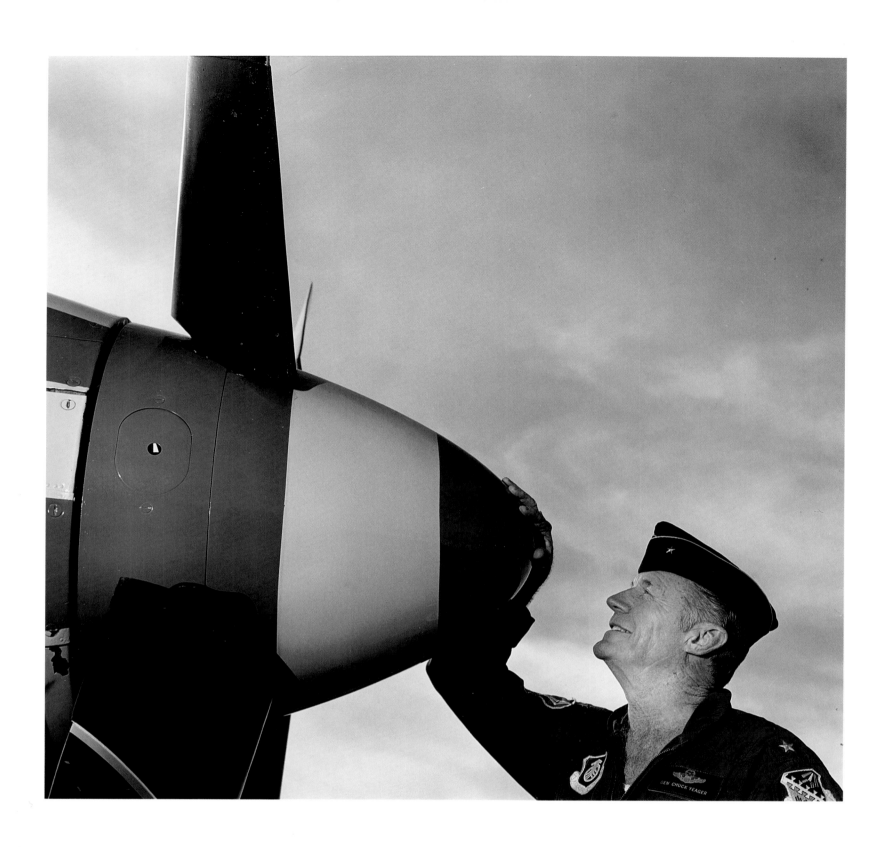

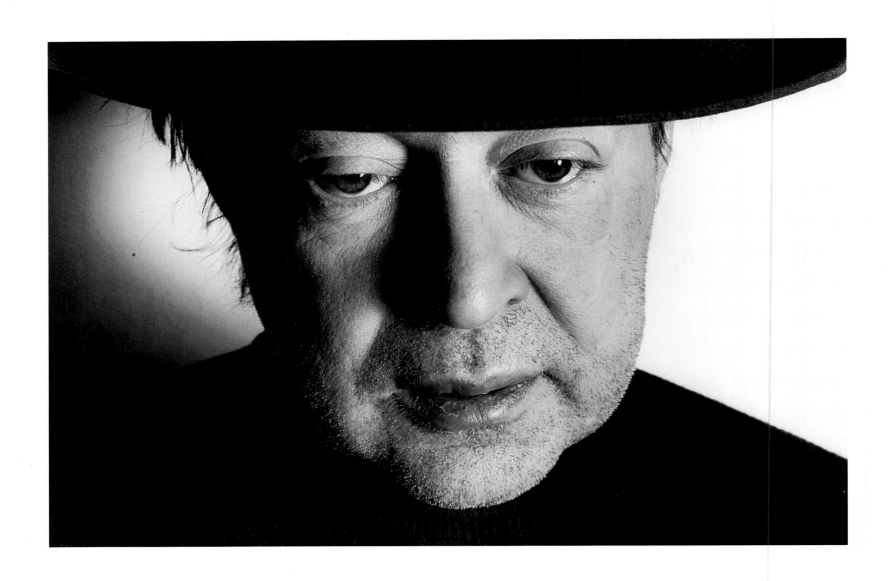

"My Illusion and Reality"

HELEN MILJAKOVICH

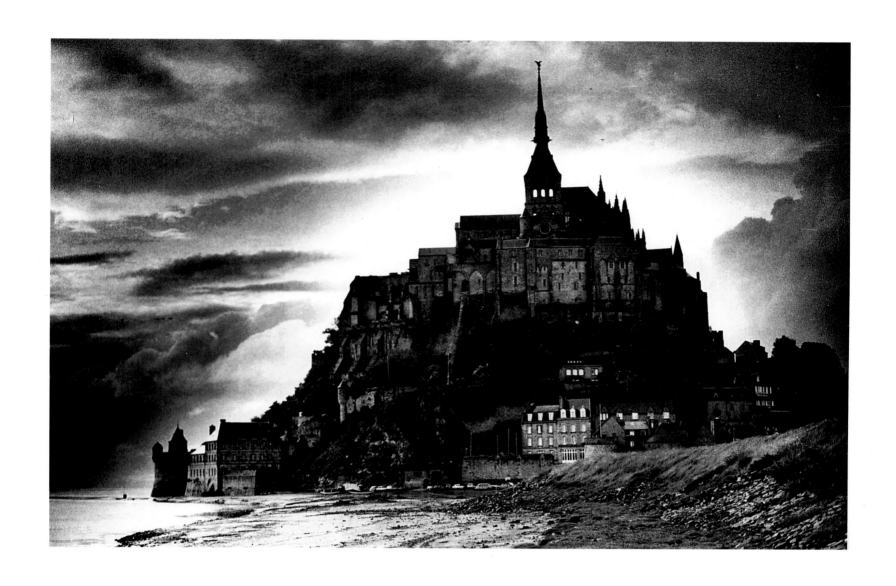

Storm clouds at the 13th-century abbey of Mont St. Michel, off the northwest coast of Brittany, France

©1974 **DAN BEIGEL**

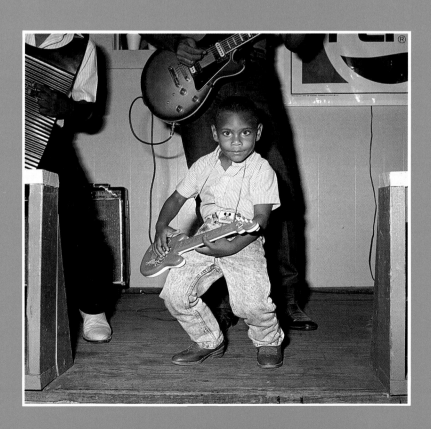

From a series taken in the
Zydeco music halls of
southwest Louisiana:

Top: "Jr. Love Accordian"

Bottom: "Gerard Delafose"

Right: "Marcel Dugas"

© 1991 **RICK OLIVIER**

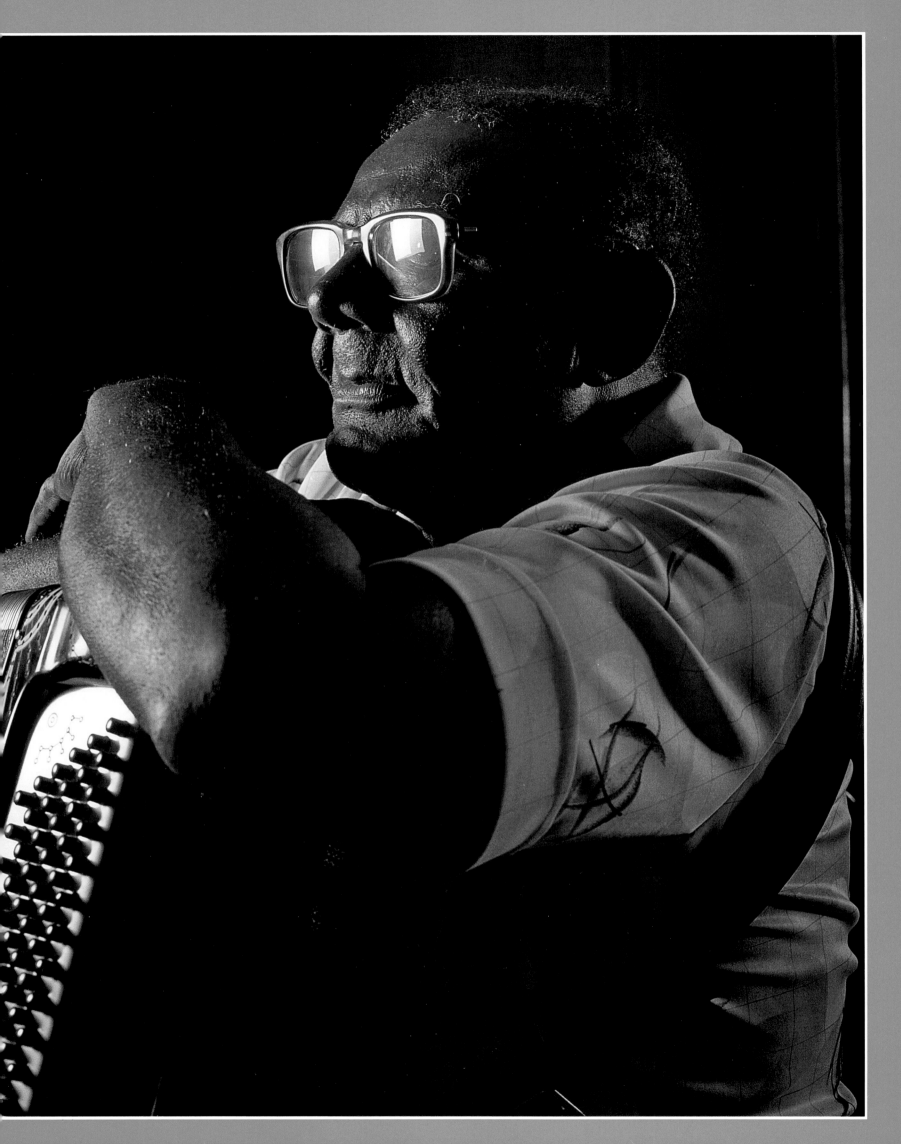

Gene Churchill, with sons
Travis, 6, and Grant, 4,
Sierra Nevada Mountains,
Lone Pine, California

© 1990 **PETER J. MENZEL**

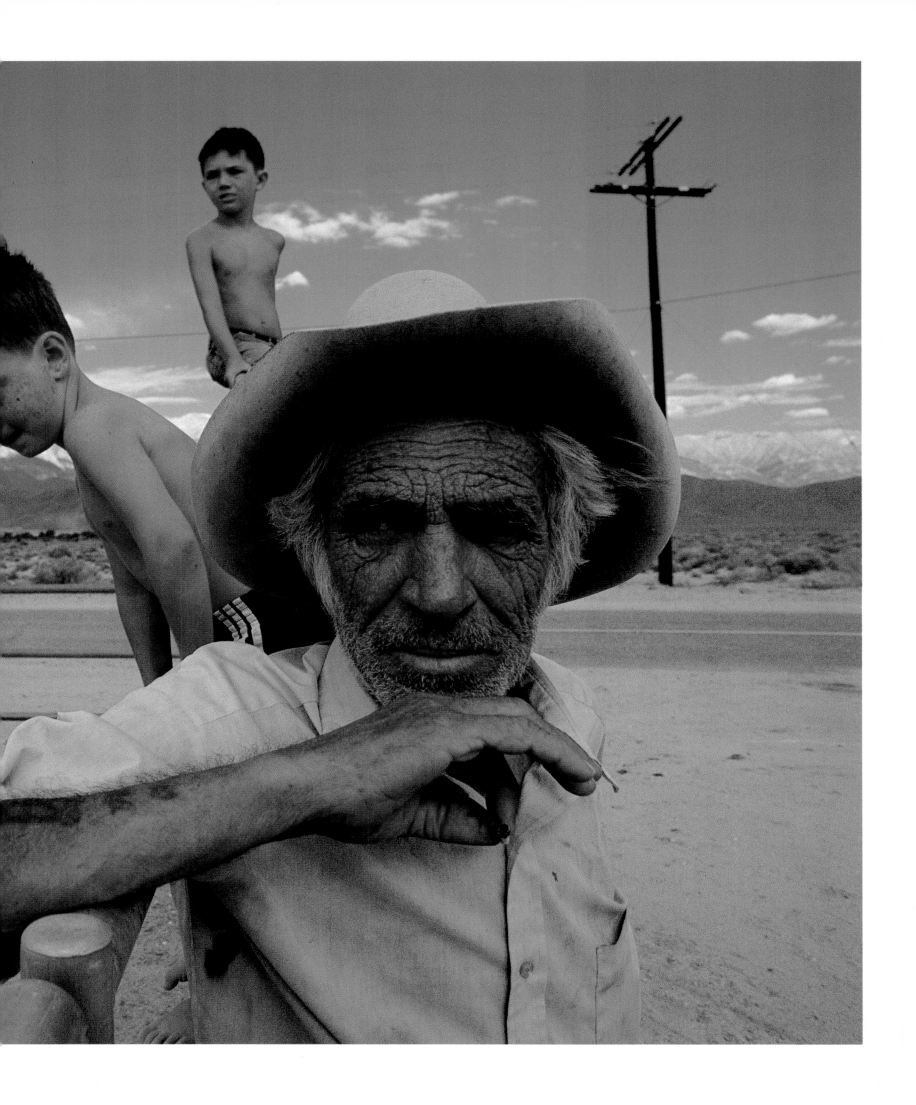

ROBERT L. CLEMENS

ROBERT ERVING POTTER

Buildings near
Geneva, New York

Musician, O'Connors Pub,
Doolin, County Clare, Ireland

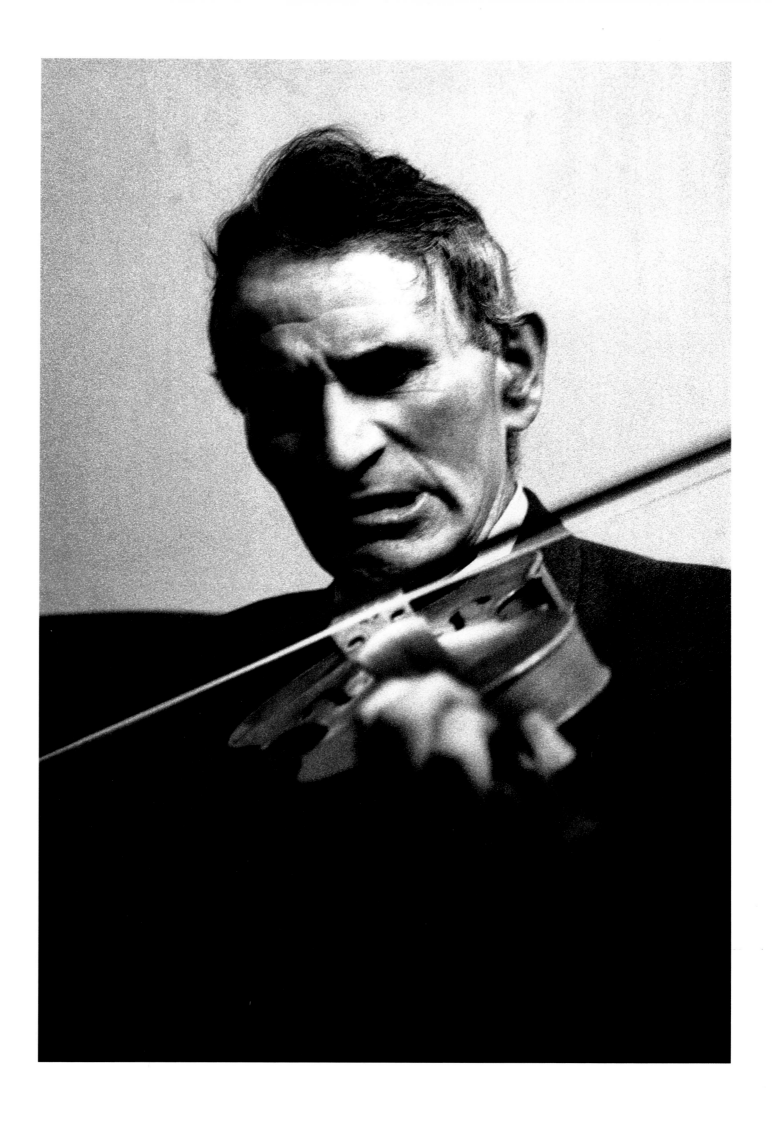

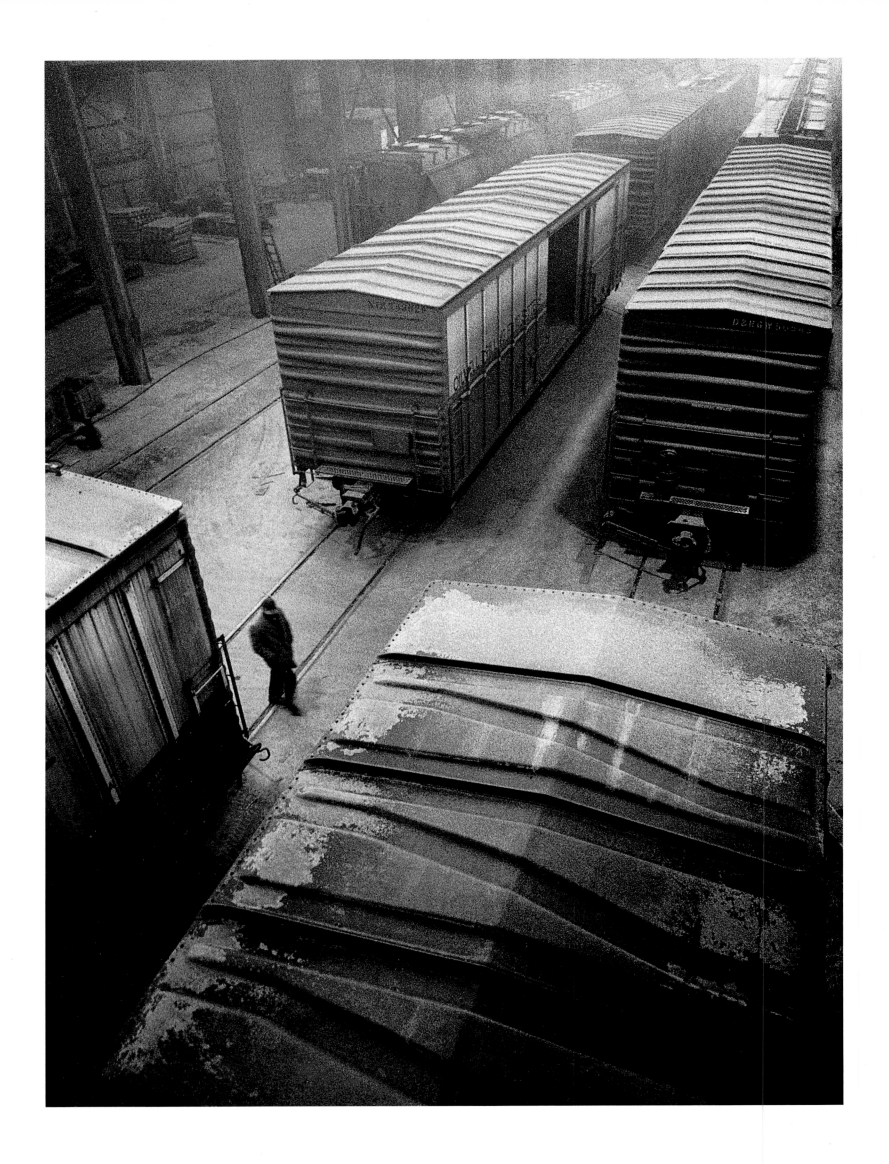

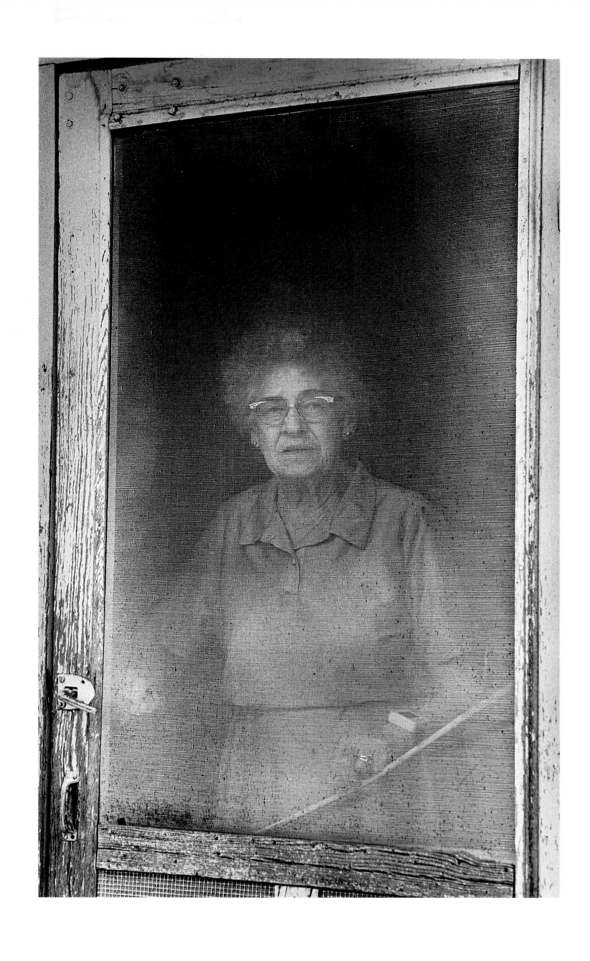

Boxcar factory,
Chicago

©1971 **STEVE KAHN**

Portrait of a farm
woman, Kansas, 1984

©1991 **SANTA FABIO**

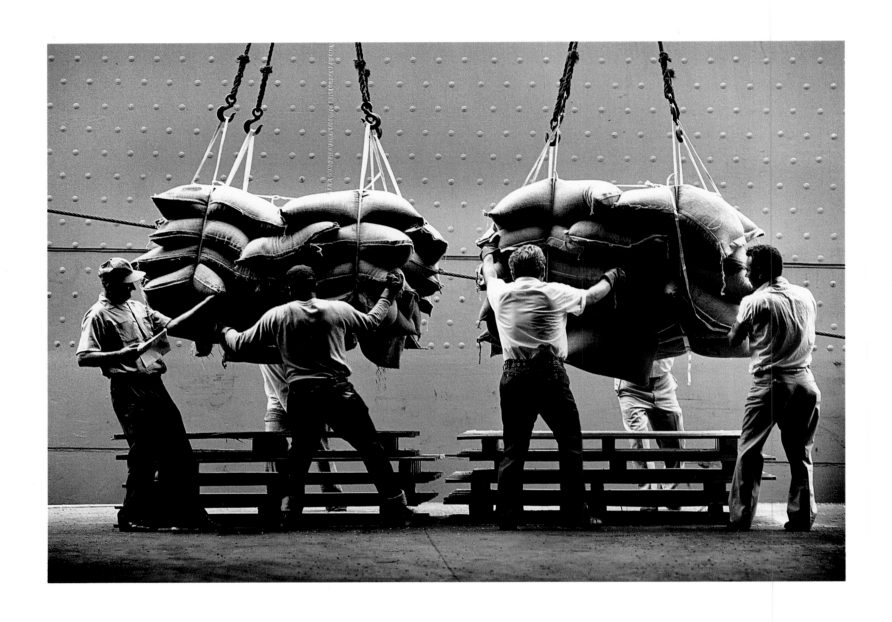

*Dockyard workers
off-loading South
American coffee beans,
Brooklyn, New York*

© 1980 **C. Bruce Forster**

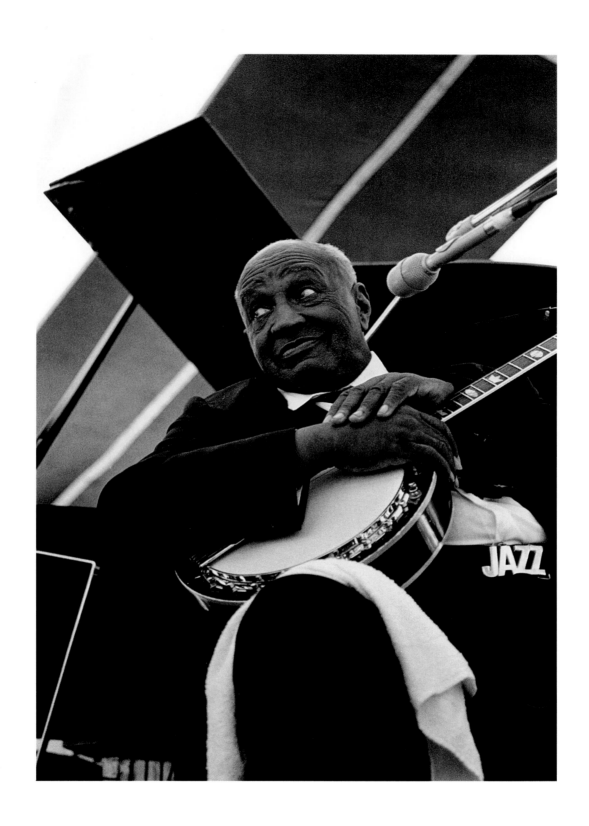

"Father Al," traditional jazz musician, New Orleans Jazz & Heritage Festival

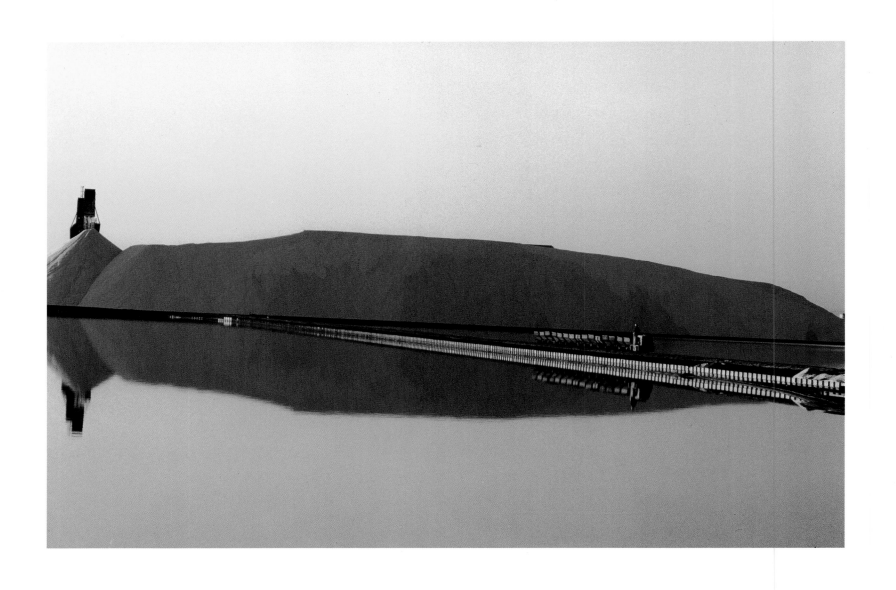

Salt train, Leslie Salt

Flats, Newark, California

LIANE ENKELIS

Engine 103, Essex,

Connecticut, 1971

BOB FATONE

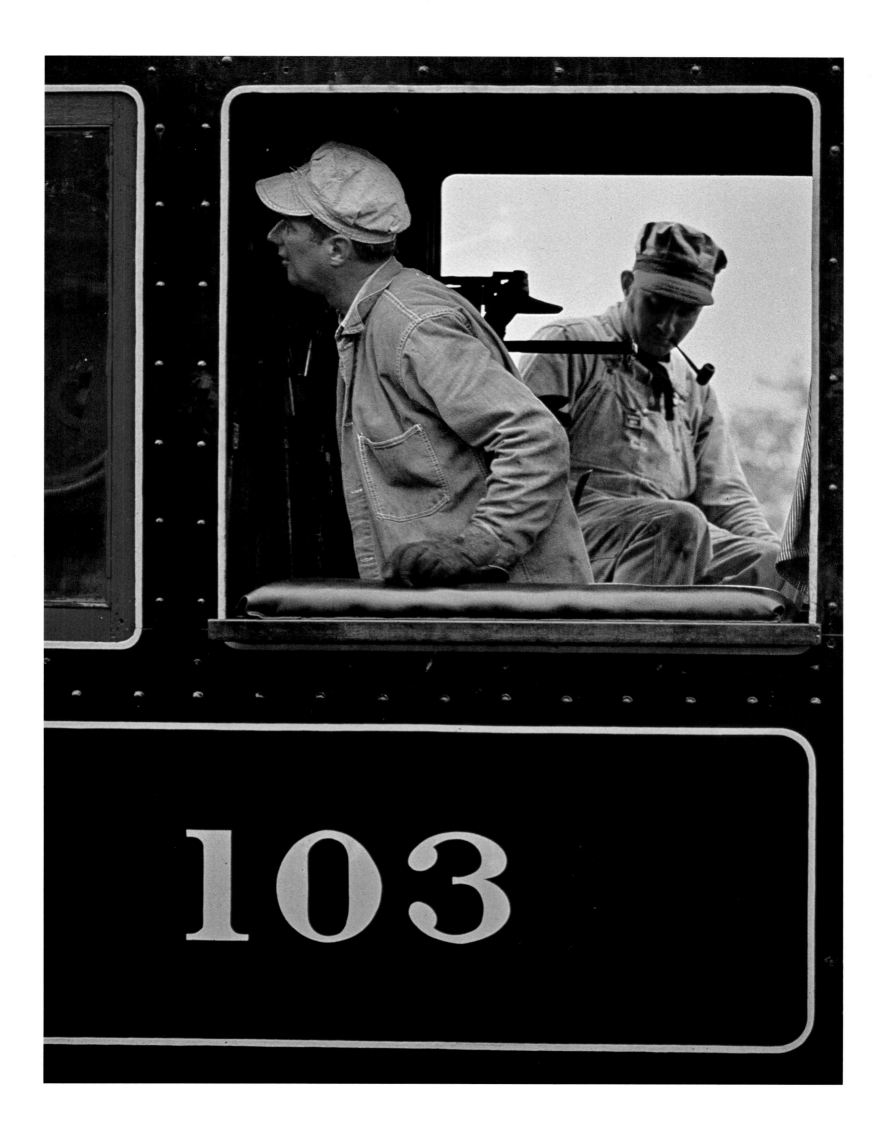

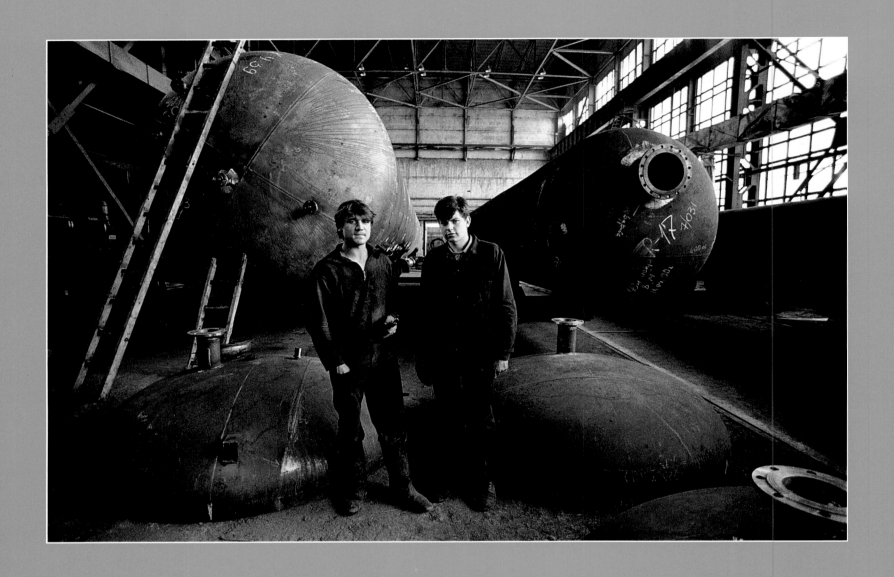

These portraits were made during the April 1990 "10,000 Eyes" celebration when Lonczyna traveled to Salt Lake City's sister city in the Soviet Union, Chernovtsy.

Above: Welders, steel fabrication factory, Chernovtsy, USSR

Right: Factory worker, Chernovsty, USSR

©1990 **LONGIN LONCZYNA, JR.**

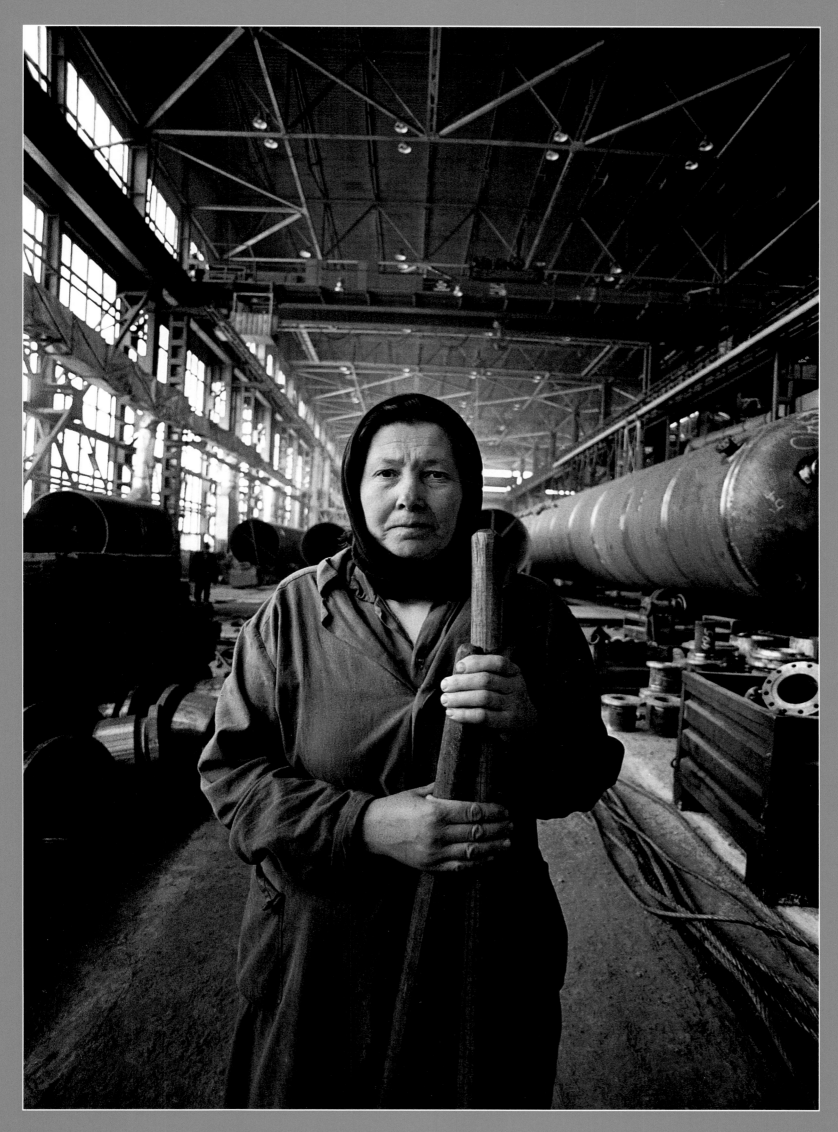

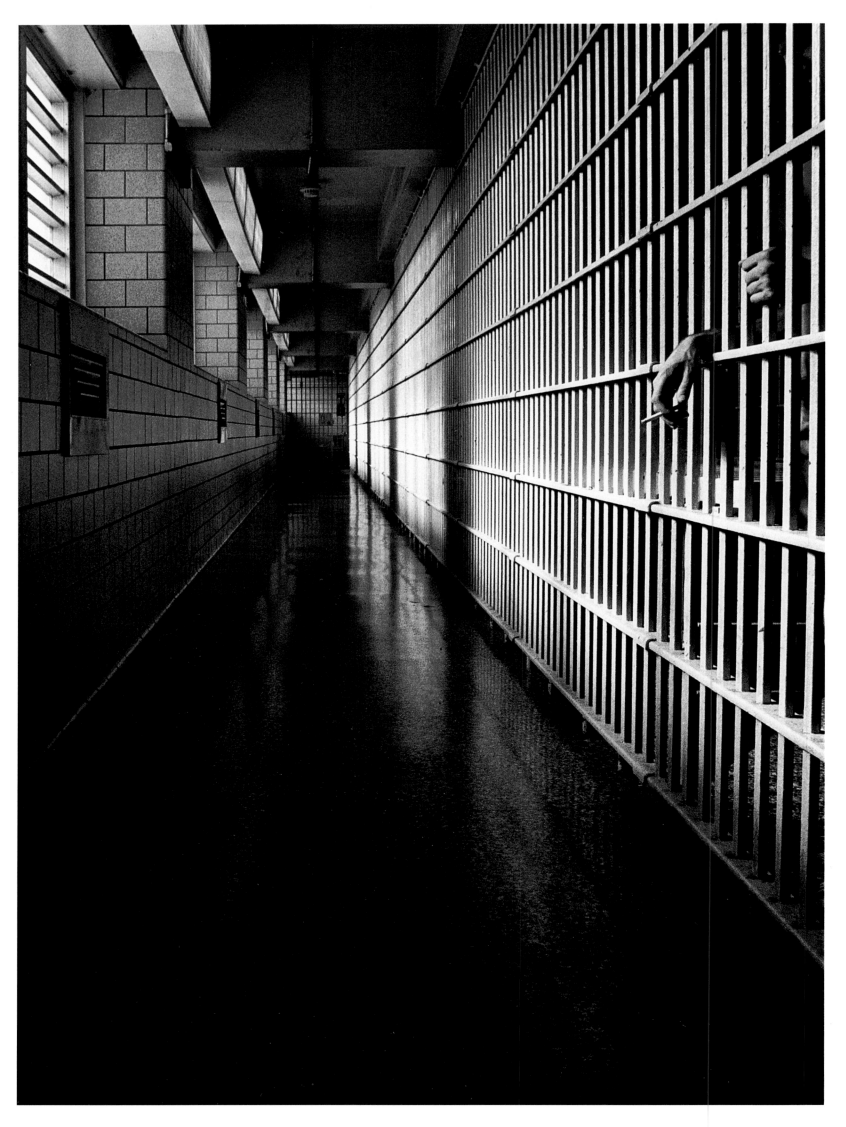

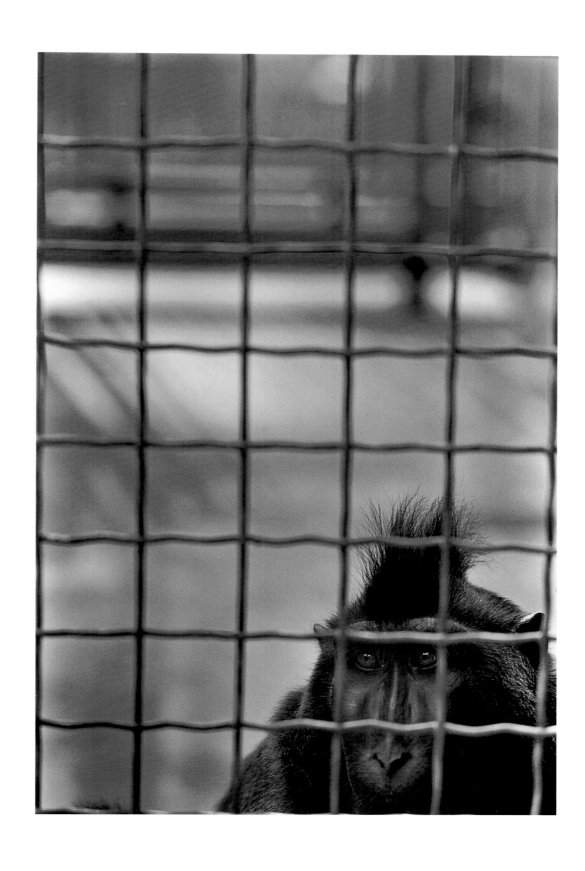

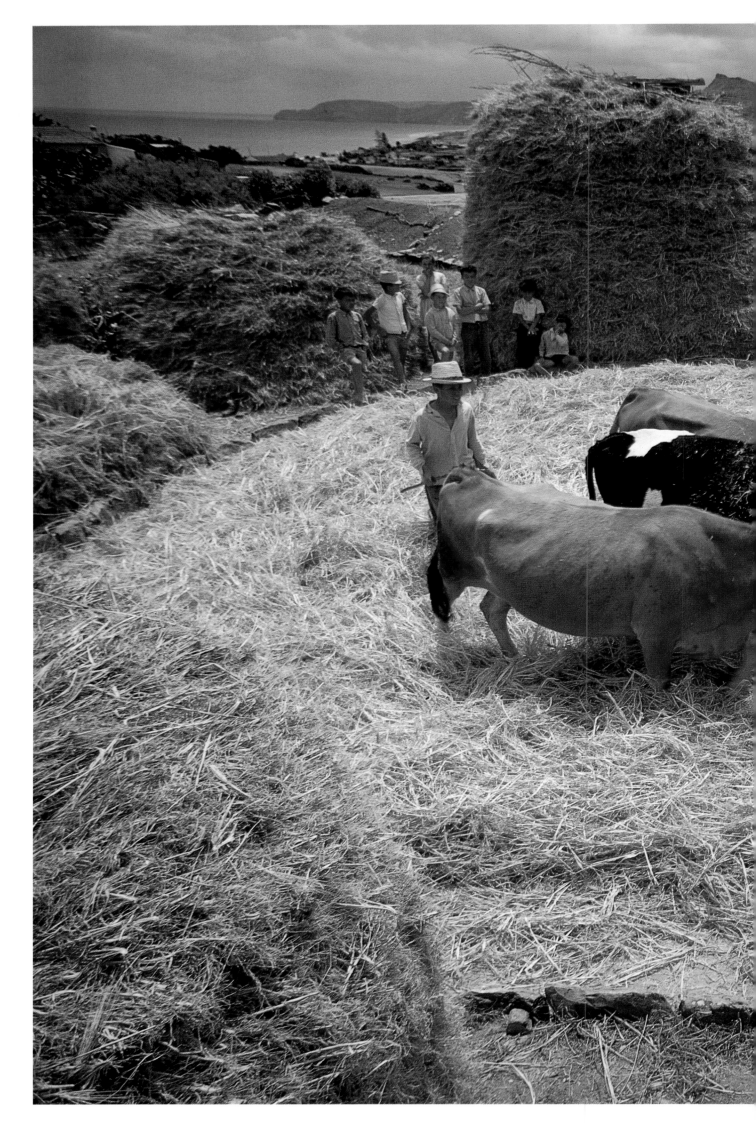

Wheat threshing,
Madeira Islands,
Portugal

JONATHAN S. BLAIR

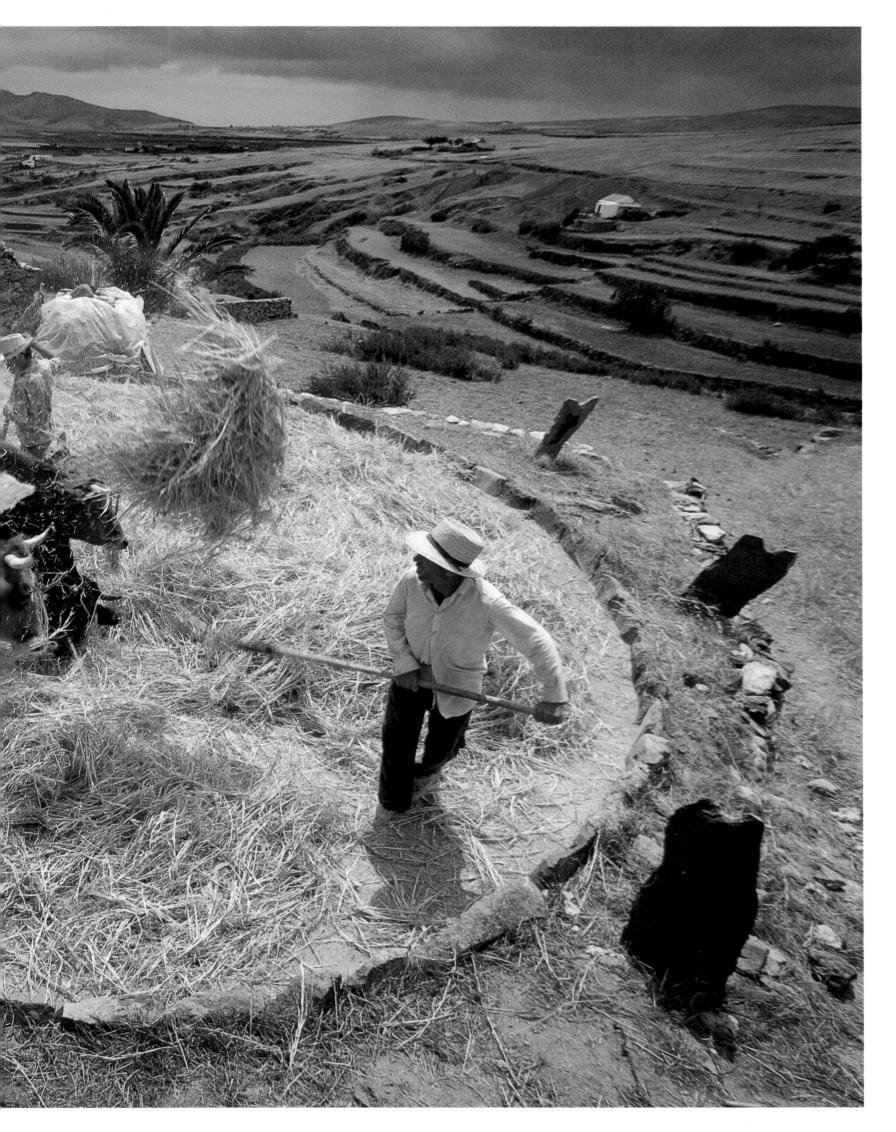

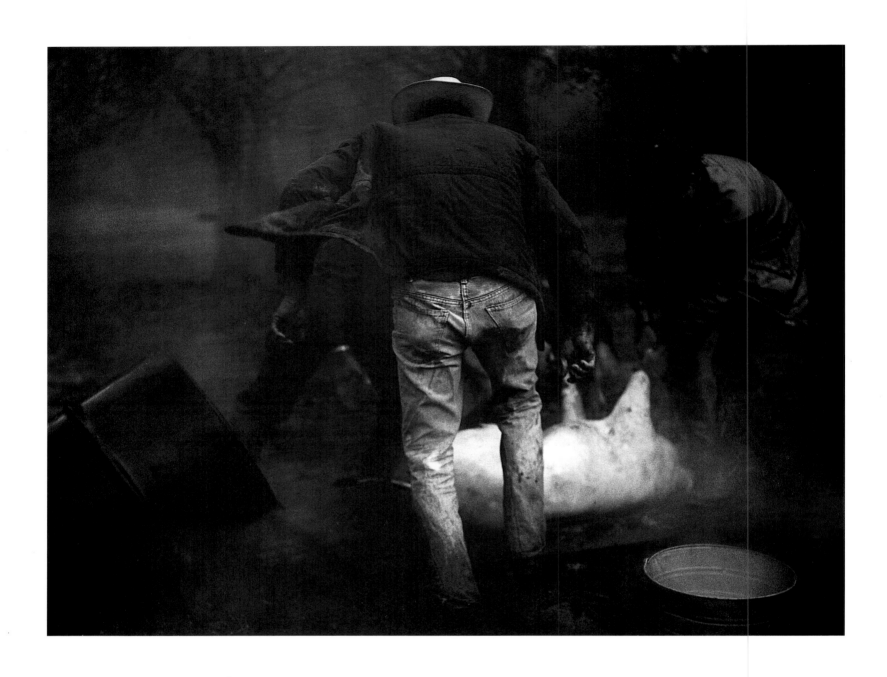

"Chloe, Louisiana, 1982"

TURNER BROWNE

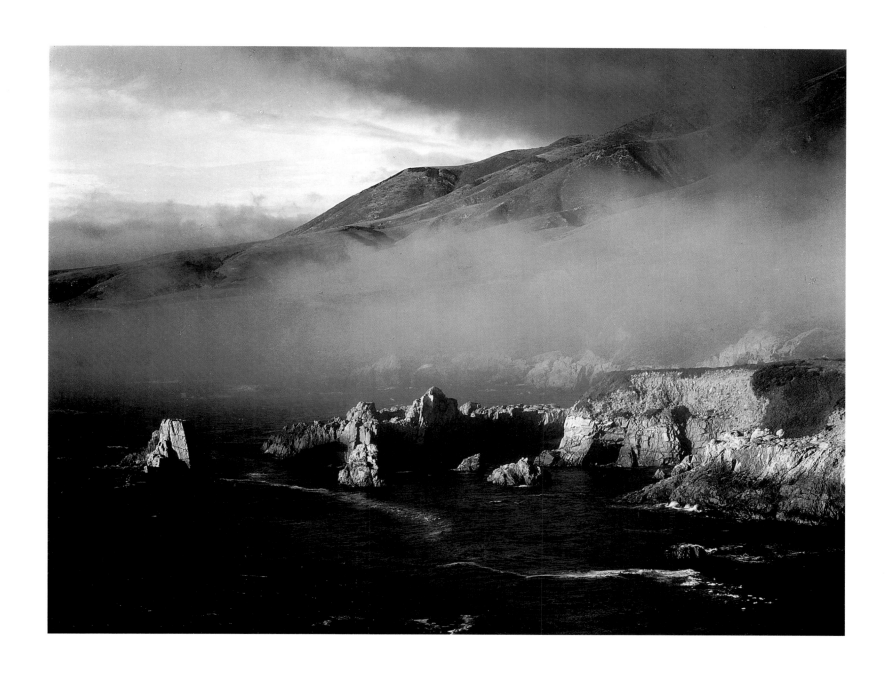

*North Cove, Soberanes
Point, Sur Coast,
California*

©1964 **MORLEY BAER**

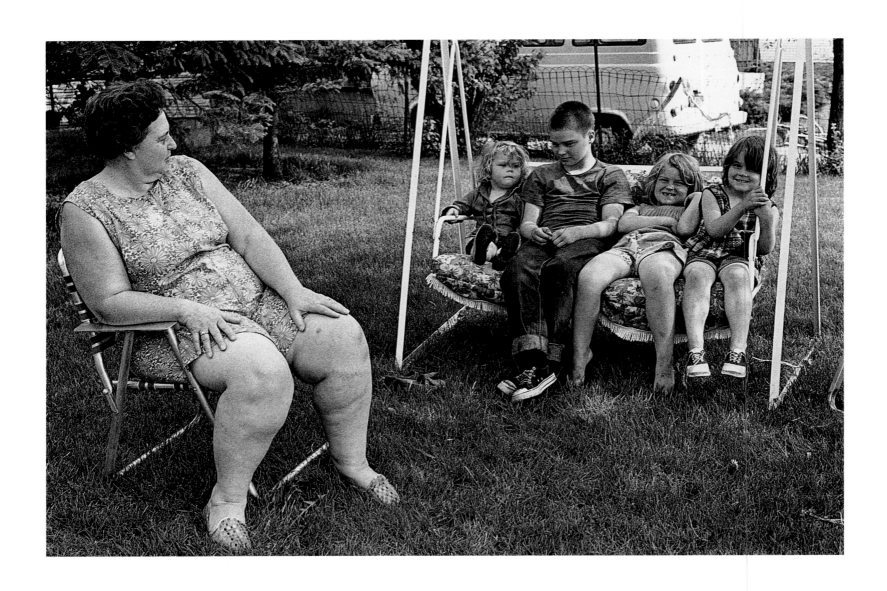

Family on swing,
Montgomery, Illinois,
1969, from a series on
southern families who
moved north during the
1960s

EARL BELOFSKY

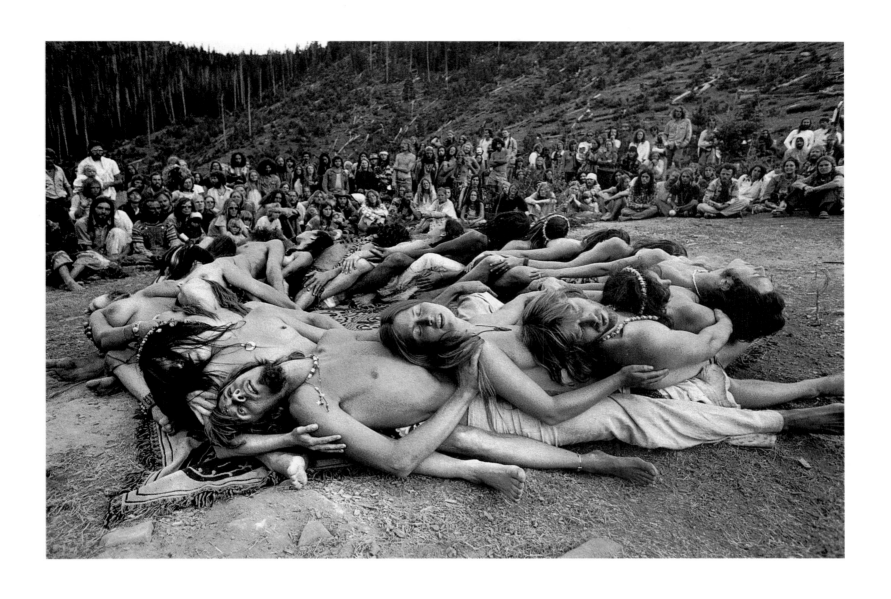

The Rainbow Family
Gathering, an annual
reunion of former, current,
and "in spirit" hippies,
Choteau, Montana, 1975

©1991 **BONNIE FREER**

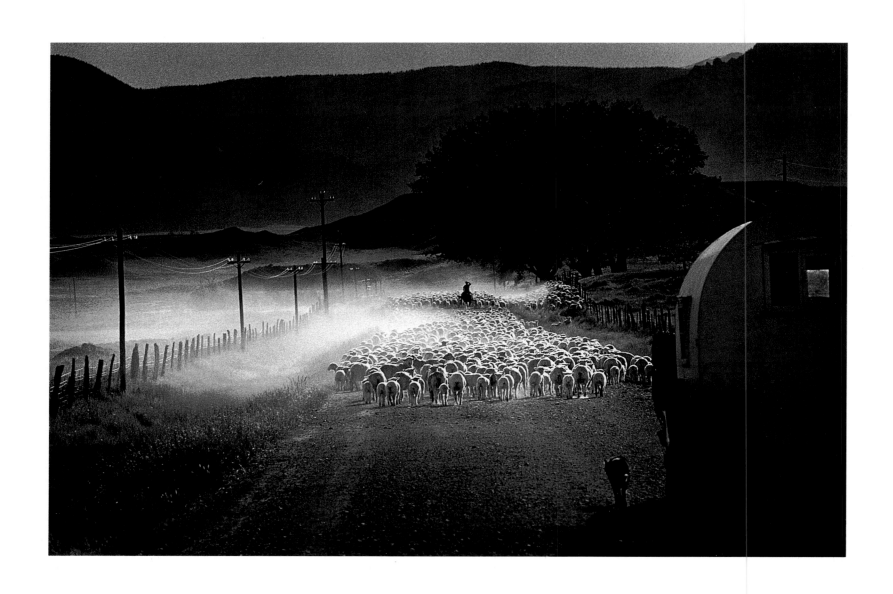

"Wyoming Sheep Drive"

GARY R. GRAF

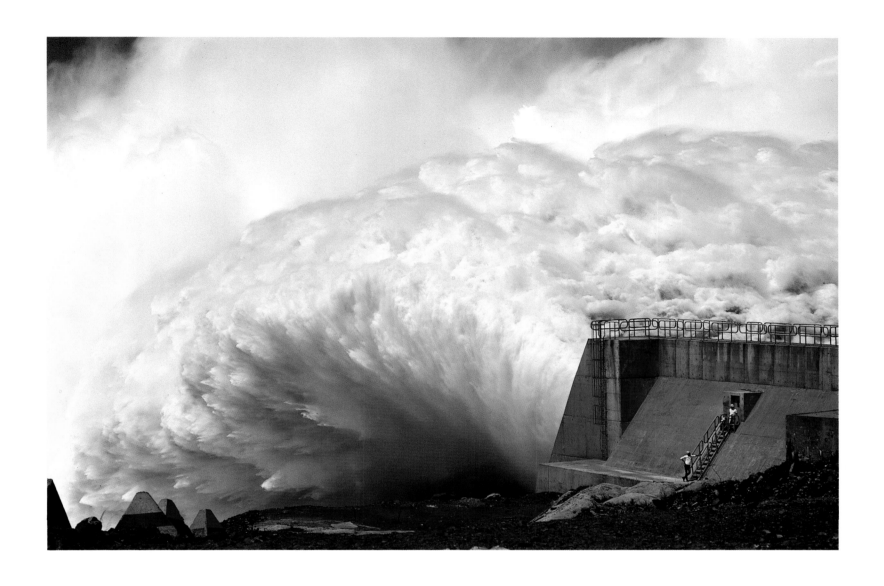

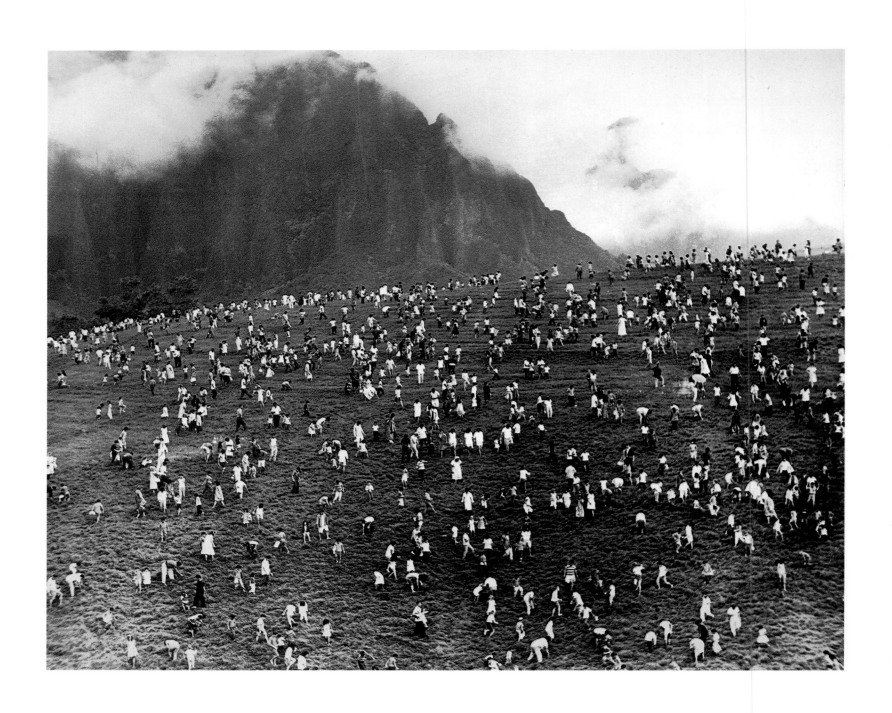

Easter egg hunt,
Kaneohe, Oahu, Hawaii

©1964 **JOHN TITCHEN**

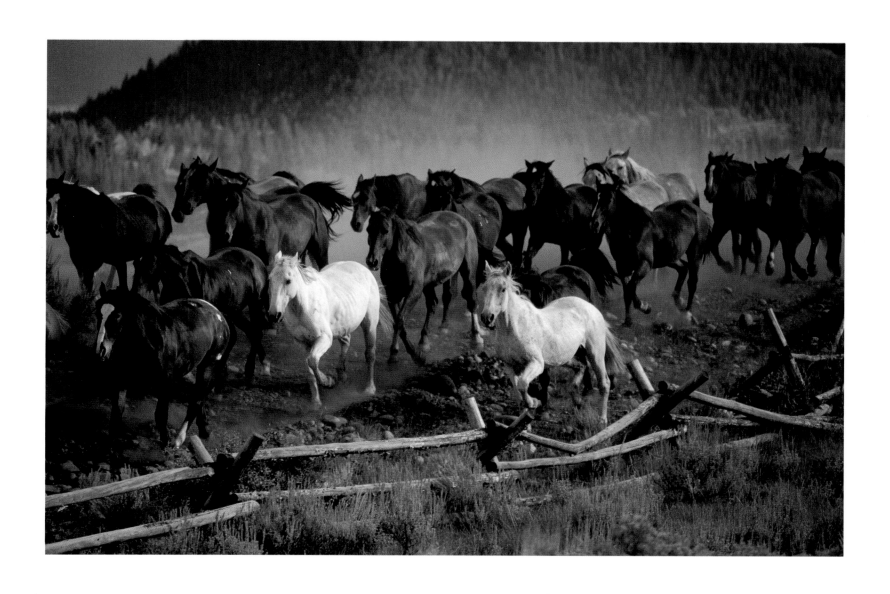

"Moving Horses"
Jackson Hole, Wyoming

© 1976 **LEWIS PORTNOY**

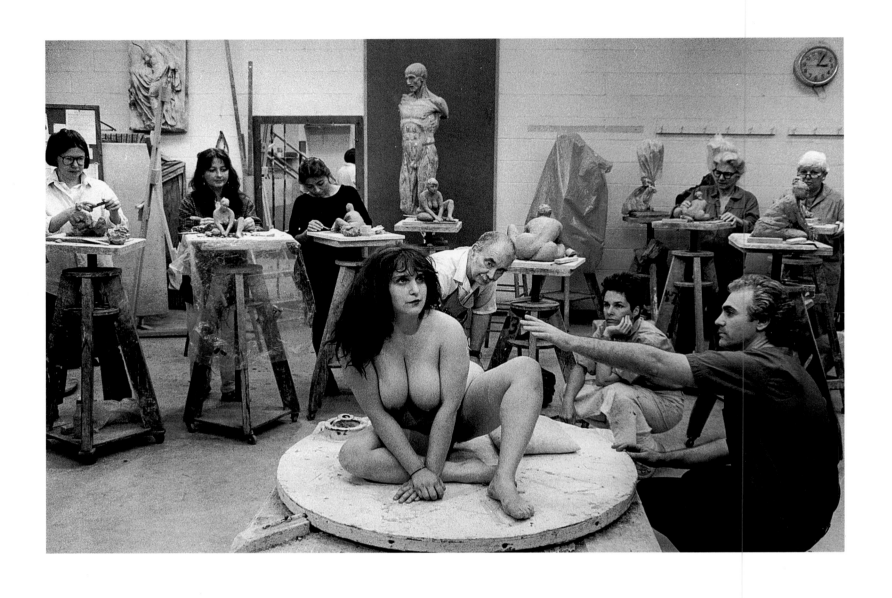

"At the National

Academy of Design"

© 1986 **MARIETTE PATHY ALLEN**

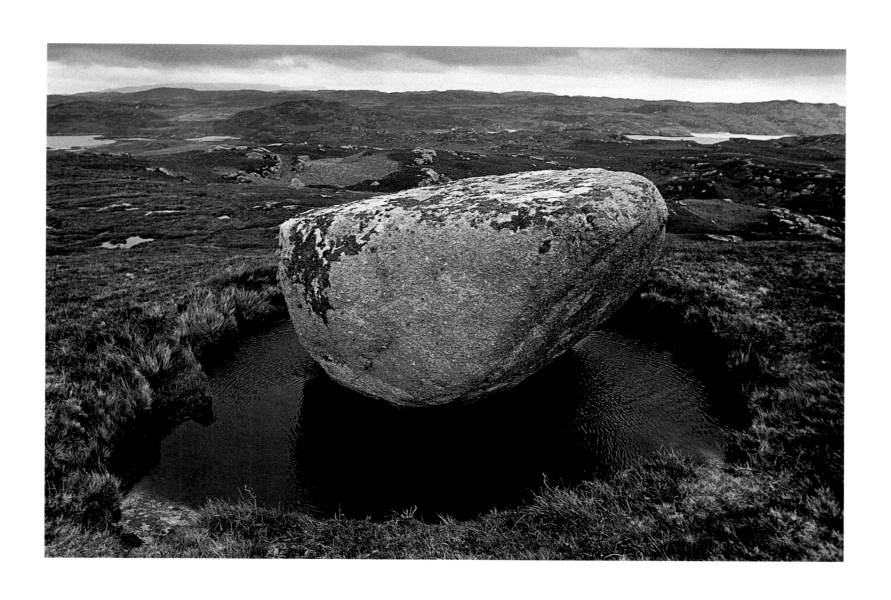

"Stone and Pool"
Isle of Erraid,
Inner Hebrides, Scotland

© 1980 **KATHLEEN T. CARR**

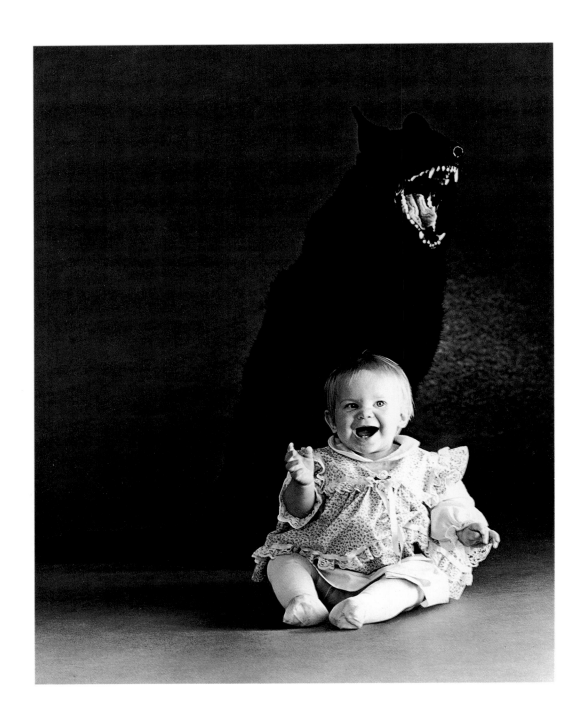

*"Arrangement in Black
and White" Secunda
made this self-promotion
image, also known as
"Brim and Baby," with
his dog and a young
model. "He yawned only
once during the entire
session . . . good doggie."*

© 1983 **SHEL SECUNDA**

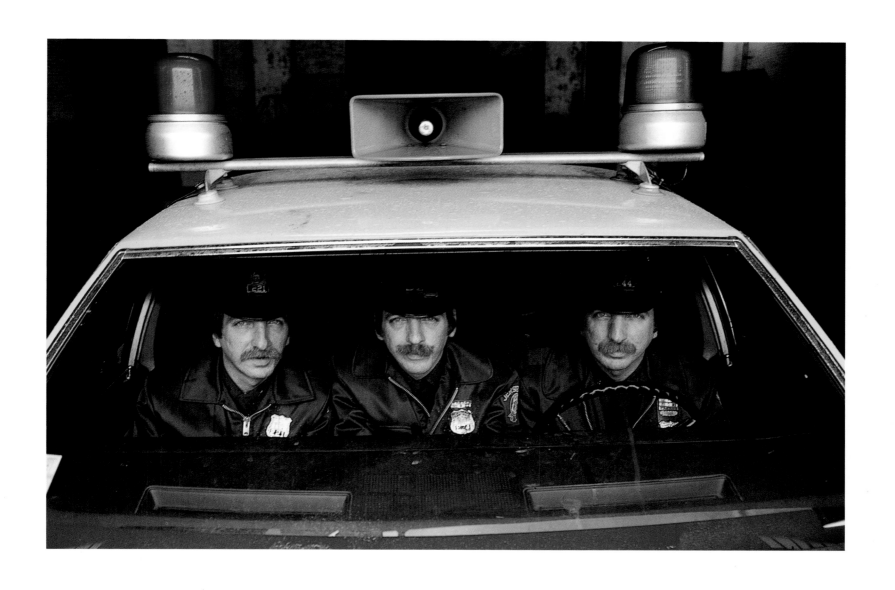

Andrew, Joseph, and Robert Koralja, police officers that have Jersey City, New Jersey, residents seeing triple

© 1981 **MICHAEL S. YAMASHITA**

PHOTOGRAPHERS

General Member unless otherwise noted.

JEFFREY AARONSON
pages 134-135
Apsen, CO
Colorado Chapter

WAYNE ALDRIDGE
page 112
Portland, OR
Oregon Chapter

JEAN ALEXANDER
page 41
Seattle, WA
Seattle / Northwest Chapter

MARIETTE PATHY ALLEN
page 222
New York, NY
New York Chapter
Associate Member

BARBARA ALPER
page 45
New York, NY
New York Chapter

TONY ARRUZA
page 52
West Palm Beach, FL
South Florida Chapter

HERBERT ASCHERMAN, JR.
page 64
Cleveland Heights, OH
Cleveland / Northcoast Chapter

JAY ASQUINI
page 50
Livonia, MI
Michigan Chapter

DAVID ROBERT AUSTEN
page 133
Sydney, Australia

KATE BADER
page 40
Sunnyside, NY
New York Chapter

GORDON BAER
page 28
Cincinnati, OH
Ohio Valley Chapter
Life Member

MORLEY BAER
page 215
Carmel, CA
Northern California Chapter

LARRY BARNS
pages 148-149
New York, NY
New York Chapter

ROB BARTEE
page 95
Denver, CO
Colorado Chapter

PABLO BARTHOLOMEW
pages 72-73
New Delhi, India

LINDA BARTLETT
pages 150-151
Washington, DC
Washington DC / Mid-Atlantic Chapter

DAN BEIGEL
page 195
Annapolis, MD
Washington DC / Mid-Atlantic Chapter

EARL BELOFSKY
page 216
Denver, CO
Colorado Chapter
Regular Affiliate

LOUIS BENCZE
page 66
Seattle, WA
Seattle / Northwest Chapter

ELIE BERKMAN
page 186
Glencoe, IL
Chicago / Midwest Chapter

JERRY BERNDT
pages 6-7
Cambridge, MA
New England Chapter

MARION BERNSTEIN
page 178
New York, NY
New York Chapter

RANDA BISHOP
page 219
New York, NY
New York Chapter

JONATHAN S. BLAIR
pages 212-213
Wilmington, DE
Washington DC / Mid-Atlantic Chapter

STEVEN BLOCH
page 145
Portland, OR
Oregon Chapter

CAROL BOBO
page 41
Seattle, WA
Seattle / Northwest Chapter

GARY BRAASCH
pages 8-9
Portland, OR
Oregon Chapter

TURNER BROWNE
page 214
Seattle, WA
Seattle / Northwest Chapter

JIM BRYANT
page 74
New York, NY
New York Chapter

SONJA BULLATY
page 60
New York, NY
New York Chapter

MARK BURNSIDE
page 108
Seattle, WA
Seattle / Northwest Chapter

KEN BUSCHNER
page 97
Rochester, NY
Western New York Chapter

CARL W. CANNEDY
page 55
Dallas, TX
Dallas Chapter

M. J. CÁRDENAS
page 100
Dallas, TX
Dallas Chapter

KATHLEEN T. CARR
page 223
Sebastopol, CA
Northern California Chapter

CHRISTOPHER CASLER
page 33
Los Angeles, CA
Southern California Chapter

JANET CENTURY
page 77
Cleveland, OH
Cleveland / Northcoast Chapter

FLIP CHALFANT
page 161
Atlanta, GA
Atlanta / Southeast Chapter

WALTER CHANDOHA
page 179
Annandale, NJ
New York Chapter
Life Member

AARON CHANG
page 169
San Diego, CA
San Diego Chapter

JUNEBUG CLARK
page 131
Farmington, MI
Michigan Chapter

ROBERT L. CLEMENS
page 200
Rochester, NY
Western New York Chapter

CHRIS COLLINS
pages 10-11
New York, NY
New York Chapter

NANCY CRAMPTON
page 188
New York, NY
New York Chapter

RON DAHLQUIST
page 37
Kihei, HI
Hawaii Chapter

DARWIN DALE
page 65
Lansing, MI
Michigan Chapter

STUART N. DEE
page 36
Vancouver, British Columbia

JOHN DERRYBERRY
page 57
Dallas, TX
Dallas Chapter

DEAN DIXON
pages 158-159
Nashville, TN
Tennessee Chapter

KIM DUCOTÉ
page 106
New York, NY
New York Chapter

THOM DUNCAN
page 164
Falls Church, VA
Washington DC / Mid-Atlantic Chapter

DICK DURRANCE II
page 113
Rockport, ME
New England Chapter

PETER ECKERT
pages 110-111
Portland, OR
Oregon Chapter

LIANE ENKELIS
page 206
Palo Alto, CA
Northern California Chapter

AARON CHANG

PAUL EPLEY
page 75
Charlotte, NC
North Carolina Chapter

SANTA FABIO
page 203
Huntington Woods, MI
Michigan Chapter

MIGUEL LUIS FAIRBANKS
pages 154-155
Santa Cruz, CA
Northern California Chapter

BERNARD V. FALLON
page 44
Torrance, CA
Southern California Chapter

BOB FATONE
page 207
Niantic, CT
New York Chapter

RAY FISHER
page 86
Miami, FL
South Florida Chapter
Life Member

ROGER FOLEY
page 96
Arlington, VA
Washington DC / Mid-Atlantic Chapter

C. BRUCE FORSTER
page 204
Portland, OR
Oregon Chapter

PEGGY FOX
pages 98-99
Cockeysville, MD
Washington DC / Mid-Atlantic Chapter

MAUREEN FRANCE
page 46
Cincinnati, OH
Ohio Valley Chapter
Regular Affiliate

JULES FRAZIER
page 173
Seattle, WA
Seattle / Northwest Chapter

BONNIE FREER
page 217
New York, NY
New York Chapter

DAVID FREESE
pages 162-163
Philadelphia, PA
Philadelphia Chapter

KEN FRICK
page 170
Colombus, OH
Ohio Valley Chapter

BOB GIANDOMENICO
page 102
Collingswood, NJ
Philadelphia Chapter

D. R. GOFF
page 76
Columbus, OH
Ohio Valley Chapter

ALAN J. GOLDSTEIN
page 168
Silver Spring, MD
Washington DC / Mid-Atlantic Chapter

GARY R. GRAF
page 218
Denver, CO
Colorado Chapter

DONALD GRAHAM
page 103
Los Angeles, CA
Southern California Chapter

STEPHEN P. GRAHAM
page 180
Ann Arbor, MI
Michigan Chapter

ADELE ARON GREENSPUN
page 141
Philadelphia, PA
Philadelphia Chapter

DIRCK HALSTEAD
page 81
Washington, DC
Washington DC / Mid-Atlantic Chapter

BLAINE HARRINGTON III
page 120
Danbury, CT
New York Chapter

H. SCOTT HEIST
page 192
Durham, PA
Central Pennsylvania Chapter

JOHN C. HILLERY
page 171
Detroit, MI
Michigan Chapter

ANDREW HOLBROOKE
page 152
New York, NY
New York Chapter

ROBERT HOLMES
page 51
Mill Valley, CA
Northern California Chapter

TED HOROWITZ
pages 230-231
Westport, CT
New York Chapter

HUGH HUNTER, JR.
page 211
Birmingham, AL
Tennessee Chapter

DEBORAH PANNELL INGRAHAM
page 176
Melrose, PA
Philadelphia Chapter
Regular Affiliate

LOU JACOBS, JR.
pages 190-191
Cathedral City, CA
Southern California Chapter
Life Member

MICHAEL JENSEN
page 105
Minneapolis, MN
Minneapolis Chapter

EVERETT C. JOHNSON
page 58
Arlington, VA
Washington DC / Mid-Atlantic Chapter

STEVE KAHN
page 202
New York, NY
New York Chapter

ZIGY KALUZNY
page 130
Austin, TX
Austin / San Antonio Chapter

CATHERINE KARNOW
pages 124-125
Washington, DC
Washington DC / Mid-Atlantic Chapter

BARUCH KATZ
page 146
New York, NY
New York Chapter

BEVIL S. KNAPP
page 143
Metairie, LA
New Orleans / Gulf South Chapter

DIANNE KORNBERG
pages 92-93
Lake Oswego, OR
Oregon Chapter
Associate Member

STEVE KRAUSS
page 121
Rochester, NY
Western New York Chapter
Regular Affiliate

HUGH KRETSCHMER
page 104
Pacific Palisades, CA
Southern California Chapter
Regular Affiliate

BIANCA LAVIES
page 157
Annapolis, MD
Washington DC / Mid-Atlantic Chapter

ARTHUR LEIPZIG
pages 136-139
Sea Cliff, NY
Long Island Chapter
Life Member

NANCY LEVINE
page 101
New York, NY
New York Chapter

ROBERT LLEWELLYN
page 59
Charlottesville, VA
Washington DC / Mid-Atlantic Chapter

LONGIN LONCZYNA, JR.
pages 208-209
Salt Lake City, UT
Utah / Mountain West Chapter

KEN J. MACSWAN
page 53
St. Louis, MO
St. Louis Chapter

JAY MAISEL
pages 48-49
New York, NY
New York Chapter

MIKE MALYSZKO
page 189
Boston, MA
New England Chapter

MARY ELLEN MARK
page 122
New York, NY
New York Chapter

DANNA MARTEL
page 35
Honolulu, HI
Hawaii Chapter

REBECCA MCENTEE
page 32
Austin, TX
Austin / San Antonio Chapter

PETER J. MENZEL
pages 198-199
Napa, CA
Northern California Chapter

ERIC MEOLA
pages 38-39
New York, NY
New York Chapter

ARTHUR MEYERSON
page 94
Houston, TX
Houston Chapter

PHIZ MEZEY
page 79
San Francisco, CA
Northern California Chapter

HELEN MILJAKOVICH
page 194
New York, NY
New York Chapter

MARK G. MOGILNER
page 34
Cuernavaca, Mexico

WILBUR A. MONTGOMERY
page 54
Indianapolis, IN
Ohio Valley Chapter

R. HARRISON NORTHCUTT
page 119
Marietta, GA
Atlanta / Southeast Chapter
Associate Member

MAGGIE O'BRYAN
page 132
New York, NY
New York Chapter
Associate Member

DENNIS O'CLAIR
page 210
Amityville, NY
Long Island Chapter
Regular Affiliate

DALE O'DELL
page 43
Houston, TX
Houston Chapter

RICK OLIVIER
pages 196-197
New Orleans, LA
New Orleans / Gulf South Chapter

DAVID OMER
page 165
Austin, TX
Austin / San Antonio Chapter
Regular Affiliate

MATHIAS OPPERSDORFF
page 147
Wakefield, RI
New England Chapter

VIRGINIA ROLSTON PARROTT
page 115
Hoboken, NJ
New York Chapter

GILLES PERESS
pages 82-85
New York, NY
New York Chapter

ARTHUR MEYERSON
page 94
Houston, TX
Houston Chapter

BOB PETERSON
page 172
Seattle, WA
Seattle / Northwest Chapter

LEWIS PORTNOY
page 221
St. Louis, MO
St. Louis Chapter

JOHN POST
page 160
Hermosa Beach, CA
Southern California Chapter

ROBERT ERVING POTTER
page 201
Chicago, IL
Chicago / Midwest Chapter
Associate Member

LOUISA PRESTON
page 117
Mill Valley, CA
Northern California Chapter
Associate Member

DAVID QUINNEY
page 114
Salt Lake City, UT
Utah / Mountain West Chapter

LARA JO REGAN
page 144
Los Angeles, CA
Southern California Chapter

LES RIESS
page 205
Jefferson, LA
New Orleans / Gulf South Chapter

SANDY L. ROCHOWICZ
page 90
Cleveland, OH
Cleveland / Northcoast Chapter
Associate Member

ART ROGERS
pages 126-129
Pt. Reyes, CA
Northern California Chapter

BEN ROSS
pages 68, 88-89
Brooklyn, NY
New York Chapter
Life Member

GALEN ROWELL
page 42
Albany, CA
Northern California Chapter

LEN RUBENSTEIN
pages 174-175
Easton, MA
New England Chapter

DON RUTLEDGE
page 78
Midlothian, VA
Washington DC / Mid-Atlantic Chapter

RON SANFORD
page 56
Gridley, CA
Northern California Chapter

SHEL SECUNDA
page 224
New York, NY
New York Chapter

BOB SHAFER
pages 30-31
Washington, DC
Washington DC / Mid-Atlantic Chapter

CORY SHUBERT
page 118
Los Angeles, CA
Southern California Chapter
Regular Affiliate

LARRY SILVER
page 142
New York, NY
New York Chapter

BRADLEY SMITH
page 87
La Jolla, CA
San Diego Chapter
Life Member

SEYMOUR W. SNAER
pages 70-71
Moraga, CA
Northern California Chapter

VINCE STREANO
page 116
Anacortes, WA
Seattle / Northwest Chapter

DAVID SUTTON
page 184
Tarzana, CA
Southern California Chapter
Life Member

WILLIAM THOMPSON
page 67
Ponisbo, WA
Seattle / Northwest Chapter

JOHN TITCHEN
page 220
Honolulu, HI
Hawaii Chapter

MARK TUCKER
page 47
Nashville, TN
Tennessee Chapter

PETE TURNER
pages 182-183
New York, NY
New York Chapter

STEVE UMLAND
pages 166-167
Minneapolis, MN
Minneapolis Chapter

NICK VEDROS
page 107
Kansas CIty, MO
Kansas City / Mid-America Chapter

MARIA VON MATTHIESSEN
page 187
Atlanta, GA
Atlanta / Southeast Chapter

DIANA WALKER
page 80
Washington, DC
Washington DC / Mid-Atlantic Chapter

DAVID WATERSUN
pages 62-63
Lahaina, HI
Hawaii Chapter

STEVE WEINBERG
page 61
New York, NY
New York Chapter

MARK S. WEXLER
page 156
New York, NY
New York Chapter

STEVEN BURR WILLIAMS
page 109
Beverly Hills, CA
Southern California Chapter

BOB WINSETT
page 185
Frisco, CO
Colorado Chapter

BILL WITT
page 140
North Palm Beach, FL
South Florida Chapter
Life Member

TONY WOOD
page 177
Belmont Hills, PA
Philadelphia Chapter

MICHAEL S. YAMASHITA
page 225
Mendham, NJ
New York Chapter

TOM ZIMBEROFF
page 193
Sausalito, CA
Northern California Chapter

ACKNOWLEDGMENTS

The "10,000 Eyes" project brought to reality this dream of mine, made possible through the efforts of many people. My heartfelt thanks go to my fellow committee members, ASMP's chapter officers and project coordinators, the National Board, our executive director and the national office, and our project sponsors, particularly Ray DeMoulin, Ann Moscicki, and Burke McCarthy of Kodak; Bob Leidlein of Refrema/Photoquip; and all the members of LABNET. I want to express special thanks to Ann Clements Borum, for her unselfish and total commitment to this project. She has truly earned an honored place in ASMP. Finally, my sincere thanks to all of our members whose energy and enthusiasm for "10,000 Eyes" made this project happen. I salute you.

Dennie Cody
Chairman, National "10,000 Eyes" Committee

ASMP has proudly been known as the voice of advocacy for those who photograph for publication, protecting their rights and promoting their concerns. Never before has the association showcased what it is we do and love so much.

These photographs express exuberance, thoughtfulness, joy, sorrow... life. Like watching a concert violinist who makes it seem so easy, the viewer of these pages will never know the years of practice, patience, and trial it took each photographer to be able to present the image you see here.

Our profound thanks go to the Professional Photography Division, Eastman Kodak Company; Refrema/Photoquip; the professional labs of LABNET; and a special thanks goes to Dennie Cody, Ann Clements Borum, and others who helped to make this project a stunning success.

David MacTavish
ASMP National President
1988–91

Getting some 5,000 highly creative, highly individualistic—and very busy—people behind a movement as challenging and as time consuming as "10,000 Eyes" was no small feat. When the whole concept was first explained to us by a few ASMP visionaries nearly two years ago, we were both excited and skeptical.

Happily for all of us in the world of photography, we let their unbridled enthusiasm and faith in ASMP's membership win the day. From the very beginning we've been proud to sponsor the noble events that led to the development of this landmark volume. Never before have we had the opportunity to see such diverse creative work from one organization.

Raymond H. DeMoulin
Vice President
Eastman Kodak Company
General Manager
Professional Photography Division

"Shouldn't we—as it is done in a democratic society—unite our forces, take the leadership and try to make the ASMP the instrument of our thinking and our aspirations?"

Philippe Halsman, 1906–79
First president of ASMP

These words, framed 47 years ago, have been the reasoning behind ASMP's goals since its founding.

Through the years the industry has changed, and so has ASMP. Now, with more than 5,000 members and 34 chapters across the country, ASMP is still dedicated to its original primary goal: to protect and promote the interests of photographers whose work is for publication.

In fulfilling its mission, ASMP seeks to keep its members informed in matters concerning business practices, legal matters, technology, and innovations. It exerts its influence through education of photographers and clients, lobbying at state and federal levels, skillful use of the legal system and courts, and by maintaining a dialogue with the photographers' client base in various media served.

Willing to listen, desirous to share, united and ready and able to act, ASMP is and always will be an organization made up of photographers, for photographers, and because of photographers. As the need to protect and promote becomes even greater and our voice stronger, we are the one organization that can and will lead photographers into the future.

Richard Weisgrau
Executive Director, ASMP

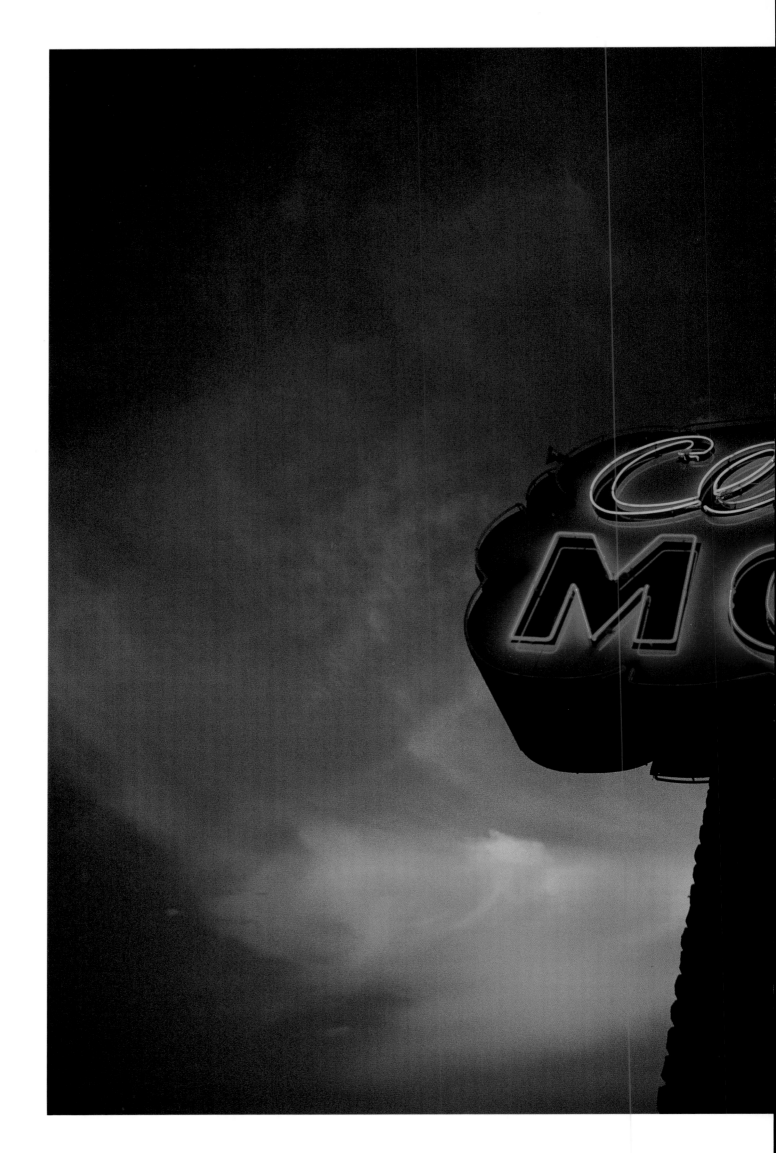

Cloud Nine Motel,
Halletsville, Texas

©1978 **TED HOROWITZ**

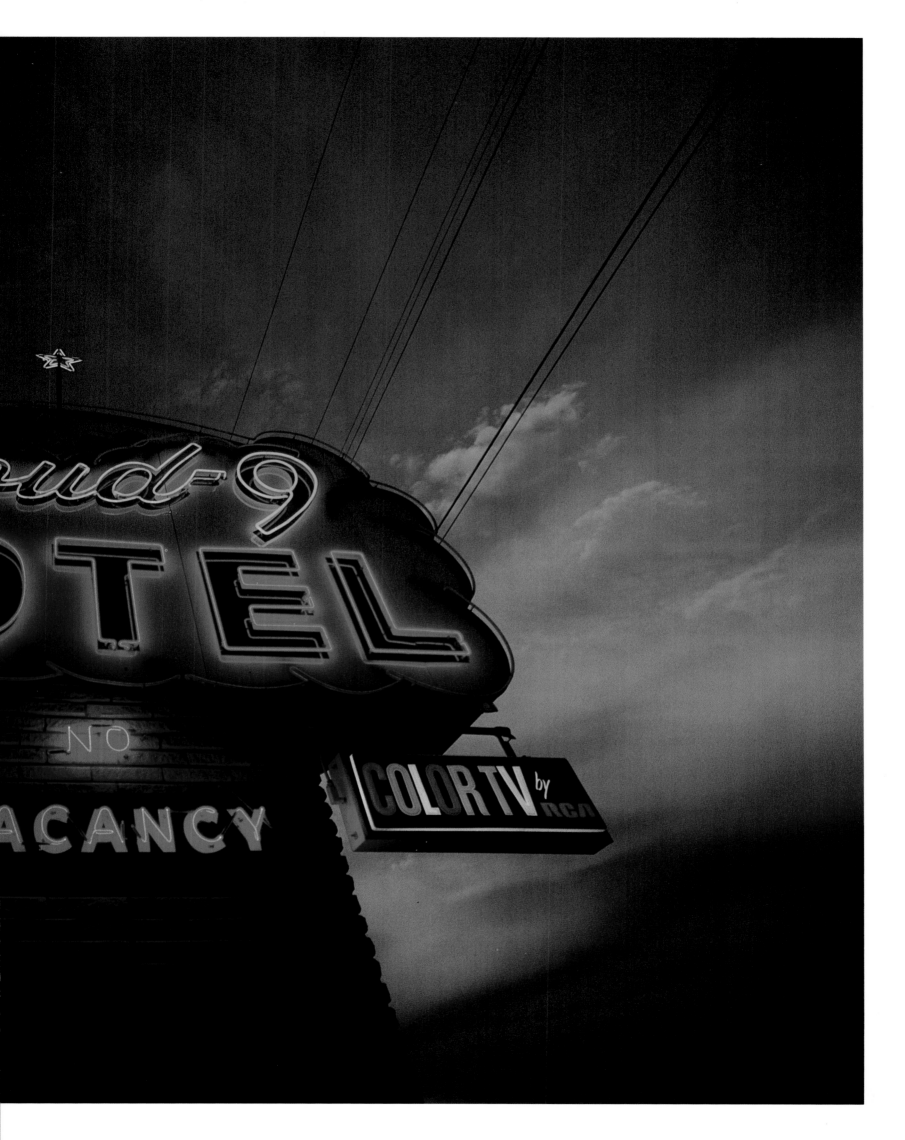